Wash and Gouache

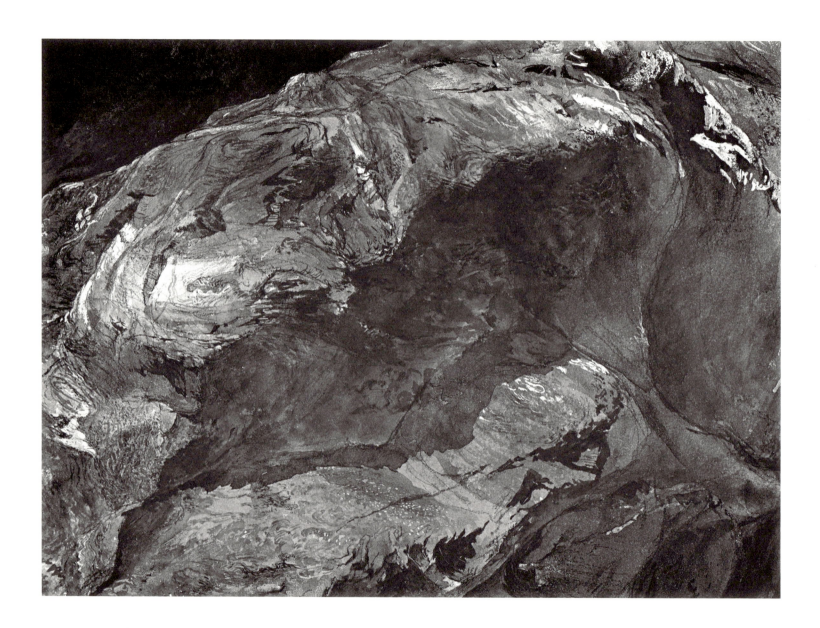

Wash and Gouache

A Study of the Development of the Materials of Watercolor

by Marjorie B. Cohn

Catalogue of the Exhibition by Rachel Rosenfield

Published by The Center for Conservation and Technical Studies, Fogg Art Museum

and The Foundation of the American Institute for Conservation

on the occasion of an exhibition of watercolors at the Fogg Art Museum May 12 – June 22, 1977

and in honor of the fiftieth anniversary of the dedication on June 20, 1927, of the Fogg Art Museum building

COVER. The watercolorist's paraphernalia: figs. 1 and 2, saucers for wash; figs. 3, 14, and 15, palettes for pigments; figs. 4, 5, and 6, three views of a double-barreled water cup; fig. 7, muller for grinding pigments; figs. 8 and 9, spatulas; fig. 10, quill brush handle; fig. 11, double-tipped quill brush; fig. 12, badger sizing brush; fig. 13, scraper (A.-M. Perrot, *Manuel du Coloriste* [Paris, 1834] pl. 1). The color of the cover reproduces Winsor green, Winsor & Newton Co.'s brand of Phthalocyanine green.

FRONTISPIECE. John Ruskin, *Fragment of the Alps* (53, detail actual size).

This book is set in Monophoto Sabon type for the text, with handset Bauer Bodoni for the headings and handlettering for the title. It has been printed by offset lithography, using a 300-line screen for the halftones, on Mohawk Super-fine paper. The sheets are sewn in signatures.

DESIGN AND CALLIGRAPHY: Stephen Harvard

COMPOSITION AND BINDING: The Stinehour Press

PRINTING: The Meriden Gravure Company

LIBRARY OF CONGRESS C.I.P. DATA

Cohn, Marjorie B., 1939–
 Wash and gouache.

 Exhibition held at the Fogg Art Museum, May 12–June 22, 1977.
 Bibliography: p. 84.
 Includes index.
 1. Water-color painting—Technique—Exhibitions.
I. Rosenfield, Rachel, 1951– II. Harvard University. William Hayes Fogg Art Museum. III. Title.
ND2430.C63 751.4'22 77-176
ISBN 0-916724-06-9

Contents

Preface

Fifty years ago the first scientific conservation laboratory in America was established at the Fogg Art Museum. Its head from 1929 through 1947, George L. Stout, has generously contributed the Introduction to this catalogue. Only three years after the founding of the laboratory, its staff, including Mr. Stout, contributed importantly to an international conference on the conservation of paintings held in Rome in 1930. Since that conference the Fogg has been a leader in the international exchange of knowledge of conservation theory and practice.

The International Institute for Conservation of Historic and Artistic Works (IIC) was established in 1950; the American Group (IIC–AG) was formed in 1960 and later became the American Institute for Conservation (AIC). In 1973, the Foundation of the American Institute for Conservation (FAIC) was established to sponsor and fund educational and scientific activities in the field of conservation.

The FAIC is pleased to join with the Fogg's Center for Conservation and Technical Studies in the publication of *Wash and Gouache*, which illustrates some of the more important technical aspects of the materials and methods of the watercolor artist, from pigments and medium to paper and even brushes. Further, insights are provided into the roles of the conservator and curator in the preservation of works of art on paper.

The Board of Directors of the FAIC wish to express their thanks to Marjorie B. Cohn, Associate Conservator of the Fogg Art Museum, for her extraordinary efforts in preparing this catalogue and in organizing the exhibition of watercolors from the Harvard collections. The FAIC is honored to contribute in this way to the fiftieth-year celebration of the Fogg Art Museum and to bring to the public further knowledge of the technique of watercolor.

Joyce Hill Stoner
EXECUTIVE DIRECTOR, FAIC

Acknowledgments

In the Spring of 1976 our suggestion for a modest exhibition of Fogg watercolors included neither requests for loans nor any proposal for a catalogue. Our idea has since grown into an investigation of the development of the watercolor technique and its materials. Its results will be preserved in this publication, and the exhibition now includes a number of important loans. None of this could have been accomplished without the early confidence in our proposal shown by Seymour Slive, Director of the Fogg Museum, and Arthur C. Beale, its Head Conservator; by Theodore E. Stebbins, Jr.; and by Joyce Hill Stoner, Executive Director of the FAIC. They encouraged us to seek funding for this catalogue, which has been generously provided by the Foundation of the American Institute for Conservation, the Stebbins Fund, Inc., and the H. J. Heinz II Charitable and Family Trust.

We have enjoyed the willing cooperation of the chief officers of the Bowdoin College Museum of Art, Winsor & Newton Co., the Library of the Boston Athenæum, the Busch-Reisinger Museum, the Houghton Library, the Map Collection of Harvard University, and the Dumbarton Oaks Research Library and Collection, who granted every request for loans. Our research has been forwarded by ready assistance from the staffs of the Fine Arts Library of Harvard University and the Art Department of the Library of the Boston Athenæum, and all arrangements for this exhibition have been ably managed by the staff of the Fogg Art Museum.

Many have given us their good advice on research problems of all kinds. We should like to thank in particular J. B. Adams, Joseph A. Adario, John N. Balston, Philip C. Beam, James Bergquist, Veronica Cunningham, Karen Davidson, Simon B. Green, Charles Haxthausen, Elisabeth B. MacDougall, Beth Mandelbaum, Sal Maurici, Manuela Mena, Frank Molea, Agnes Mongan, Konrad Oberhuber, Phoebe Peebles, Kate de Rothchild, Mark Samuels-Lasner, Leon P. Stodulski, Deborah Wye, and Henri Zerner.

R. Craigen Weston undertook the entire procedure of scientific pigment identification, from the sampling of the original watercolors to the selection of methods of analysis to their successful execution. These analyses have made possible an accurate assessment of the function of pigment characteristics in watercolor techniques and in visual effects peculiar to the medium. David P. Becker made essential contributions to our catalogue entries, and he has been our cheerful courier and confidant. Janet Cox and Suzannah Doeringer edited sense and sequence into our text, Melissa Marsh typed it in record time, and Patricia Perrier prepared the index. Stephen Harvard and William Glick, taking on two amateurs at very short notice, have given us a professional and beautiful publication. We thank them, and we hope that they all realize, as we do, how great their contributions have been.

Marjorie B. Cohn
Rachel Rosenfield

Introduction

The key was handed over during a brief ceremony in the court; the new building of the Fogg Art Museum was declared open. That was the summer of 1927. Installed on an upper floor was a restorer. He had learned how to make picture frames and to lay gold leaf. In the workshop of a restorer he had learned how to attach a wooden lattice to the back of a panel, how to adhere fresh linen to a fabric support, and how to remove and apply varnish.

In 1977, sheltered by that same building, this catalogue is presented. A part of its content deals with the construction and the condition of a class of paintings. These are matters of conservation. In 1927 that term was seldom used in the United States. When it came into use later, many looked upon it as a new-fangled synonym for restoration. What is the difference?

The field of knowledge comprised by the term, conservation in the arts, has been outlined in four tables: rudiments—knowledge of the raw materials out of which artifacts are fashioned; cardinal artifacts—those objects made by man which are deemed worthy of scholarly notice; degradation—the effect on artifacts of agencies which lead toward destruction; and reparation—measures that may be taken to preserve and to recover what remains of the substance and the character of a degraded artifact.

Restorers were occupied with reparation. Methods and formulations found effective were jealously guarded. Criteria accepted in the markets of art prevailed. If a damaged or degraded object left the restorer's workroom looking fresh and unharmed, the job was acclaimed as satisfactory whether or not the inherent character of the object had been kept.

Development of knowledge needed for responsible conservation in the arts had begun centuries before the Fogg Art Museum moved into its new building. Many had contributed: learned restorers, historical scholars, and men of science. The strongest force which pulled together earlier fragments and began studies toward further development of knowledge had its dwelling in universities. There the physical sciences offered acquaintance with the rudiments and with the agencies of degradation; there the arts fostered understanding of the history, the construction, the character, and the quality of artifacts; fully equal as a source of strength was the prevailing climate of candid inquiry. With suspicion, the faculties watched the mongrel pup that had crawled through the academic fence. After a time a few learned to tolerate it.

The shape of the body of knowledge that is conservation in the arts begins to be seen. It is rough, ungainly, and undernourished. To those who look closely the shape must seem little more than a wobbly skeleton. Muscle and sinew have yet to grow. This exhibition and this catalogue will aid the growth.

George L. Stout

Wash and Gouache

WATERCOLOR AT HARVARD

Although this exhibition of watercolors includes selected loans from the Busch-Reisinger Museum (30, 31, 47, 56),* Houghton Library (2, 36), the Harvard Map Collection (65), and Dumbarton Oaks (50), it does not represent the riches to be found in other Harvard collections. The Peabody Museum, Museum of Comparative Zoology, and Gray Herbarium hold watercolor records of the exploration of our world at large and in small; Countway Library contains a wealth of watercolor medical illustration; the Theatre Collection includes designers' renderings over the centuries; even the University Archives preserve exquisitely colored amateur views of late eighteenth and early nineteenth-century Cambridge and Boston, most executed under the unwitting patronage of the College, which then required of its graduates in science mathematical theses, including perspective studies.

Watercolors in these Harvard collections are often appealing beyond the simple poignancy of things lost and times past, and some rise to artistic significance beyond their origins. All, however, remain examples of watercolor as an applied art. In its expressive range, in the technical simplicity of its elementary essentials, cleanliness, ease of transport, and storage, and, not least, in its economy, watercolor has always been the favored means to represent the otherwise invisible: the unbuilt house, the beating heart, the marvelous discoveries still without homey associations or an accepted vocabulary.

This exhibition is a selection of pictures of purer function, self-sufficient in their images, although a few also served other

* Here and throughout a number in parentheses refers to the entry for the watercolor in question in the Catalogue of the Exhibition.

ends: Gillieron's rendering from a buried palace remains our best view of the fresco (20).[1] Others aided in the completion of art works in other media: the Albert Moore (41) is squared for transfer; Arthur Dove, whose *Gas Tank* (17) is an exact miniature version of an oil painting, is known to have used a pantograph to enlarge his watercolors onto canvas;[2] Turner's intensely colored *Bally-Burgh Ness* (60) was his model for an engraving in black and white. Yet each can be valued without knowledge of its ultimate function. The criterion of merit within the medium of watercolor is the only qualification for inclusion in this exhibition.

Watercolor assisted at the birth of art studies at Harvard, for Charles Eliot Norton, John Ruskin's friend for forty-four years, modelled the first professorship in fine arts at the University on Ruskin's tenure as the first Slade Professor of Fine Art at Oxford. When Norton joined the faculty in 1874 he hired a watercolorist, Charles Herbert Moore (42), to provide the essential visual complement to his rather literary lectures. Moore prepared himself for teaching by studying in Venice with Ruskin.[3]

Ruskin was Turner's ardent champion; and Edward Forbes, an apt pupil of Norton and Moore, would bring back from Europe in 1901 Turner's *Simplon Pass* (61, pl. 6). Though Forbes gave the watercolor to the Fogg only in 1954, it was a touchstone of the collection[4] even before Forbes served as the Museum's Director (from 1909 until 1944). His Turner was joined in 1919 by Ruskin's *Fragment of the Alps* (53), given by the artist to Norton in 1858, and other students and associates followed these pioneers' lead in their collections and donations.

It was noted in connection with Winslow Homer's career that "Bostonians have always been great collectors of watercolors, for some occult reason, perhaps connected with thrift."[5] To

9

their thrift should be added their irrepressible Anglomania, essential to their extension of the Ruskin-Norton-Forbes connection.[6] Fortunately for the Fogg watercolor collection, the star pupil Grenville L. Winthrop was as much a Francophile as Anglomaniac. Graduating from Harvard in 1886, he fortuitously lacked earlier and later generations' prejudice against watercolor as a minor genre. The Fogg owes to Winthrop its Blake and Pre-Raphaelite watercolor collections of world rank, its masterly examples of nineteenth-century French watercolors, and the amplitude of its Winslow Homer holdings, also fostered by Forbes. Of the sixty-five paintings in this exhibition, twenty-seven were given by Grenville Winthrop.

The purchase of contemporary watercolors of the highest quality underscored the Museum's commitment to the medium in earlier years. The Louise E. Bettens Fund, endowed in 1915 "for the encouragement of Painting by artists who are citizens of the United States," was used to acquire a superb group by Demuth, Marin, and Hopper, represented in this exhibition only by single examples (16, pl. 3; 38; 25).

Directors and donors in later years have felt less the attractions of watercolor. Although the Fogg's collection holds drawings of every period, few watercolors antedate the nineteenth century to reveal Europe's early development of the medium; although the Museum's interest in contemporary art continues, it has tended to collect more conventionally defined categories of drawings as well as paintings in the tradition of oil on canvas. Nonetheless, its masterpiece of the mid-twentieth century, Morris Louis's *Blue Veil*, can be admired for all the attributes of pure watercolor; and perhaps this exhibition will turn more attention to the medium as a whole. The limits of the watercolor collection have the good fortune to bracket exactly the period of the medium's greatest development, providing the opportunity to study in depth the revolution in artists' materials in the nineteenth century and its interactions with artistic ambitions and ideals of the time.

Before analyzing technical developments of the last two hundred years, it will be useful to sketch the period's own conception of the physical transformation of the medium. As watercolor had long since been identified as the amateur's medium, the opinions of artists and of the general public were usually held with peculiar intensity, lacking the customary mediation of critics and scholars. Also, in its role—one among many—as the amateur's art, watercolor encouraged a certain special spokesman, the professional author of instruction manuals for amateurs. This essay will depend heavily upon manuals, which are particularly useful in research into materials, as they generally ". . . assumed that the reader is a beginner who has never handled color nor brushes, and knows nothing about them."[1]

Not only are the manuals rich in descriptions of contemporary practice, they also attempt to proselytize the public toward concepts and processes, even to the point of opposition among themselves. And so latter-day students are able not only to learn from wider reading the currency of some technique that one teacher has condemned by silence; they can also gauge more generally the ebb and flow of technical fashion and esteem.

Ironically, while by all accounts the English led in every aspect of watercolor's development throughout the nineteenth century, including the production of manuals, French instructions are generally more informative. With the exception of Ruskin, a protean amateur–author–artist–drawing master, English authors seemed always to recollect the words of their seventeenth-century predecessor: "But to particularlize everything would seem to be a plot upon your patience."[2] The French may simply have reflected their heritage of encyclopaedic authors; more likely, artist and amateur, alike late starters behind an entire nation of experts in the new art, hoped for mastery through the conquest of every detail.

A definition and summary history given by a French writer in 1891 remain valid: "Watercolor . . . is in varying proportions a mixture of old-time manuscript illumination with gouache[3] and

wash. All those painting techniques which have water for their medium and gum arabic for their binder are of the greatest antiquity; but watercolor in the strict sense, which is only a wash in color and where the paper is reserved for the lights, came into ascendance only at the beginning of this century...."[4]

The first moments of "gouache and wash" are represented in this exhibition respectively by *Studies of Three Men's Heads and a Chalice* (39), probably an illuminator's sketch, and by the drawing of Saint Nicholas (32), which is kin to works by the wash technique's first master, Albrecht Dürer. The early wash style may be associated with the coloring of prints (whose outlines are approximated in this drawing by pen lines), a prime function of watercolor wash for five hundred years. Handling of the colors is differentiated here from the pen line by its broad, soft touch. However tentative the watercolor of this drawing may seem compared to the assured strokes of later painters, it is employed solely to indicate hue rather than describe form or contour; and the glint of gray stubble on the saint's rosy cheek is as delicate an observation as any description by Isabey or Lami (29; 35, fig. 13).

The wash style gradually developed through the landscape views represented here by *The Schelde at Antwerp* (1). The gouache style, in one of its aspects, evolved into ampler yet still minutely touched landscapes such as *Parc de Saint-Cloud* (45, fig. 3). Moreau's landscape is atypical in its naturalism within the gouache tradition; he was remarked upon as exceptional among French watercolorists in working out-of-doors.[5]

The transparent style seems innately more congenial than the opaque manner to representation of the luminosity or turbulence of changing skyscapes and the attenuation of landscape detail through layers of intervening air. Only in nineteenth-century England, however, would an impetus toward topographical description in watercolor burst the limitations of observed fact, first and most notably in the work of Turner (60, fig. 16; 61, pl. 6). His visions were recognized as revolutionary, and his materials and methods were equally acknowledged by his contemporaries to be radical departures from customary usage.[6]

In 1779 a French author, after giving a limited account of appropriate pigments and a single sentence on technique, could casually dismiss wash drawings: "That's all one can say about a manner of working used only for drafting and surveys, but which requires skill in drawing."[7] The English, however, progressed so quickly that by 1812 Rudolph Ackermann, an artists' supplier, publisher, and arts *entrepreneur*, could write:

Paintings in water colours, as performed by the British artists of the present school ... may almost be considered as a new art.... In speaking of this new art it must be understood to apply to painting with pigments prepared in gum, in contradistinction to painting in distemper, or body colors ... compounded with white.... These [latter] works ... are deficient in those excellencies that were provided by the invention of painting in colours prepared with oil; namely transparency and depth of tone. The modern art of painting in water colours emulates the transparency of oil, and calculating its power from the highest degree of light to its deepest degree of shade, may almost vie with that mode of painting....[8]

The exact technical innovations through which English watercolors came to merit Ackermann's estimate, accurate both in its observation of the effect of new materials and methods and in its assessment of the importance of technical development, will be discussed later. It is the explicit *desirability* of a close imitation of the effect of oil painting—the bellwether of a new consciousness of the changing potential of watercolor art—that concerns us here; for ambition would guide technique.

Beginning in the late eighteenth century, English watercolor artists struggled to establish their medium's credentials as high art—against painters in oils, who would admit them into the Royal Academy only in 1812 and then segregated them into a separate gallery; and against the public, whom they won over more easily, with the possible exception of the simpler folk, whose countryside gave painters their inspiration. Ironically, suspicious Welchmen who imprisoned a sketching party in 1803 believed the hapless artists to be that kind of gentlemen to whom

Gautier had dedicated his watercolor manual in 1687—generals, now appearing in Wales as Napoleonic spies, who would use their brushes to record enemy redoubts.[9]

The public's conversion to watercolor was speeded, certainly, by a spate of new manuals. Earlier books had passed quickly over the mechanics of painting to dwell on niceties of representation: one specified the exact combinations of pigments to color seventy-four separate species of flowers.[10] New books introduced English artists' manipulative innovations, in particular the art of laying a wash and reducing it again, to approximate the oil painter's methods of glazing, scumbling, and working from dark to light. The pertinent question occasioned by the founding in 1804 of the Society of Painters in Water-colours— "whether the novel term *painters* in water-colours might not be considered by the world of taste to savour of assumption"[11]— was answered with a reverberating "no" by the growing company of amateurs, patrons, and artists.[12]

Amateurs' efforts were constantly encouraged by a new sort of tradesman, the artist's colorman, who dealt not only in the raw materials of art but also in prepared supplies, and by English developments in colors and papers. Although professional artists had until recently prepared their own materials, amateurs could hardly be expected to assemble the apparatus or undergo the training necessary to create predictably workable, permanent, and beautiful substances.

Once educated to patronizing the colorman, the public's tastes became insatiable, requiring the stimulation of ever more ingenious apparatus and variety in supplies. By 1853 Winsor & Newton Co., specialists in watercolor preparation since the firm's founding in 1832, were appointed Artists' Colour Makers to England's first amateurs, Queen Victoria and Prince Albert; the profession and the medium were exalted to apotheosis.[13]

By this time England's superiority in all aspects of watercolor art was acknowledged worldwide. In France, eighteenth-century artists such as Natoire, a master of transparent watercolor in the handling of drapery and shadow in his *Bacchanale* (46, fig. 1), had been indifferent to the ridges of sediment in his washes and

had employed—brilliantly—white for both highlights and tonal modulations. Many nineteenth-century French artists followed the English fashion, forswearing gouache and purifying their washes. In 1891 Pissarro, an admirer of early nineteenth-century English watercolor masters (if not contemporary practice),[14] could lead a graduated wash across a sheet of best Whatman "Not" as perfectly as any Englishman (49).

German dependence upon English materials is particularly striking to the modern reader, as out of a thicket of *Fraktur* instructions a manual stipulates pigment usage in roman type, e.g.: "Yellow Ochre, Brown Pink, Cobalt, **und etwas** Rose Madder, **als schattenton**."[15] The German student had to be prepared to recognize foreign names on imported pans and tubes. In

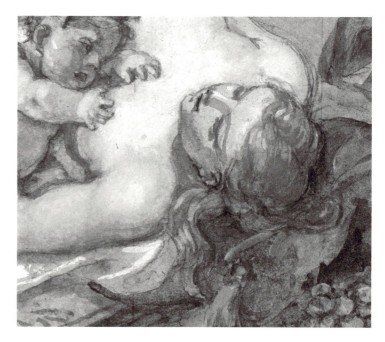

FIG. 1. Charles Joseph Natoire, *Mythological Scene: Bacchanale* (46, detail actual size).

12

America English colors were also recommended over domestic products, because of "the lack of long experience . . . and, second, the fact that too many of our manufacturers have no conscience."[16]

It must be emphasized that English supremacy was not based on leadership in the development of the basic substances of art, although they did play a large role in the synthesis of known natural pigments and the creation of new ones. England specialized in the preparation of materials specially adjusted to artists' requirements and in the promotion of their products.[17] The development of a satisfactory opaque white pigment for watercolorists' use is the best case in point, for its introduction marked another step in the "progress" of watercolor toward the emulation of oil painting.

Included among the white pigments in English and French manuals of the early nineteenth century was zinc oxide, first adapted as a pigment by the French in the late eighteenth century. Watercolor artists had long sought a substitute for lead carbonate, standard in oil paints, which darkens on exposure to impure air without the protection of oils and varnishes; but zinc oxide was reputed to be difficult to handle in washes and to have poor covering power.[18] In 1834 Winsor & Newton introduced with appropriate hoopla their patented "Chinese White," zinc oxide so finely divided that its working properties were greatly improved. The pigment's quality and its inventor's advertising efforts caused a revolution in English technique, although a rival colormaker would grumble in 1850 that zinc oxide was "more celebrated as a pigment than used."[19]

Ironically, in the very year of Winsor & Newton's innovation transparent watercolors by William Callow were shown at the Paris Salon. These generated great excitement among the French public and artists,[20] as had watercolors by Bonington shown at the Salons of 1822 and 1824. Otherwise, French knowledge of English technical developments in the medium was limited to what had been transmitted through visits by Delacroix and Gericault to England and lesser English artists to France and through the influences of the English transparent miniature style.[21]

By mid-century, when English watercolors were shown at the Exposition Universelle of 1855, the French had adopted the wash technique. Their confusion was complete upon seeing the English adopting gouache: "I can pass without a break from oil painting to watercolor: these two genres are less separate in England than with us," commented one French critic, ". . . they obtain effects that we have never even sought."[22]

About 1846 Winsor & Newton introduced moist watercolors in metal tubes,[23] which permit the application of large touches of relatively dry watercolor at full saturation. This was the final step required for the complete realization of the oil technique in watercolor. Ten years later John Frederick Lewis, President of the Old Water-colour Society, a bastion of the transparent wash style, exhibited an enormous painting executed entirely in opaque watercolor to huge critical acclaim.[24] Although Lewis abandoned the medium for oil the next year (to make more money), others, notably the Pre-Raphaelites, continued to refine and complicate the "oil" watercolor manner. By 1875 their foremost promoter, Ruskin, could inspect a Burne-Jones oil painting and declare to a curious Cardinal Manning "so quietly and authoritatively, 'Pure water-colour, my lord.'"[25]

Ruskin's and Manning's technical bafflement was shared by the public and by some English artists, who came to sense the contradictions suspected by the French critic of 1855: "Artists who give themselves so much trouble to do in water what they might easily do in oils are like the romantic lovers who come in down the chimney when the door would be opened at the second knock."[26] Though a reviewer of an 1867 English watercolor exhibition seemed to approve of the painters' ambitions, the warmth of his recollection of the "good old school," that is, the transparent wash style, betrays changes to come:

> Early methods . . . have gone out. Artists now spend days and weeks over a study. . . . Artists of the good old school [used] . . . a rapid hand, a keen eye, a mind bold in generalization, a purpose to decide what to do, and then to do not doubting. . . . Transient effects can alone thus be transcribed. . . . Watercolours of this type are too sketchy, slight, or rude to take a place

in a gallery of finished drawings. . . .[27]

A decade later a manual writer would proscribe the imitation of oil:

> It has become fashionable with some water-colorists to use a great body of paint. This is a mistake. Water-colors should not have the appearance of oil colors and *vice versa*. The great strength of water-colors is not in solidity, but in thinness.[28]

This reversal of opinion is exemplified by Whistler's portrait of *Maud Reading* (64)—entirely transparent, all lights left by the reserved white of the paper, with no attempt to conceal skips over the sheet's rough texture nor tag-ends of washes that dried before they were reworked. Boldini's *In the Studio* (7) and Homer's *Fourth of July Fireworks* (22) are also assertively "sketchy," although both depend upon opaque white and abrasion or blotting for some highlights.

Fashion turned to hitherto private images by early nineteenth-century artists such as Constable (12, fig. 2), whose earlier public had known only his oil paintings.[29] Attributes of "a rapid hand, a keen eye, a mind bold in generalization" were resurrected, but now within the new status of watercolor as a medium capable of creating finished—in the sense of final—images. The immediacy and freshness of *Flatford Mill* were somehow grafted onto the idea of painting as formally presented in Burne-Jones's *Second Day of Creation* (9, pl. 2). The latter watercolor and its five companion paintings, replicas of stained-glass church windows and originally imbedded in a single gigantic frame of the artist's design, must be remembered in the context of Burne-Jones's resignation from the Old Water-Colour Society in 1870. He wanted "big things to do and vast spaces, and for common people to see them and say Oh!—only Oh!"[30] But he did not renounce watercolor for such purposes.

Both the public and artists had come to believe in the potential of watercolor for significant statements, and the new change in the medium's vocabulary may have been due to some sense that the technique had been betrayed by its pursuit of the appearance of oil.[31] More likely it was simply another manifesta-

tion of the general shift of artistic vision away from the formal and descriptive formulae of mid-nineteenth-century painting, evident also in the Impressionist and Japonisme movements.

By the end of the century an artist such as Winslow Homer, whose oil paintings were strongly criticized in his lifetime for their sketchiness,[32] would create in his studio[33] an enormous *oeuvre* of finished watercolors (23), unrelentingly conscious in their color harmonies and composition but with a reliance on freedom of gesture in their execution which could be gained only by speed and security of hand beyond thought.[34]

Artists and public alike finally accepted William Blake's judgement for watercolors if not for oils, as applicable to Homer's *Key West* (24) as to Blake's *Circle of the Gluttons* (5): "Let a Man who has made a drawing go on and on and he will produce a Picture or Painting, but if he chooses to leave it before he has spoil'd it, he will do a Better Thing."[35]

As usual, the manual writers followed fashion and interpreted the current style to encourage the amateur of shallow perceptions. The sketch as finished picture was, it seemed, even easier than earlier formulae for minute representation: ". . . colours which may be locally crude and raw are blending into subtle mixtures 'in the air' [that is, to the viewer at a distance] and there is a strange suggestion of texture without the laboured portrayal of actual detail. . . ."[36] Two hundred years earlier a manual writer had promised that exact detail would enlarge the artist's vision;[37] now, there is a conscious renunciation of precision: "we shall *see* more while *portraying* less."[38]

Edward Lear, who described himself as working in the manner of early topographical artists,[39] may reasonably be considered a pioneer of the sketch as final image. Not only did he customarily rework with pen and wash his outdoor pencil studies years after their original execution, but he would select from his pencilled color notations those that seemed particularly evocative and pen them into the finished image, too. Thus in his *Roorkee* (36) "ox [meaning ox-gall, a yellow pigment] and Lake [a red pigment]" was rejected for transcription, as the colors could speak for themselves; but "Bright yellow-green

foliage scattered, Aspen=like–light grey trunks run through'' is as much a part of Lear's final image as the washes themselves.

The aesthetic of the watercolor sketch penetrated artistic consciousness so deeply that in 1937 Picasso would take his customary materials, oil paint and solvent, and, diluting the colors to washy thinness, blend them wet-on-wet on rough white paper in a perfect negative of the nineteenth-century "oil manner" watercolor (48).[40] Miró, too, would accept the concept of the sketch in his *Une Femme* (40), especially in the aggressive assertion of his brush's touch, anathema to earlier wash purists. The self-consciousness of his attempt to simulate the appearance of the sketch is betrayed by the elaborate stylus and chalk underdrawing, calculated by the artist to be legible just to the point of the picture's completion. Though the illusion of swift im-provisation is preserved, the painting is as carefully constructed as Burne-Jones's angels.

We return to Lear's ambiguous presence in 1874 as a technical survivor from 1800 and a conceptual precursor of 1900, or even 1950; for it indicates the paradox in which watercolor found itself by the early twentieth century. Manual writers had long since felt the obligation to recapitulate the successive stages of the medium's nineteenth-century development, ranking the various techniques according to some scheme of aesthetic function, relative difficulty, or presumed merit. By the early twentieth century the story of watercolor's technical evolution had become so compressed that survivors of every school asserted their particular "correct" interpretations, and watercolor was beset by factionalism.[41]

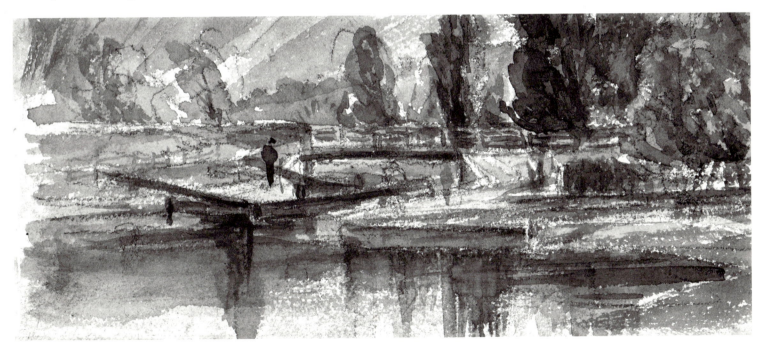

FIG. 2. John Constable, *Flatford Mill* (12, detail actual size).

Watercolor no longer presented a unified aspect to the public, comprehensible as a separate technique of major rank. By 1968 a manual writer, resigned to the contemporary anarchy of technique, would claim that "since we are no longer tyrannized by the conception of the 'pure' watercolor . . . the only question about a technical process should be—does it work?"[42] Moreover, with the appearance at mid-century of oil paintings asserting the validity of the sketch on a gargantuan scale and of acrylic washes on raw surfaces eight feet wide but perceptually comparable to paper, watercolor was joined and beaten in the arena of public attention.

Thus the advice given to a young artist several decades ago sounds reasonable enough to modern ears: Adolph Gottlieb remembers that "A dealer, when I was very young, was considering giving me a show of my watercolors, and she turned me down. She said, 'Well, you know, the history of art was never made with watercolors anyway.'"[43] In fact, however, throughout the history of art from its most primitive beginnings and especially in the nineteenth century, watercolor has played a significant role. It is to the specifics of its eighteenth- and nineteenth-century technical development, so inextricably intertwined with its aesthetics, that we now turn.

PAPER

A watercolor wash has the properties of a colloidal dispersion. This state of matter is assumed by extremely small particles, such as the pigments used in watercolors, suspended in a liquid such as water. Presuming the proper conditions, which will be discussed further, the particles remain dispersed through effects of Brownian motion—"the purely mechanical reaction of the innumerable collisions between all the particles [both water molecules and pigments] in the system"[1]—and surface tension.

It is essential that the wash remains in a liquid state—in a puddle—long enough for the pigment particles to distribute themselves uniformly. Thus a support for the wash must be relatively flat, with an even texture, or "tooth," have consistent absorption properties, and be only slightly absorptive in the short term. If the support is to be used to best advantage with the transparent or translucent substance of watercolor, it also must be white, so that light will reflect through the layers of color and provide the highlights of the design where color is absent. These requirements were not fully met by paper available before the end of the eighteenth century.

Ackermann attributed the ascent of the British watercolor school in part to the development of "wove" watercolor paper by James Whatman in the 1780s.[2] All earlier papers had a rectilinear grid pattern impressed by the screens on which paper pulp was formed into sheets. Whatman's initial innovation several decades earlier was to replace the usual coarse screen of the paper mould with a wire cloth of so fine a weave that it left no discernable mark on the pulp.[3]

His new wove sheet was greeted with enthusiasm by some printers and by watercolorists in particular, dependent as they are upon the uniformity of their working surfaces. As early as 1767 Thomas Gainsborough wrote to a book publisher begging for wove paper, having been tantalized by a single sample and then disappointed by receiving in error old-style "laid" sheets: "I am at this moment viewing the difference of that you send [laid] and the Bath guide [wove], holding them edgewise to the light, and could cry my Eyes out to see those furrows."[4] A watercolor on wire-marked paper such as *Lucia Carrying Dante in His Sleep* (6) by Blake, who was utterly indifferent to the desirability of a uniform wash, shows in its sky in particular the pattern imposed by the sheet's "furrows."

Wove paper has its own texture, imposed by pressing the pulpy sheets while drying them. By 1850 Whatman developed three surfaces for his watercolor papers: hot-pressed; cold-pressed, known in England as "Not," meaning not hot-pressed; and rough, in order of increasing tooth. Manual writers stressed the importance of texture to produce effects peculiar to watercolor:

The great charm of Water Colour Painting lies in the beauty

and truthfulness of its aerial tones . . . depending entirely upon the fact of the paper . . . being *granulous*, that is, upon its surface presenting so many little hollows and projections, which receive transparent washes of colour, whereby an alternation of light in the protuberances, and half-light in the cavities, is maintained.[5]

"Not" was generally advised for landscape painting, although rough was suggested for exceptionally large works or for free, sketchy effects. In order to adapt the sheet's surface for everything that an artist might want to represent, one author even suggested that rough paper be chosen for the sake of a "picturesque foreground," presumably filled with dry-brushed shrubbery and rocks, but that the sky area be burnished smooth before washing, to insure that it be "fine, vaporous, and nothing like the foreground."[6]

The effect of dry rough paper on very wet washes was particularly appreciated in the late nineteenth century and on to the present day, for quick handling of the brush draws the color only across the highest points of the sheet's surface. Air is trapped in its hollows, to bubble through the drying wash and leave sparkling white "holidays," an effect used to notable advantage by Marin in his skies (38). It is equally effective although far more subtle in Homer's *Key West* (24, fig. 7), which was painted on a smoother sheet. Pinpricks of white remain in the paper's fine grain, practically below the level of perception, to enliven what would otherwise be a bland tone. Their presence, incidentally, proves that Homer, in true sketch style, began his painting on a dry sheet. Preliminary washing with pure water would have filled its grain and permitted complete wetting by the colored wash. In Hopper's *Highland Light* (25), also begun on a dry sheet, the sky was washed once and retains its holidays of white; the shaft of the lighthouse was rewashed at least three times,[7] filling the paper's grain completely.

If a painter wanted to particularize every detail he would tend to select a smoother paper even for landscape, although only Ruskin would reject a rough surface with polemics: "Coarse, gritty, and sandy papers are fit only for blotters and blunderers."[8]

Smoother papers were generally recommended for figure studies, flower paintings, and other intricate subjects, with the finest surfaces reserved for miniature portrait painting.

If unabsorbtive paper is without tooth, washes do not tend to run smoothly, finding little friction in the surface to overcome a liquid's natural tendency to coalesce into droplets.[9] Miniaturists were forced to work with a delicate, interrupted touch; one manual writer ascribed their manner of "dotting, technically termed 'stippling,' which so many mistake for the end instead of the means,"[10] to early miniaturists' use of ivory (2). Chosen for its smoothness so that the artist could preserve detail in the age of rough laid paper, ivory is completely nonabsorbent and would defeat any attempt to lay a wash: "a little heap of colour collects where the brush first touches or leaves the surface, and the intervening space . . . will present something of the irregularity of a flow of water on a greasy plate. . . ."[11] Indeed, if paper was selected for a miniature portrait, the artist was advised by one author to prepare it with a smooth wash of white or to burnish it with a wolf's tooth.[12]

A wash's characteristics depend upon a paper's absorbency as well as texture, and quick absorption is as great a complication as is water-repellancy. If the moisture is immediately drawn from the brush into the paper fibers the wash will not flow nor the pigments disperse evenly. The colors will be dull; in watercolorists' parlance they are said to "sink." All papers would be as absorbent as blotters without special treatment called "sizing."

If an artist can control the difficult handling characteristics of unsized paper, distinctive effects can be obtained. The brush's individual touches are preserved even in a wet wash, the liquid being absorbed so quickly from the pigment that it has no tendency to spread, and the sheet's surface takes on a lustrous softness without shine. Oriental papers, unsized in the Western sense, are ideal for this usage, and Japanese vellum papers had a certain vogue, together with many other artistic products of the East, at the end of the nineteenth century.[13]

More interesting, however, are works by artists who indi-

vidually discovered that the special properties of Oriental papers complemented their personal artistic vision. Louis Moreau seems to have sought out Chinese paper, which has a surface distinctively marked by the sweeping strokes of the papermaker's drying brush. These strokes may be seen in the texture of the thinly washed sky of *Parc de Saint-Cloud* (45), where the wash has been selectively absorbed. The artistic use of Oriental paper was practically unknown in Europe at this time, and Moreau seems to have had no followers in his practice, perhaps because of the exquisite softness of touch required and the impossibility of reworking without damage to the matte, almost suede-like finish. In fact, Moreau himself, apparently wanting to alter his monogram in *Parc de Saint-Cloud*, was forced to lay a paper patch over the area rather than simply repainting it (fig. 3).

After their medieval beginnings and until the end of the eighteenth century Western papers were usually sized with a gelatin solution; newly formed sheets were dipped by the papermaker into a tub of size, coating both sides. English papers used for watercolor before Whatman's innovations were more or less weakly sized, and Ackermann remembered the hazards of washing on laid paper, "... which was fearfully done; a small blot or sinking of the paper was considered an irremedial misfortune. . . ."[14] Corrections were impossible before the development of a hard sizing because the skin of many earlier English papers would abrade easily, as can be seen in Blake's *Circle of the Gluttons* (5), where the artist, in attempting to reduce a delicate wash to create a nimbus around a falling figure, has rubbed away the paper's surface.

Manual writers of every nation and persuasion through the nineteenth century and into the twentieth were uncharacteristically in harmony, declaring that "The best and proper paper for all serious efforts at finished work is Whatman's specially made watercolour paper. . . ."[15] Their approval was based not on its texture, for wove papers were soon widely available from many sources, but on its uniquely hard-sized surface, whose properties encouraged the development of techniques of sponging, rewashing, and the taking out of highlights by wet processes at the turn of the nineteenth century.[16] Turner, whose abuse of his sheet's surface was notorious, customarily used Whatman paper,[17] and Whatman watermarks may be found on the Pissarro (49) and Demuth (16) watercolors in this exhibition.[18]

The deficiencies of Whatman papers were likewise associated with hard sizing: a graphite underdrawing did not catch on the coated paper fibers and so washed off easily,[19] and washes were difficult to lay smoothly[20] on the nonabsorbent surface and tended to dry with hard edges.[21] The latter difficulties could be modified by rewashing (permitted by the hard size) or turned to

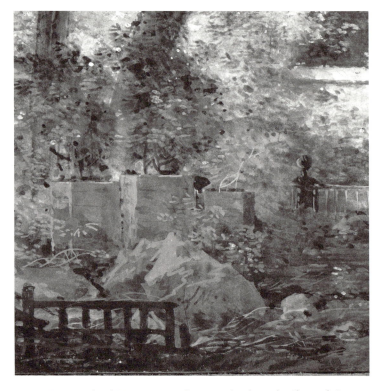

FIG. 3. Louis-Gabriel Moreau, *Parc de Saint-Cloud* (45, detail actual size).

18

the artist's advantage, as will be discussed later.

Other qualifications in the universal praise for Whatman paper also refer to its sizing. Whatman sheets, made by hand, were exquisitely finished, even to the nicety of trimming any projecting irregularities from the back of each sheet.[22] This had the side effect of locally removing its sizing. As "pitfalls and mortification meet one at every turn when the paper takes the colour in an eccentric way,"[23] it was considered essential for the artist to determine the right side before beginning a wash. Manuals recommended that the artist either sight across the sheet for the dull spots that would be found on the wrong side or look for the watermark J WHATMAN, which read correctly from the right side.[24]

Sizing faults on the reverse of a sheet could thus be avoided, but unsized areas which penetrated to the front were another matter. Continental purchasers in the nineteenth century found English paper peculiarly susceptible to such flaws, caused by mold that digested the gelatin sizing in irregular areas. French manuals of the 1830s speak highly of English paper, specifically Whatman, but always caution the purchaser to beware of "stains from humidity,"[25] that is, the visible residues of mold known as foxing, which develop under conditions of high humidity. They frequently recommend Dutch paper, specifically Kool's, as a more reliable substitute.[26]

The reason for French suspicions of Whatman's sizing, so acclaimed in England, is made clear by a late nineteenth-century writer's description of the conditions of importing paper over the Channel. Paper would "remain for several weeks in the depths of the ships' holds," and then be stored by French wholesalers in warehouse cellars, guaranteeing a long dank delay before the French artist obtained it.[27] In fact, conditions of storage and sale, as well as chauvinistic attitudes toward foreign products, always modified manuals' opinions of specific artists' materials.

Many watercolorists sought out papers other than the standard Whatman which were not found at the colorman's shop, not merely to save money but also to gain qualities of color, texture, and sizing that suited their particular style. Typically, however, any distinctive paper favored by a well-known artist would acquire a certain reputation, with the inevitable result. David Cox, who worked in a brilliant wash style (13), favored a "rough Scotch wrapping paper . . . very unabsorbent of colour . . . made from old linen sailcloth well-bleached."[28] Imitations of Cox's paper soon appeared at the color shops.

George Cattermole, who used thick colors mixed with white, did not require a heavily sized sheet. He was fond of "sugar paper," a thick, dull, absorbent sheet, originally blue in color, that grocers wound into cones to hold cake sugar. Again, the art supplier knew a good thing when the artist saw it, and soon sugar paper was "prepared especially for him by Messrs. Winsor & Newton, and known by his name."[29] Winsor & Newton also supplied Cartridge (originally a rough sheet favored by Thomas Girtin, a pioneer of the wash style), Creswick, and Harding (reputedly made by Whatman[30]); and thus the firm could accommodate almost every requirement of the late nineteenth-century watercolorist.

Whatman also produced in association with Winsor & Newton a deluxe watercolor paper, Griffin Antiquarian, a huge sheet (52 by 31 inches) of remarkable toughness. It was watermarked W&N and stamped with Winsor & Newton's griffin trademark; its high price—7s a sheet in 1866—was commented upon by the French.[31] Only one other watercolor paper was ever produced that was considered an advance over Griffin Antiquarian taken on its own terms. Its manufacture resulted from a combination of circumstances: first, the elaboration of a technique which made extreme demands on the artist's paper; and second, the general decline in quality of papermaking through the nineteenth century.

Although in 1873 it was reported that "Whatman's drawing papers are almost universally used,"[32] and that Antiquarian would "bear, perhaps, more scraping and rubbing than any other,"[33] a writer in 1917 commented critically that "Whatman paper takes colour beautifully if painted *à premier coup* but it is not strong enough to take much wear and tear."[34] His test for

resistance to wear and tear, however, lay far beyond Whatman's worst apprehensions: a sheet was satisfactory "if, after it has been worked on and the paint dried, we can get it quite clean again with soap and a scrubbing brush, and in such a condition that it makes a good ground for a new picture."[35] This writer was satisfied with paper developed in 1895 by John William North, a watercolorist whose style was marked by tortuous scraping procedures.

North's "O.W." paper, certified pure by the Royal Water-Colour Society and stamped with their monogram RWS, was manufactured by J. Barcham Green & Son, "in a very unremunerative commercial venture."[36] It had an extremely hard gelatin-sized surface that withstood any amount of reworking (and rejected an even wash until well aged, "with the perishing of the size"[37]), and it was made of one hundred percent linen pulp.

The requirement of pure linen fiber was an important one to manual writers by 1895. With the invention of the cotton gin in 1793 cotton rags for paper pulp became more widely available as cotton production increased geometrically, while linen manufacture remained constant[38] and then presumably declined. Paper made from linen rags was generally agreed to withstand washing and sponging better than any other kind and to scrape and cut with a clean edge, whereas paper made from cotton was considered, simply, cottony. Manual writers warned that cotton paper fibers would fluff up and cause the colors to blot.

Watercolorists were advised to avoid cotton-pulp papers insofar as they could, and as late as 1957 English watercolor paper manufacturers were praised for withstanding the otherwise general usage of cotton in rag-pulp papers. This attitude does not necessarily reflect the actual quality of a well-made cotton-pulp sheet, however.[39] Even the lineal descendant of North's O.W. paper, Barcham Green's Hayle Mill Linen, was ultimately converted to a cotton-pulp sheet; and the firm's present-day watercolor paper, also a cotton-pulp sheet, has recently been recertified by the Royal Water-Colour Society.[40]

In the nineteenth century the Royal Water-Colour Society did not necessarily share North's passion for a durable surface, but the Society and North, together with artists and their public throughout Europe and America, had become very concerned for the permanence of watercolor paper's substance.

Allusion has been made to the fact that North's O.W. paper improved with age. This effect was appreciated in other watercolor papers well before North's time. Early nineteenth-century artists such as J. D. Harding would pay "a guinea a sheet"[41] for aged paper, and somewhat later Winsor & Newton would advertize that they had "succeeded in getting together a choice stock of Whatman's Drawing Papers of mature age. PRICES DOUBLE THOSE [of new papers]."[42]

Although writers did not explain the effect of aging except to remark that washes could be managed better on older paper, the phenomenon may have been real and, if it existed, was probably a result of the mellowing of hard sizing. Overall, however, it more probably reflected artists' awareness that old papers in general were of better quality than new. As early as 1820 Francis Nicholson, a watercolorist as concerned in his day with the purity of materials as North would be at the end of the century, noted that "if the paper be of a clear and light cream colour, it will be better than the whitest, the bleaching of the latter being effected by such means as are injurious to some of the substances used in painting. . . ."[43] A British patent had been obtained in 1792 for the use of calcium hypochlorite to bleach paper pulp.[44] Chemical bleaching rapidly supplanted the previous methods of selecting only the purest rags for papermaking and exposing the pulp to air and extended water-rinsing to whiten it. With chlorine, less pure fibers could be used and production speeded and increased.

It was quickly recognized that the chemical could be harmful both to the paper's fibers and to colors, and manual writers through the nineteenth century constantly echoed Nicholson's warning against an overwhite sheet. It was even understood as early as 1835 that papermakers' efforts to counteract the effects of chlorine might also have a deleterious effect on colors:

. . . pure paper is essential to the permanence of colouring. . . . if the bleaching acid employed in manufacturing remains ever so little in the paper, both the texture and the colours will suffer in permanence; and if in the concern of the papermaker to neutralize such acid, the paper be surcharged with alkali or alkaline earths, they will prove no less injurious in these and other respects: it is highly necessary therefore that these circumstances together with the proper sizing and aluming of paper should be attended to, and that, if wanting . . . the artist should reprepare it himself, by a judicious application of weak isinglass [fish gelatin] size and roach [rock] alum.[45]

The warning and remedial instructions were given by George Field, who together with Nicholson was a pioneer in the study of color permanency. He was fully aware of the dangers of acidic and alkaline conditions to colors, but he seems to have been unaware of the hazards of alum.

Alum (aluminum sulfate) had been in use since the seventeenth century as a hardener for gelatin sizing.[46] It was recommended in the eighteenth century as a paper sizing and as an ingredient in watercolors, when the artist prepared them himself, to prevent them from sinking on weakly sized papers of the time, as well as to serve as a pigment base for vegetable dye colors.[47] By the nineteenth century it was almost uniformly recommended as a preliminary wash, sometimes in combination with gelatin[48] and sometimes with starch water,[49] on paper whose sizing was suspect, although it was noted that this practice was unnecessary and even undesirable on a sheet of good quality.[50] English writers stipulate alum washing less often than Continental authors, perhaps because of the relatively easy availability of Whatman paper in England and also because of the hazards of shipping and storage to which paper sent to the Continent were exposed.

Today alum in sizing is recognized as a major cause of paper's acidic embrittlement and deterioration, but this is in response not to an inherent characteristic of the chemical but to the effects of an essential change in the method of its use in papermaking. In fact, although by the end of the last century it was realized that it was possible to overdo the use of alum as a hardener for gelatin,[51] in its traditional usage alum is only weakly acidic. When the amount is carefully controlled it is *relatively* harmless[52] compared to its use in the new process patented in 1807 as a paper sizing in combination with rosin. In this method common by 1870, aluminum resinate is precipitated onto the paper fibers in the pulp stage, leaving a residue of sodium sulfate and free sulfuric acid that ultimately leads to the sheet's deterioration.[53]

Unfortunately, the rosin/alum process was and is attractive to papermakers: gelatin tub-sizing is a process additional to the actual manufacture of paper, and gelatin is difficult to maintain in optimum condition. Rosin/alum sizing employs stable, dry chemicals which can be incorporated directly into the paper pulp, thus saving a step and, in the early nineteenth century, making more efficient use of newly introduced papermaking machinery. Throughout the nineteenth century manuals warn against the use of machine-made paper, particularly in the discussion of sizing.[54] Probably only the universal endorsement of Whatman, a handmade, gelatin-sized sheet, and similar papers has protected nineteenth-century watercolors from the problems of deterioration that beset contemporary books, documents, drawings, and prints on machine-made papers.

The only case in which machine-made paper was recommended was in the execution of very large works[55] such as Gillieron's fresco rendering (20). Similarly, fine linen was also advised for large watercolor paintings, as it could be stretched to any size.[56] Compared to smooth white paper, the weave and tone of cloth produces a duller effect, and the artist was instructed to size its surface with gum arabic and paint with opaque colors. In conformity with such advice, *The Second Day of Creation* (9, pl. 2) was painted on finely woven linen in watercolors of high intensity, undiluted, and sometimes with an admixture of white. The painting is not beyond the dimensions of watercolor papers available at the time, but such a scrupulous imitation of oil painting would include, of course, a duplication of oil's traditional support.

By the twentieth century a great number of competitors of O.W. and Whatman's various products had appeared.[57] Their variety of surface and handling qualities offered new choices to artists, some of whom had become disenchanted with contemporary watercolor productions and blamed the hard-sized, gleaming papers for the paintings' supposed shortcomings:

> . . . the [technical] accomplishment is out of all proportion to the dignity of the interest on which it is lavished. . . . The fault, however, does not seem to lie with the lack of subject matter so often as with some inherent defect in the medium as employed by modern artists. . . . the blot of wet colour on white paper, with all its luminous freshness, is undeniably poor and crude in [aesthetic] quality. . . . The fault would appear to lie with the paper employed.[58]

More absorbent Japanese papers and silk enjoyed some popularity, and one hardy soul even rediscovered Cattermole's original sugar paper: "I use [grocer's unsized sugar papers] at such times as I am out in . . . storms, as the rain beating on the paper only softens the hard outlines. . . ."[59]

Machine-made papers manufactured in imitation of hand-

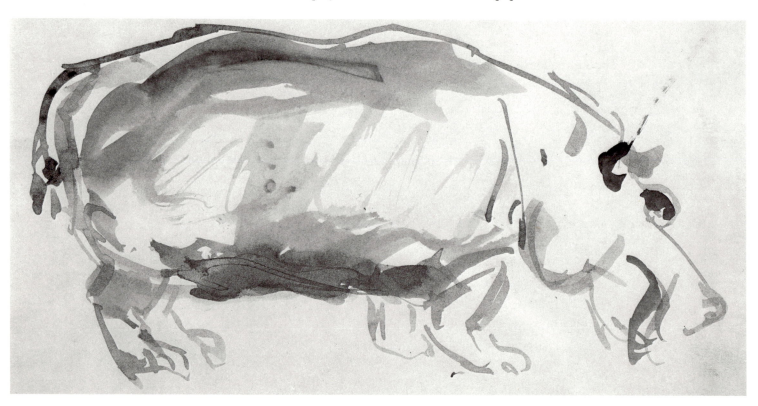

FIG. 4. Alexander Calder, *Studies of a Hippopotamus* (10, detail 78% actual size).

made watercolor sheets could still be used by artists disinclined to imitate the traditional glistening wash surface: Hassam (21) selected a sheet whose "right" side[60] was textured in a close approximation of Whatman "Not," but he turned it over and painted on the back, which carries the distinct impression of a coarse wove screen. He selected heavy pigments, which he applied in a masterly wash technique. Because of the paper's textured surface, which acted like a grating, the pigment particles did not distribute themselves uniformly but settled into the pores, creating the effect of a scintillating screen of atmosphere hanging before his landscape and sky.

Other artists, particularly those who were disinterested in either gouache or wash techniques and whose sketch style was now abbreviated to single strokes spaced widely across their page, were not dependent on any of the traditional watercolor papers' special qualities. Painters such as Nolde in his early years (47) and Calder (10, fig. 4) seem to have picked papers at random. In the twentieth century such a casual selection practically guarantees the use of machine-made paper, sized with alum and rosin, as it did in these instances.

Even these swiftest of drawings disturbed the weak, unsupported papers sufficiently to cause cockling—wavy ripples radiating from the design that indicate the sheet's expansion under the touch of a wet brush and subsequent contraction as the paint dries. In Calder's pink and blue hippo's tail, in particular, the intensely colored mottling within single strokes indicates how the sheet dimpled during the sketch's execution, before the lines could dry, allowing the wet pigment to puddle into small areas.

The phenomenon of cockling is a characteristic of all papers to some extent, even of the best watercolor sheets. It is usually a function of the sheet's thickness, thinner papers being more susceptible. The quality of thickness has not been mentioned in this discussion of watercolor papers; it is best considered together with those steps recommended to watercolorists to prevent cockling during a wash's execution and to encourage their paper's drying in a smooth and predictable manner.

If a well-sized paper is thick enough its substance will react so slowly to water applied on its surface that the sheet will dry before it begins to cockle. Therefore to simplify the process for amateurs many modern manuals recommend the use of the heaviest papers,[1] which are as stiff as light cardboard. This is a very expensive solution to the problem of cockling, however, and most watercolor artists have preferred a lighter paper, prepared so that it will resist distortion. Not one of the watercolors in the present exhibition is on exceptionally heavy paper.

A stiff sheet can be made by mounting light-weight watercolor paper on card stock, and such watercolor boards were commercially available in the nineteenth century, including all grains of Whatman in sizes up to 27 by 40 inches.[2]

The mounting card would not, of course, match the paper's quality. A 1929 manual warned against purchasing mounted papers or doing mountings themselves on ". . . cheaper board . . . made from wood pulp, chemically treated. . . . it turns brown with age and eventually stains through your paper."[3] In earlier years the pre-mounted paper itself was suspect: "the paper is not always good; it is often on the wrong side."[4]

Accordingly, the artist has usually been urged to prepare his papers himself, whether by pasting them down over their entire surface to boards,[5] or by stretching them. Even light-weight watercolor paper will withstand distortion if it is stretched taut. Stretching has generally been preferred to all-over pasting as, after a painting has been completed and dried, its edges can be detached and the sheet easily framed or stored; and there need not be repeated expenditures for backing boards.

Stretching instructions were included as accepted practice in the nineteenth-century manuals that advised an elaborate wash technique.[6] The stretching method described as oldest[7] required only an ordinary drawing board on which the dampened sheet was pasted at its edges. The exact degree of dampening had to be nicely calculated so that the sheet would not shrink in drying to the point of splitting,[8] and the artist was also occasionally cau-

tioned against the wooden board's staining his dampened sheet.[9]

The recommended adhesive through the nineteenth century was usually strong animal glue, sometimes starch paste, or in France *colle à la bouche*, an adhesive compounded of equal parts of glue and sugar, fruit flavored, and made up in little lozenges to be held in the mouth, the dissolved adhesive being applied with the tongue.[10] In all cases, the edges of the sheet would be carefully folded at right angles to the surface, so that the sheet could be moistened with water and the edges glued without one liquid spoiling the application of the other. The edges were adhered to the board in opposite pairs, the shorter sides first.[11] By the twentieth century various prepared adhesive tapes replaced glues; at first gummed paper tape was recommended,[12] and more recently pressure-sensitive tape such as masking tape has been preferred, as it can be peeled away without damaging the sheet's edge.[13]

Variants on stretching and pasting included adhering the watercolor paper to a pad of layers of stretched common paper[14] or to calico stretched on a frame.[15] Many nineteenth-century manuals recommended stretching without adhesives, however, and the artist could always simply pin his dampened sheet to a board, preferably with rust-proof tacks. A row of close-set, paint-soaked pinholes, distorted by the tension of stretching, at the edges of Cox's *Moorland* (13) indicates his use of this technique.

The nineteenth-century colorman was quick to offer an alternative, however. An assortment of devices was patented that clamped the dampened sheet between an outer frame and an inner interlocking panel or frame, crimping the paper's edge to hold it fast (fig. 5), or that pierced the sheet's edges with a set of pins that fit into corresponding holes in a back panel or frame—a sort of iron maiden for watercolor paper (fig. 6).[16] Both gadgets could be shut fast, the interlocking frame by wood strips on its reverse that swivelled to insert their tips into notches in the outer frame's back edges, drawing the two elements together snugly; and the pin-stretcher had hinges and hasps that closed the device tightly. The unpainted edges of *Highland Light* (25),

creased to the back along their entire length and crimped at the corners, without a trace of adhesive (which would have indicated that the sheet had been pasted to a board), betray Hopper's use of the first sort of stretching frame.

There seems little to recommend one stretcher over the other, although the former seems to have been in more common use in the studio. It was available in a large variety of sizes to fit all possible fractions of standard watercolor sheet dimensions, up to one 28 by 19 inches to accommodate a full sheet of Imperial; and the artist's supplier was always ready to prepare any size that was not available from stock.[17] The pin-stretcher, an invention credited by the French to the British,[18] appeared a little later in the nineteenth century. It was favored by sketchers in the field, as three or four sheets could be stretched on top of each other, saving the weight of a collection of panelled boards.

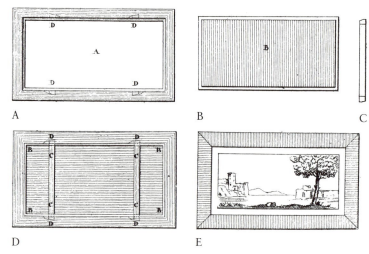

FIG. 5. Four views of a paper stretching board: A, outer frame from the back; B, inner panel from the front; C, one of two fastening sticks; D, back of the stretching board with the sticks locked shut; E, front of the stretching board with a watercolor in place (F. P. Langlois de Longueville, *Manuel du Lavis* [Paris, 1830], pl. II).

24

Both kinds could be made in the form of double frames, as opposed to a frame locking over a panel, thus permitting the artist the option of remoistening his paper from the back during his course of work. The wet-sheet method of painting was favored by many artists,[19] and various other preparatory procedures were developed to retard the sheet's drying. The wet watercolor paper could be laid over several sheets of soaking wet blotters[20] or over a slate, glass, or zinc plate, which would retard evaporation from the reverse; or the methods could be combined.[21] The sheet might even "be mounted on a piece of heavy cardboard with a strong hide glue; after this has dried it may be soaked overnight in water: the glue will swell and retain the moisture for many hours."[22]

Stretching frames had one further effect that may even have influenced nineteenth-century artists' growing sensibility to wa-

MAHOGANY SKETCHING BOARDS.

A very light and portable contrivance, being a thin Mahogany Board with iron pins inserted, over which several sheets of damped paper can be placed; and a slight frame with pin holes being then shut down upon them, they are firmly held while drying, and when dry. The sheets of paper are thus strained ready for use with great facility and cleanliness.

Best Framed; brass bound, 4to Imperial, Plain, 7s. 6d. each; Polished, 10s. 6d. Ditto, ditto, Half Imperial, Plain, 12s. 6d. each; Polished, 18s.

FIG. 6. Pinned paper stretching board (*Winsor & Newton's List of Water Colours*, p. 54, bound in Thomas Rowbotham, *The Art of Sketching from Nature* [London, 1869]).

tercolors as finished images worthy of exhibition. The devices were made of wood, usually mahogany, and their outer frames had neatly mitred corners. When locked in place over a blank sheet they looked like nothing so much as finished picture frames (fig. 5, E). Who could blame the artist if he responded to the suggestion, with all its implications?

A pre-stretched (rather than pre-mounted) sheet has also been available for over a century;[23] it is especially popular with amateurs who wish to avoid studio apparatus. Watercolor paper of all kinds is made up in compressed pads or blocks, all four edges joined in the same manner as a notepad's single bonded side. The paper is under some tension, but as manual writers indicated, a wet wash could cause the surface to ripple "like unto the Bay of Biscay,"[24] and the last sheets on the pad would become "loose and useless."[25] Also, outdoor sketchers would have to take along several blocks, which are quite heavy, since a painted sheet cannot be detached until the washes have dried without danger of cockling. In general, blocks were recommended only for small works, 10 by 14 inches (quarto Imperial) or less; in fact, the only sheet in this exhibition that can be identified by adhesive residues at its edges as coming from a block, Dove's *Gas Tank* (17), is very small indeed (5 by 7 inches; 16th Imperial).

An attempt has been made to determine paper preparation methods for most of the watercolors in this exhibition, without any real success except for the three works mentioned above. Most of the sheets are blank on their reverse, and many have adhesive residues either all over or along their edges at the back, which would seemingly indicate that they were prepared by pasting or stretching. But these have been mounting methods favored by picture framers as well as artists,[26] and so the point is uncertain.

An examination of the sheets' edges may reveal pigment slopped over the sides, which would seem to contraindicate the use of stretching frames. This occurs often in Homer's watercolors, yet in many of his paintings, and in Sargent's as well, the paper sizes are consistently less than regular fractions ($^1/_2$, $^1/_4$,

etc.) of standard paper sizes. It appears as if a small border had been removed from all edges of a half-Imperial sheet, for example, in the case of the *Hunter in the Adirondacks* (23). Works painted on frame-stretched papers were usually cut down to remove their crimped or pierced edges; they would have a blank margin, formerly covered by the frame's inner edge, unless this too had been cut off.

Perhaps the only sheets in this exhibition that can be said definitely not to have been prepared before painting are the two sketchbooks and such finely worked portraits as the Isabey (29), whose modest hatchings would not have warped the heavy card stock on which it was painted.

The sketchbook origins of Constable's *Flatford Mill* (12, fig. 2) are betrayed by its three dirty edges and the stitch marks and cord impressions along the fourth. Covering only a part of the dry sheet, the painting bespeaks a quick execution, evoked by fleeting effects of cloud and wind yet undoubtedly enforced by the artist's anticipation that the paper would cockle if the process were prolonged.

The Cross sketchbook of several pages (14) is even more revealing of unstretched paper's unruly habits, which dictate a certain manner of execution. Only the cover sheet is fully worked in repeated wet washes. The first interior sheet is washed overall, but in a more summary style that doubtless dried more quickly, so that the artist would not have to wait long before turning the page. Thereafter, however, apparently unwilling to wait even briefly, Cross divided his pages in half horizontally so that a washed sketch at the top could dry while he completed a pencil study at the bottom. When he wanted again to execute a full-color, full-page study, he resorted to crayons, which required no drying time, of course, but which, being opaque and penetrated by the paper's grain, lack the intensity of comparable watercolor washes.

His paper prepared, the traditional watercolorist did not immediately set to washing but would first lay out his design in an underdrawing. Portrait miniaturists tended to use graphite[1] or metalpoint traced over with fine brush lines,[2] and gouache artists sometimes preferred charcoal, since graphite's slick surface would repel wet paint, thus making an opaque medium seem disconcertingly transparent.[3]

Other materials were pressed into use for commercial reasons: Rowlandson would pen outlines in red ink and quickly run the sheet through a press with another sheet on top, to get two drawings for the effort of one.[4] Nicholson admitted to going one step farther.

> I manufactured an incredible number of drawings. My process was by etching on a soft ground . . . different views . . . from which were taken impressions with black lead [graphite]. This produced outlines . . . perfectly like those done by the pencil. . . . This was nearly half of the work, and in the long days of summer I finished [that is, washed] them at a rate of six daily.[5]

These were extraordinary procedures, however; most manuals advised (and most artists employed) graphite points.

Even graphite was a peculiarly English specialty, mentioned as early as 1573.[6] Through the nineteenth century the pigment was used just as it came from the mines: "The best black-lead pencils . . . are those made of pure Cumberland lead, cut into strips and enclosed in red cedar."[7] Graphite's natural origin could be proved by its anisotropic hardness: "When pure, the lead will be found to cut freely[8] on two opposite sides, and harder on the other two. In using such pencils, the draughtsman can, by turning the pencil as he desires, produce a light or dark line."[9]

Yet by mid-century the production of fabricated graphite pencils was customary in Germany and France. There the graphite was ground up and compressed with clay to produce points of various (but homogeneous) hardnesses. Fabricated graphite,

now the usual form in pencils, is less easily erased than the natural pigment, an attribute appreciated by some early watercolorists, since it is therefore also less susceptible to "washing up."[10] In general, graphite of medium hardness (no. 2 in present usage) was recommended by the manuals. Too hard a point would emboss the sheet and too soft would dirty it, and thus either extreme would sully a pure wash.[11]

Charcoal,[12] perhaps the most common sketching medium in traditional techniques other than watercolor, was occasionally recommended for the very first tentative outlines, as it could be followed by a more precise graphite outline and then dusted off with a bird's wing[13] or handkerchief.[14] Although no manuals explain the effect, charcoal was never in early years allowed to remain on the watercolorist's page because it ". . . withdraws the majority of organic colouring matter from suspension. . . . A pale tint of rose madder in water, if a pinch of . . . vine black be added becomes rapidly decolourized, the pigment being completely absorbed,[15] although not really destroyed."[16] Only in the early twentieth century, when traditional organic watercolor pigments, mostly vegetable extracts, had been largely replaced by mineral pigments, does one find any recommendations of charcoal for a final drawing.[17]

Other sketching media such as crayons were generally contraindicated because of the difficulty in erasing them without tearing through the paper's delicately sized skin,[18] and even erasing an incorrect graphite underdrawing was a constant problem for the watercolorist. India rubber and art gum (usually called "caoutchouc" in the nineteenth century) would "injure the surface of the paper"[19] and cause the washes to blot. Stale bread was recommended,[20] but it could make the paper's surface greasy and thus wash-repellant.[21] Scraps of white leather gloves or "wash leather," considered the gentlest eraser, were old-fashioned by their last mention c. 1890.[22] Thus for fear of injuring his paper, the watercolorist was only rarely encouraged to erase his underdrawing, although one landscape instructor recommended, "after the mountains have received their first tints . . . erase the pencil outline with india rubber, or with art gum,

the color being perfectly dry. The result of this will be a charming aerial effect, and the removal of any hardness of the edge of your wash."[23]

Indeed, the watercolorist was usually more interested in retaining his underdrawing than erasing it, and manual writers observed early that a wash of pure water would drive the graphite particles into the sheet and tend to fix them in the paper fibers.[24] Artists who dampened their paper overall before beginning to paint were advised that a separate fixative was unnecessary,[25] as were those in the age of chemically white-bleached sheets who commonly washed in as an undertint "warm but broken colour applied all over the surface."[26]

But hard-sized papers such as Whatman held the graphite poorly,[27] and stronger fixatives were sometimes recommended: "*water-starch*, prepared in the manner of the laundress, of such strength as just to form a jelly when cold, . . . thin, cold isinglass, or rice water,"[28] skim milk, pressed through the back of the sheet when dried with "a warm but not very hot flatiron,"[29] and in modern times acrylic matte medium or varnish diluted 1:1 with water and sprayed over the underdrawing.[30]

Although manual writers from the beginning advised a disciplined underdrawing—"A clear and decided Outline possesses a manifest superiority over an imperfect or undecided one"[31]—and many artists have conformed to this style, other watercolorists have allowed themselves more freedom, finding inspiration, perhaps, in an improvisatory first effort. In *Flatford Mill* (12, fig. 2) Constable's rough, crumbling line is as expressive of the wet and breezy scene as the broken washes that followed. He did not feel constrained to paint to the line, however; a graphite figure at the center has moved into the left middleground in the wash sketch, and a legible line is never critical to a final effect.

Other artists give their underdrawing a larger voice. Following his heavy graphite lines carefully with pale wash, Hassam (21, fig. 7) has caused them to read as a dark edge, a boundary, in much the same way as the edges of his saturated wash, intensely dark from their concentration of gum binder, delineate the lighter puddled centers. Ingres has likewise used graphite and

color for equivalent final effects, although in an entirely different style, in his *Virgil Reading the Aeneid* (27). Instead of washing freely over bold lines, he has touched only the tips of his tools, pencil and brush, to the tracing paper. Their marks are glistening points of modulation on the slick surface, one of tone, the other of hue.

Schiele's underdrawing (56) carries the concept of black line as a color boundary to its extreme. Gaps between the artist's tessellated washes are entirely filled by line so that intricate, pure-color juxtapositions, ordinarily achieved only with the most finicky style in transparent washes, can be stroked on boldly. Through such an underdrawing the artist could negate the risk of colors' blotting and yet achieve an image without any visual interruption by the required intervening network of dry paper.

In Homer's *Key West* (24, fig. 8) the function of line and wash are separated rather than joined. Paint is reserved for the expression of tonal areas and their boundaries. Any line in this system that does not separate one tone or color from another is executed in graphite: the one-dimensional masts and rigging of the schooners at the left are drawn in pencil, but their two-dimensional topsails are defined by boundaries of wash around reserves of white.

Audubon (3) has carried the differentiation between graphite and wash still further, taking up his pencil again after the water-color's completion. Graphite traces the veins of honeysuckle leaves and, in combination with chalk, imparts both sheen and softness to the robin's downy throat.

The use of drawing media other than graphite for textural effects over a finished wash is not uncommon in artists who were not primarily watercolorists, such as Audubon or Daumier. Unimpressed by the sanctity of the wash technique, Daumier in his *Butcher* (15) has chosen to draw a few final details in crayon. The sooty outline of the joint at the right contrasts with the dark luster of its background wash in an effect absolutely unobtainable in pure watercolor, or even with added graphite. These touches are the imaginative exception rather than the rule in the watercolor technique, however, where by definition effects are to be sought with wash and brush.

FIG. 7. Childe Hassam, *White Mountains, Poland Springs* (21, detail 200% actual size).

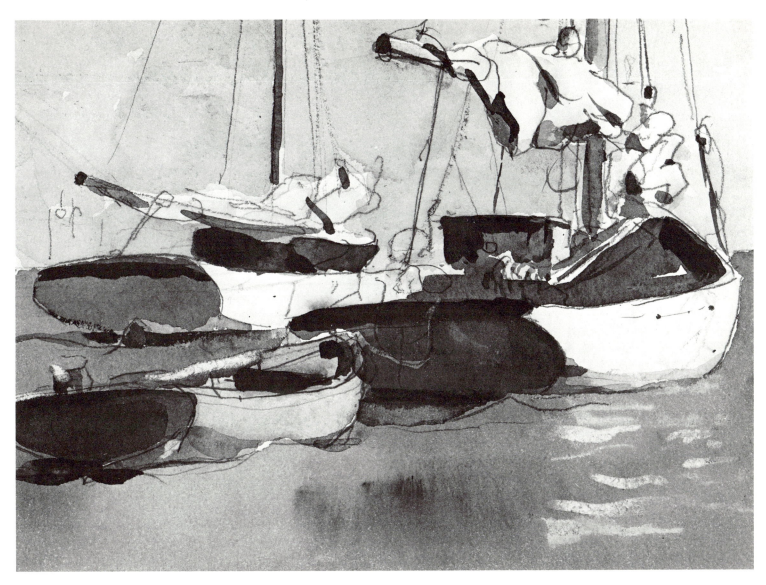

FIG. 8. Winslow Homer, *Key West* (24, detail actual size).

Although the usual tool of watercolor is now known in English as a brush, until only recently[1] it was called a pencil; for pencil once denoted any artist's brush capable of delicate effects and a fine line. The traditional brush had stiff hairs of equal length and a broader tip, as is required by oil painters to manipulate their viscous medium.

The watercolor pencil/brush has an entirely different usage, however, and thus a different form and substance. It must provide a large reservoir for a watery fluid (its body of fine hairs) and a very small outlet for this fluid (its tapering point), so that surface tension will keep the fluid from discharging all at once. Yet the outlet must be capable of sensitive enlargement by infinitely modulating pressure, so that a controlled wash can be released. Thus the ideal watercolor brush will be made of hair so supple and resilient that it will flex but not deform. The brush will tend to retain its shape against light pressure, the weight of the body of wash, and will regain its shape immediately upon the relaxation of stronger pressure, the touch of the artist pressing its tip against paper.

With such a brush the artist can stroke firmly, spreading its hairs to wash broadly; and yet as he raises his hand, the tip will reform so quickly that the fluid will be closed off in an instant. Such a brush will flex so softly that its touch will not "wash up" an underlying dried color; Pissarro's technical advice to his son —"you won't dirty the tone if you don't press too much on your brush . . . work with the point"[2]—is manifest in the transparent delicacy of gradations in his *Landscape, Eragny* (49).

An artist would select a watercolor brush, therefore, by judging the perfection of its point: "Your *pensills* must be chosen clean and sharp poynted, the hairs not divided into parts (as many of them do, being drawn gently out of your mouth between your Lips)."[3]

Another definition of "pencils," as opposed to brushes, depended on the "smallness of their size and, in being manufactured of a much finer and softer hair. In some cases the hair of the marten, or of children, and even swansdown are used. . . ."[4] Children's hair and swansdown were not commonly used; perhaps they were too exotic a fiber, but they also do not possess sufficient resiliency to contain a body of wash. The Asiatic marten, however, known as the Russian sable or kolinsky,[5] has been acclaimed by all writers even to the present day as providing the world's finest watercolor brush hairs. Before the twentieth century brown sable was considered superior to red, although today only the red can be found in suppliers' catalogues.

In earlier years the best sable brushes were made in France,[6] and today only the French still produce the otherwise outmoded watercolorist's brush with its hairs set in a bird's quill rather than the usual rust-proof metal ferrule. Quill brushes were traditionally sized by their source and could be obtained as small as a Lark and as large as an Eagle, with many gradations in between (fig. 9). The Large Swan was the biggest brush commonly available, as the Eagle was and is prohibitively expensive. In 1871 an Eagle cost a guinea (compared to 10s for a Swan no. 1; a tube of Chinese white was 1s),[7] and today its modern equivalent, Winsor & Newton's "Albata" no. 14, costs $82.50 (compared to $60 for a no. 12; a tube of Chinese white is $1.05).[8]

A large sable, which holds a great amount of liquid, is essential to lay an even wash. Its point being almost as delicate as a Lark or Crow, it is exceptionally versatile. Manuals have consistently recommended that the artist purchase as large a brush as he could afford and could comfortably handle, and prudent artists have always been very solicitous of their brushes' care.[9] Various precautions were advised in the manuals, above all, careful rinsing, to remove all color from the heel of the brush. Otherwise the shafts of the hairs would become brittle where they pass into the quill and would break off in use. The artist was warned not to clip straggling hairs but to wet the brush and pass it quickly through a candle flame. Separated hairs would dry instantly in the heat and be singed back to the body of the brush tip, which, remaining wet, would escape intact.[10] Being made from fur, brushes are attractive to moths; the artist could keep a piece of camphor in his paintbox[11] or dip his brushes in campho-

FINEST SABLE BRUSHES.
For Water Colour Painting.
BROWN SABLE HAIR.
Domed Points.

THE BRUSHES DESCRIBED ARE THE SAME SIZES AS THE
ENGRAVINGS.

6d.

8d.

1s.

2s. 6d.

3s. 6d.

5s.

7s. 6d.

Messrs. Winsor and Newton solicit especial attention to their Stock of Water Colour Sable Brushes, which are of the very Finest Quality, and selected with great care.

WATER COLOUR BRUSHES,
FOR SKIES, WASHES, AND LARGE WORKS.

A.—Large Round Wire-bound Brush, made of Siberian Hair, a most useful Brush where large washes of colour are required.

PRICE 3s. 6d. EACH.

B.—Large Flat Brush in Albata, made of Dyed Sable Hair, suitable for skies, foregrounds, and large works.

PRICE 3s. 6d. EACH.

BROWN DYED SABLES.
In Metal Ferrules, and Black Polished Handles.

Flat or Round.

These Brushes are the same in size and form as the Sables in German Silver Ferrules. See page 18.

	s.	d.			s.	d.
No. 1 each	0	7	No. 6 each	1	2	
2.	0	8	7.	1	6	
3.	0	9	8.	2	0	
4.	0	10	9.	2	9	
5.	1	0				

A.

B.

FIG. 9. Sable quills and large wash brushes (Winsor & Newton Co., *Illustrated List of Colours and Materials*, pp. 17 and 20, bound in Henry Warren, *Artistic Anatomy of the Human Figure* [London, 1854]).

rated alcohol before putting them away.[12] A moist sponge would keep the brushes limber in storage in hot weather.[13] Split quills could be repaired by cutting a notch across the extremity of the fault to prevent it from continuing[14] or by binding with tape and shellac.[15]

Splitting was a common defect of brushes set in quills, as the ferrule was extended by the insertion of a wooden, bone, or ivory handle (fig. 12), which was held fast only by friction. If pushed in too firmly, the quill would split; yet a loose handle was apt to drop its sopping wet tip onto a painting without warning.[16] The curve of a full-length quill such as that used by Winslow Homer made the brush clumsy (''gauche'') in the hand[17] compared to a symmetrical shaft, but even after the introduction of metal-bound sables with fixed handles, watercolorists favored quill brushes because they were comparatively light[18] and thus more delicately responsive. They also tended to wear less rapidly, since a metal ferrule breaks the hairs at the heel more readily.[19]

Another advantage of the quill with its detachable handle was discovered in a use peculiar to the wash technique. Quill brushes could be fitted to each end of a shaft; the artist would reserve one for color and one for pure water, so that he could lay a wash and gradate it without fear of loading the water brush with an excess of color or sullying either tip with another tint.[20]

When metal-ferruled sables were introduced they were adopted by many watercolorists not as an equivalent for quills but in addition. Unlike the quill, the metal ferrule can have a flat cross-section. Flattened sables, known as brushes and not pencils, were introduced in the mid-nineteenth century as approximations of the oil painter's brushes.[21] Charles Burchfield recalled that in 1916 he "abandonned the pointed brush for the sable 'bright' [a flat shape] oil brush, which allowed a more robust, firm stroke, similar indeed to the oil on canvas technique."[22] Such a brush was used for the modelled strokes in *August Sunlight*'s dark houses, painted in the same year (8, fig. 21). As watercolor paints were made more viscous in the mid-nineteenth century and were used in direct imitation of oils, artists like

Burne-Jones adopted hog bristles as well as brush shapes from oil painters.[23] The textured surface of *Second Day of Creation* (9, pl. 2) betrays this practice.

The usual alternative hair for the watercolorist's sable is not hog bristle but what is known as camel hair, which is actually the long guardhairs from the Russian squirrel's tail. Camel is commonly thought of simply as a less expensive sable; the Swan no. 1 that cost 10s in sable was 1s6d in "Siberian Hair" and 1s4d in "French Camel Hair," for example.[24] In fact, however, camel has somewhat different handling properties. It is a finer hair than sable in brushes of the best quality, and is much softer and less resilient. Thus although a comparable size will not hold so full a wash as sable[25] nor take so perfect a point, it can be used with great gentleness in shading with single strokes, and it has been preferred by artists uninterested in washing broadly. William Blake said, "An even tint is not in nature—it produces heaviness. Nature's shadows are ever varying. . . . its spots are its beauties."[26] His watercolors are built up by a repetition of delicately varied touches (4, pl. 1; 5; 6), and not surprisingly he abhored sable and would only use camel hair brushes.[27]

A broad, flat camel brush as well as a badger-bristle "mop"[28] (fig. 9) could be used to blend and soften washes. Even sponges or bits of sponge, leather, or blotting paper set into the draughtsman's traditional brass crayon-holder[29] would be employed much as brushes, to work over colors previously laid in with more conventional tools. A sponge was probably used to mottle the washes to imitate weathering on Gillieron's fresco copy (20). Modern times have seen even greater improvisation; Adolf Dehn was pleased to report that he made his own brushes by gluing shaving-bristles, feathers, and toothbrush bristles onto handles.[30]

This variety of choice might suggest that artists have preferred to use many brushes. In reality it was often stressed that in watercolor, as the brush was rarely expected to leave a visible trace in the finished image,[31] all that was essential were two large sables that came to fine points, one for color and one for wash. A finer brush might be added for details, and handles of

different lengths were suggested, the shorter for washing and the longer for detailed work.[32] However, since purity of hue in watercolor is dependent on the cleanliness of the brush, some manuals advised that it would be a convenience to the artist, washing at top speed before his sheet could dry, to have brushes for each color. One author even recommended that their quills be color-coded to forestall any chance of error.[33]

Likewise the artist was warned against laying his brushes down carelessly, for fear of soiling their tips. Presumably the brush rack illustrated by Barnard (fig. 12), which held each brush tip separate and perfectly pointed, was usually approximated by the artist's clamping spare brushes crosswise in his mouth, after the fashion of John Singer Sargent.[34]

PIGMENTS

With his paper selected and stretched, his sketch completed, and his brush in hand, the watercolorist is set to paint. A late eighteenth-century satire of the artist at work hints at the technical complications:

Betty! bring me up a pan of water, and wash that sponge: it is really so hot, I cannot lay my colour smooth. Where's the flat brush? Oh dear! that Prussian blue is all curdled. . . . There, you've knocked down my swan's quill, and how am I to soften this colour? It will be all dry before you wash out the dirt. Give me that brush. Oh, it's full of indigo! there is the horizon spoilt! Quick! quick! some water! Oh, that's gall! And the sky is flying away![1]

The painter has been confounded by exactly those variables itemized by twentieth-century chemists instructing the amateur in experiments in colloid chemistry: "Factors like hardness of water, purity of common chemicals, room temperature, and humidity, are . . . beyond the control of the authors. Cleanliness and type of glassware are also important."[2] Although the watercolors on display should not be thought of as experiments in colloid chemistry, a discussion of some of the properties of col-

loidal systems will go far to explain certain effects unique to watercolor technique, as well as its complexities and hazards.

Contrary to common belief, watercolor washes are not dyed water solutions but dispersions of solid particles in water. The particles are so minute that the effect of gravity is outweighed by the force of their collision with each other and with molecules of the water with which they have been mixed, so that they remain suspended indefinitely in the water and do not settle to the bottom.[3] Though ground more finely than oil pigments,[4] watercolor pigments are on or above the upper borderline of the dimension required to remain in suspension; and many of the handling techniques for watercolors have been developed to overcome this problem by both color manufacturers and by artists. In fact, in the eighteenth century, when pigments were ground by hand with a muller on a stone or glass slab, artists were color manufacturers, and manuals advised various means to achieve a "soft"[5] grind.

When ground past a certain point, individual particles tend to agglomerate rather than reduce further under pressure, and thus a seventeenth-century author recommended grinding with the "gall of a neat,"[6] that is, ox-gall. This is a natural wetting agent used traditionally in many aspects of watercolor painting to alter the surface properties that play so important a part in any colloidal system; in grinding, ox-gall promotes the penetration of particle clumps by water, the medium in which the pigment is ground.

Mineral pigments have a higher specific gravity than organic pigments: "one pound [of alizarin, an organic red] will almost fill a half-gallon can. A pound of vermilion [mercuric sulfide] will go into a four-ounce jar."[7] If the Vermilion particles are larger than a truly colloidal dimension, they will tend to sink rapidly in water. Grinding can be followed by stirring the pigment into water, pouring off the top fraction of the liquid, and evaporating it to obtain the finest particles of dry color, which remain suspended longest. The particle size (and the pigment yield) will be smaller in inverse proportion to the patience of the refiner.

The technique was adopted by the artist in mixing up quantities of wash, which he would decant to remove particles of undissolved cake color. But one author warned against attempting this with certain pigments such as "Vermilion, Emerald Green, etc. . . ." that are so heavy that "the liquid poured from them would possess little or no colour. . . ." He noted that "these colours are not, however, used as washes . . . ,"[8] undoubtedly because of their reluctance to assume a colloidal state.

By the nineteenth century only William Blake among renowned watercolor artists is known to have made his own watercolors,[9] and the tedious niceties of pigment preparation became the concern of the colormen. Through their innovations the texture of mineral pigments in particular was greatly improved;[10] the development of Chinese white has already been mentioned. In 1871 J. Barnard & Son advertised their new Cobalt blue, notoriously a heavy and difficult pigment: ". . . beautiful flat washes . . . perfectly free from a granular aspect. . . ."[11] Its improvement was credited to its method of production, ". . . having been materially aided by the employment of steampower and improved mechanical appliances for the purposes of grinding. . . ."[12]

The English led the way in the development of machine-ground pigments, and Continental manuals in the late nineteenth century noted that English watercolors were preferred to domestic products because of their fineness and homogeneity.[13] There was, however, some prejudice against machine-grinding, although the sentiment that machines *could* not grind so fine a pigment as hand methods may have arisen from a suspicion that machines (and perhaps their operators), without conscience or artistic sensibilities, *would* not grind them so fine. In any case, colormen felt compelled to advertise that "It was not until after the most careful experiments that we found that machine grinding was equal to the best hand grinding"[14] and that "The granite mills which grind WEBER Artist Colors, have been specially designed and constructed to carry out the identical motion of hand-grinding. . . ."[15] Today, while authors may recommend that the oil painter prepare his own pigments, all agree that home-ground watercolors are not worth the trouble, being ". . . more likely to be grainy and to pick up or wash off easily."[16]

Even if finely ground by machine, the greater density of mineral pigments required the artist to stir his prepared washes constantly, an action that would become automatic, the amateur was assured.[17] Selective settling of mineral colors is so pronounced and rapid that the artist was advised to make up mixed washes of an organic color (Indigo) and a mineral color (Indian red) with an excess of the latter "to allow for the change made by a settling of a part of it."[18] The effect must even be considered in applied washes, for the mineral color will settle out and dry below the organic color, thus exaggerating the hue of the latter in the finished painting beyond the artist's expectations.[19]

Watercolorists were not slow to adapt this effect to good purposes on textured papers, where the sediment would collect differentially deep in the paper's grain. Cobalt and Cerulean (cobalt and tin) blues were particularly recommended,[20] and such a sedimenting pigment was used by Hassam to form the textured veil drawn across his *White Mountains* (21). In contrast, Prussian and Indigo blues were known to be completely free from any tendency to sediment; and Homer selected the latter to flood across his *Fourth of July Fireworks* (22). Although there is some modulation of tone in the mid-range, due to the additional thickness of the color film deep in the heavy grain of the paper, the darkest areas are uniform in tone. In such a wet wash a sedimenting blue would have settled off the paper's nubs, leaving them comparatively bare and white.[21]

It is no wonder that early nineteenth-century artists working in the transparent wash style preferred traditional organic pigments such as Carmine and Indigo,[22] long after their use was supplanted in oil painting by more permanent substances artificially produced from inorganic compounds. Indeed, one may wonder if the development of the "oil manner" in early and mid-nineteenth-century watercolor painting was not influenced by the temptation of the beautiful hues of mineral pigments, whose opacity and heaviness were less of a liability if handled in a relatively dry manner.

Even fine pigments which easily assume the colloidal state in a

wash may be precipitated by chemical or mechanical impurities. Salts, the most notorious chemical offender,[23] might be present in the wash water; and manuals commonly advised the use of distilled water, or at least rainwater or water of "the softest kind."[24] Salts might be present in the pigments themselves. Viridian, among others, is prone to such contamination if imperfectly refined.[25] In earlier years, when watercolor paints were conventionally kept in little seashells, the artist was required to soak or boil his containers before use, to protect his colors.[26]

Foreign particles present in water or colors or dirty wash-saucers would also mottle a wash, sometimes by local concentrations of fluid generated by changes in its surface tension around the solid particles (40), sometimes by the impurities providing nuclei onto which the dispersed pigment could precipitate. "Airborne dust is the commonest source of foreign nuclei,"[27] a fact that did not escape the notice if not the analytical understanding of manual writers. Dry-cake colors were often recommended over moist colors because dust did not adhere to them,[28] and authors constantly warned artists to keep their colorpans clean,[29] one suggesting the use of a particular "large Brush, called a Fitch, to wipe off the Dust from them."[30]

BINDER

In 1598 in a discussion of binders for water-borne pigments, among the "gummes of diverse sortes . . . Arabicke . . . is held the best."[1] The opinion is maintained to this day, and the finest watercolors are still made with gum arabic, the natural secretion of the acacia tree. It goes by various names depending upon the native habitat of the tree, for the original gum arabic from Turkey is no longer available, supposedly because the underground springs that nourished the Turkish trees have dried up.[2] Although *Acacia arabica* grows in Morocco and India, the best modern gum comes from the *Acacia senegal* and takes its name from that tree and its place of origin.[3]

The gum's value to watercolor goes far beyond its simple gum-miness—its essential capacity to stick paint to paper. Gum arabic plays the crucial role in the maintenance of a stable dispersion of pigment particles in water. As a lyophilic colloid, it possesses, to quote *Webster's Third New International Dictionary*, "a strong affinity between a dispersed phase and the liquid in which it is dispersed." In water gum arabic is not at all susceptible to coagulation or precipitation, and, more important to the watercolorist, it lends these properties to unstable suspensions of particles in water.

As noted, many watercolor pigments are actually above the upper limit of colloidal dimensions, but "water-peptizable colloids like . . . gum arabic . . . are often called protecting colloids because they prevent agglomeration and consequent settling of finely divided precipitates."[4] This property of gum arabic is so dominant that it will even protect pigments from salt contamination, as was known to watercolorists before the word "colloid" had ever been heard.[5]

Gum arabic maintains the dispersion of pigment particles until the film of wash has dried and the colors are gummed in place, an important contribution to the wash's final appearance. "The volume taken up by a system when it precipitates is a function of the stability of the sedimenting particles. Stable particles that do not coagulate . . . have ample time to assume positions of minimum free energy to each other, and a close-packed dense sediment forms."[6] Thus in a well-gummed watercolor wash, each particle of pigment is used to its greatest efficiency, presenting the largest area and the most compact surface of color possible, so that the maximum amount of colored light is reflected rather than being dispersed within a porous or flocculent coating.[7]

The effect is greatly enhanced because the dried gum alters the refractive index of the coating, by filling any remaining irregularities with a transparent film. The pigmented surface becomes more transparent to light reflected from the paper below, much as wet frosted glass is more transparent than dry. Accordingly, a pure and undisturbed wash gains noticeably in depth and intensity of hue. Gum makes watercolors "bear out,"[8]

and watercolorists have gloried in their washes' "bloom . . . the fetish of the watercolor method of work, and its greatest beauty."[9]

As might be expected from the discussion of the varying properties of mineral and organic pigments, different pigments require different amounts of gum, in order to wash well and adhere to the paper. Two watercolor pigments no longer in use, Sap green and Gamboge,[10] were concentrates of natural vegetable juices and needed no gumming whatsoever.[11] Ultramarine, Brazil lake, and Bister, all also obsolete, required more gum than usual,[12] as did Carmine, an exceptionally beautiful and fugitive red which was heavily gummed in hopes of preventing its fading.[13] Other pigments, notably chromates, affect the gum; and dextrin, a weaker binder, may replace it.[14] Still others, such as Cobalt blue, that dry into exceptionally hard cakes, may require a more soluble additive such as sugar to permit their easy use.[15] Gumming was also varied according to the pigment's use, especially in miniature painting. Intense colors such as browns and blues, which were intended to bear out with force, might be heavily gummed, while the paler flesh tones ("lake, yellow ochre, and vermilion") would be lightly gummed to achieve a more delicate effect.[16]

These properties were discussed more completely in manuals of the eighteenth century and earlier, when the artist was required to gum his colors himself; but they had consequences in later years when artists worked with colormen's dry cakes, which are also manufactured with varying amounts of gum.

Dry-cake colors were invented by the colorman William Reeves c. 1780. They were accepted immediately, and Reeves was awarded "the Greater Silver Palette" by the Society of Arts' Committee on Chemistry "as a mark of approbation of their method of preparing pigments for painting in water colours."[17] Within only a few decades his invention was bracketed with Whatman's as the technical fulcrum on which the rise of English watercolor turned:

> Until [about thirty years ago] every artist was obliged to prepare his own colours: which, generally for want of sufficient knowledge of their chemical properties, and leisure to grind and prepare the pigments, gave much trouble, and produced but indifferent success. Indeed, so little understood was this necessary branch by the colourmen themselves, that not only were the worst colours prepared by them, but even these were . . . scarcely fit for use. Reeves' new process . . . at once removed this inconvenience. . . . Upon this invention others have made considerable improvements, until the preparation of watercolours has almost attained perfection.[18]

Gum arabic is incorporated into pigments during or after grinding in water. The paint is dried into cakes, but protective lyophilic colloids being what they are, the dried cake can be worked into a colloidal dispersion again and again.[19] Thus not only can the watercolorist wash up his color from the cakes, he can also wash up washes previously applied and dried on his paper, with a higher proportion of gum making a pigment more liable to washing up. This can be a serious hazard to the picture if washing is repeated over heavy, granular pigments such as Vermilion that require extra gum for proper adhesion to the paper. On the other hand, techniques have been evolved to turn this property to the artist's advantage.[20] But before discussing the refinements of the wash technique, the basic processes must be described.

WASHING

Dry watercolor paints are rubbed up with water before being diluted into a thin wash. With homemade pigments, the watercolorist worked around his shell with a wet, clean finger[1] or else an ivory spatula, if he did not want to waste even a grain of such expensive pigments as Ultramarine.[2] Dry cakes might also be rubbed up with the finger, to save wear on an expensive Large Swan,[3] but the brush is the usual tool.

The artist was advised against slopping water on the cake with the brush to soften it, as this action repeated will eventually harden the pigment,[4] presumably by washing out its lyophilic

binder. Instead, the cake was to be pre-moistened, either with a wetting agent such as ox-gall[5] or with the breath followed by a few drops of water, applied by the truly fastidious with a pipette.[6] One author recommended dipping the cake in water;[7] another objected: "do not, on any account, dip the cake of colours into the water, for by that means the edges become softened, and crumble. . . ."[8] Even the simple operation of dissolving his color rouses the watercolorist to factionalism. If a quantity of wash is needed, the moistened cake is rubbed on a saucer to the consistency of cream. The colored paste is then diluted and decanted,[9] or the wash might be mixed in a paper funnel, which would trap sediment at its tip.[10]

His washing water readied, the artist sets the prepared paper before him at a slight inclination. With his largest brush full of dilute color, he begins at the top drawing the brush horizontally across the sheet, refilling the brush and repeating the operation below each prior stroke, "methodically advancing a pool of liquid color across the surface of the paper"[11] until the desired area is filled. The tilt of the board causes excess wash to follow the brush; if the angle were inclined more toward the vertical, as is customary for oil painting, the liquid would, of course, simply drool to the bottom of the sheet.[12]

The color can be gradated in the process of washing by adding pure water to the brush at each stroke; conversely the wash can be intensified by beginning with pure water and continuing with additions of color. A combination of perfectly gradated washes may be admired in Pissarro's *Landscape, Eragny* (49), where the artist apparently stood his sheet on its side, laid a gradating blue wash in the sky and then, reversing the sheet, laid a gradating yellow wash over the blue,[13] to depict the golden side-light of an autumn afternoon mellowing an azure sky.

Overlaying of transparent washes naturally became a great specialty of the watercolorist: Kandinsky has used a simple two-wash system with broad noncoincident areas as the central motif in his *Landscape* (30); the shaft of Hopper's lighthouse (25) is a more complex example.

Advocates of pure wash urged self-discipline on their pupils,

for such transparent overlays require that the first layer be virtually dry before reworking: "Be patient, and let your first tint dry before you touch it again. . . . you only flurry yourself by dashing at nothing."[14] Others recommended everything from paper bonfires[15] to electric hairdryers[16] to speed the process. Of equal concern were the pigments used, as some tend to wash up more readily than others. Indian red, reputed to dry particularly hard on the sheet,[17] was a common ingredient of preliminary mixed-gray tints, whereas Vermilion, though useful for final touches, was a virtual pariah on the washer's palette.

The wash method as described is generally suitable only for covering large areas. If the shape of a smaller form may be relatively sketchy, its wash, too, can be laid in boldly; for its "colour looks much more lovely when it has been laid on with a dash of the brush, and left to dry in its own way."[18] Yet as Ruskin went

FIG. 10. Vasily Kandinsky, *Landscape* (30, detail 200% actual size).

on to admit, its edges as well as its form would "be a *little* wrong," for if a wash does not cover the sheet and its edges are left on view, it will evaporate on dry paper with a visible concentration of pigment and binder at its edges. The effect results from the constant motion of the particles within the wash against the barrier of its edges and the tendency of the wash's edges to dry much more rapidly than its interior area. The bane of watercolorists interested in aerial effects, it led to the development of wet-sheet washing techniques and to the reworking of edges by "softening off," that is, by "extending the colours by touching upon its edge, with the pencil and water only. . . ."[19]

Other artists appreciated hard edges, some as a sort of badge of the brilliancy of their wash style: "Be careful to leave the *edges* of the tints undisturbed, as this gives *air*, and prevents the sketch from looking like a coloured print. . . . the raw edge is the very thing that gives spirit to the drawing."[20] Some watercolorists have used their washes' edges as lines as well as boundaries.[21] Kandinsky's spot of rose wash, the floating center of a concentrically ringed sun above his *Landscape* (30, fig. 10), dried hard-edged in pink strong enough to read as a "drawn" circle even though it is surrounded by the visual clamor of black-jagged ink lines and bright-colored rings.

Hard edges can be put to more representational use in shadows washed in freely. As the manual writers observed, "The darkest parts of shadows are near their edges, the middle being lighted by reflected lights."[22] Thus Shinn's blue washes on his white paper (57) perfectly convey the luminescence of shadowed fresh snow and the sharpness of its boundary with sunshine.

Pissaro has exploited the effect even more subtly. Wishing to place a fence in the distant middleground of his *Landscape, Eragny* (49) that would not interrupt the softness of his passage with drawn forms, he dotted in a series of wet rose puddles. In drying, their minute hard edges formed the outlines of the fence pickets, yet their transparent centers allow the shimmering greens beyond to shine through as clearly as before.

Exact, intricately shaped washes were executed in another manner:

with a large *Pensill*, wash over carefully the whole ground, that you mean to cover with somewhat a thin and waterish *blew*; and after with a reasonable great *Pensill* full of Colour and flowings, lay over that very place, with thick and substantial Colour. . . . In doing of this, be very swift, keeping your *Colour* moyst. . . . the watering over the *Card* before with a thinn *Colour* makes the rest, that you lay after, to settle even and handsome, which otherwise would lye in heaps, like unto drift *sand*.[23]

The quick and uniform blending of color into relatively pure water (a perfect example of the pigment assuming colloidal dispersion) was but a first step toward the observation that colors could be blended together wet on the paper rather than applied as transparent layers—and that hard edges could be prevented from forming by this process. Watercolorists at the turn of the nineteenth century, only newly accustomed to the use of pure color in direct washes, approached the wet-into-wet method cautiously. David Cox in his manual of 1813 stipulated overlaying washes in every case except in that one moment when nature itself blends colored light: ". . . when [the sky washes are] perfectly dry, colour the extremity of the rainbow with red; then soften it with yellow, which will produce an intermediate tint of orange. While the yellow is wet, run in a blue, which will give a green. . . ."[24]

Within forty years Penley would write, "It is advisable to run the first colours one into another, without any reference to form. . . . This is termed blotting in, and consists of so many indications of colour only."[25] Later recommendations for wet versus dry methods would often depend upon the criterion of subject, much as paper texture had been decided upon for generations: "methods of work may be roughly divided into two great classes—the dry and the wet. . . . Flower painting will be dealt with according to the dry paper method, while for Landscapes and Marines a wetter system of work will be explained, Figures, Animals, and Still Life being painted in a combination of the two."[26] A clear realization of the difference in effect between the two methods, especially in the appearance of washes'

edges, is found in Hassam's sky (21), where a wet-blended blue stroke was followed by another blue stroke applied just below after the sheet was virtually dry.

Artists became concerned with methods to retard drying. The elaborate systems of wet paper preparation have already been mentioned, and a steaming tea-kettle could always be pressed into service.[27] The wet method was pursued so passionately that it made a positive virtue out of what would seem unendurable hardship: "Artists sometimes work out in the open when it is so cold that the colour freezes on the paper. This has been turned to advantage as, when the drawing has been brought into a warmer temperature, the ice melts, the edges soften, and the colour can be manipulated into charming effects."[28]

Though most watercolorists have lacked this dedication, many have observed and exploited the eccentric blendings of

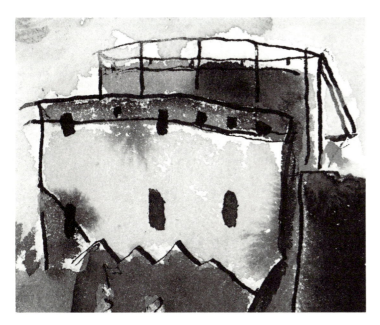

FIG. 11. Arthur Dove, *Gas Tank and Building 38* (17, detail actual size).

colors bled into each other wet. "An exceedingly watery tint added to one nearly dry comes out one way; a bit of thick pigment touched to a wash just floated in comes out another way; and two tints combined of the same . . . strength in still another way."[29] The colors "spread gradually in a branchy way"[30] as a result of currents set up at the conjunction of two colors in a relatively liquid medium, caused by differences in their specific gravity or the energy potential of the solutions, or by the inter-diffusion by capillary action of colors in a relatively damp medium across the moistened sheet.

The painter may capitalize upon happy accidents; the "branchy" diffusion of gray into tan where two soaking washes touched in Arthur Dove's *Gas Tank* (17, fig. 11) was meticulously imitated in radiating brush strokes in his oil painting of the same subject. A watercolorist may even attempt to foster such accidents through his method, although very few are capable of Homer's control of wet-into-wet blending seen in *Key West* (24, fig. 8). Striations of the free diffusion of a darker splash of blue into his pale wash perfectly represent the shimmering, rayed, refracted shadows that hang under sloops bobbing on a pellucid tropic sea.

An artist such as Calder, whose impetuous draughtsmanship heeds neither the deliberation demanded by overlapping transparent washes nor the anticipation required to achieve exact hues by wet-into-wet blending, may still benefit from properties of both techniques. In the belly of Calder's hippopotamus (10, fig. 4) drawn first in blue and then washed over in red, the hard edges of the blue strokes had dried just firmly enough so that when the red swept away their liquid centers, linear definition remained within the now-blended pool of rose and lavender. All seems accidental—that the first strokes' edges hardened just in the span of time required to finish the form in blue and begin again in red, that the red and blue could combine in exactly the volume and strength required to round out the hippo's belly—but the artist's sleight of hand was surely informed enough and responsive to catch each effect as it materialized and to capitalize upon it in the final (if not finished) form.

Methods of washing and color blending focussed the artist's attention on color effects, especially as the properties of watercolors seemed to embody in practice theories about color and light which rode at the forefront of contemporary science in the late eighteenth century. The very transparency of eighteenth-century organic watercolor pigments in particular stimulated an awareness of the subtlest aspects of color, for a transparent pigment on white paper will assume its hue more from the color of light transmitted *through* it, reflecting off the white paper and back to the eye, than from the light reflected *off* of it.

Yet if enough pigment grains, however transparent, are piled together they become opaque in much the same manner as a snow drift is opaque although its constituent parts, ice crystals, are perfectly transparent.[1] The hue of many pigments differs when seen by transmitted or reflected light, much as metallic gold, yellow in ordinary circumstances (opaque/reflected), appears green when beaten into thin leaf and viewed against the light (transparent/transmitted). Thus Alizarin, a popular pigment that is the essential coloring substance of the traditional Madder, is scarlet when painted thickly but more bluish when drawn thin.[2]

But complexities of individual pigments, though of peculiar concern to watercolorists, pale before the problems of pigment combination. Artists quickly gain a rough working knowledge of the deadening effect of mixing colors. No pigments are absolutely pure in the spectral sense; all reflect and/or transmit a certain fraction of other hues together with their dominant color. Mixing them may intensify their secondary color "noise" at the expense of the intended harmony of dominants: the mixture will be, in artists' terms, "muddy" or "dirty." Some mixtures will be "cleaner" than others. Some manual writers took pains to indicate which mixtures are relatively satisfactory and which are not: "ultramarine and crimson lake, Antwerp blue and gamboge, . . . scarlet lake and burnt sienna will be clean, cobalt and gamboge, Antwerp and chrome, . . . light red and raw umber will tend to be 'dirty.'"[3]

With the constant multiplication of patent colors concocted by artists' suppliers to attract the jaded eye, the manual writers also warned against concealed mixed pigments: "Some of the colours in the makers' lists are a combination of others, and it is often better to hold them separately. Cyanine, or Leitch's Blue, is a mixture of Cobalt and Prussian Blue . . . [etc.]."[4] The artist, conscientiously mixing only pure pigments himself, could be undone by the ambitious colorman.

It was thus of great interest to watercolorists that color mixtures retain their purity better and give a more intensely colored, livelier hue when washed on in separate transparent layers or wet-blended individually onto the sheet rather than pre-mixed on the palette. Light reflected from the paper through layers of washy colors or through the intermingled washy currents of pure hues seems to retain the depth and vitality of its components, which are blended by the eye into a new hue. There quickly arose an enormous literature on the proper sequence and balance of pigment applications for the best results.

Practical manual writers considered pigments' handling characteristics as well as their final effects: "The general rule, that a much purer compound hue may be produced by passing one tint of different chemical character over another than by applying them mixed together holds true with more force in watercolour painting than in oil. In such operations, however, as the earthy and mineral colours will not bear friction, they must be applied last."[5] Artists in the earlier years of the nineteenth century were particularly concerned to balance warm and cool hues, with conflicting theories on the proper washing sequence.[6] In the later years, particularly after the widespread publication of Chevreul's color theories, they turned to systems of complementary colors.

Thus Turner's *Bally-Burgh Ness* (60), for example, opposes two cool pigments, an opaque and a transparent blue, to two warm ones, an opaque and a transparent red, with a gloss of the third primary color, yellow, to complete his spectrum. Nolde's

watercolor (47), though it presents a full-color image in its completed form, was in fact executed in complementary color systems. The pigments were laid on heavily enough to allow us to ascertain their sequence: over a black brush underdrawing the artist first laid blue. He allowed it to dry and then complemented it with yellow and orange run together. Next he added a second set of complements, rose and green, to complete the painting. Pissarro, likewise working in the full spectral range over his entire sheet (49), set up systems of complementaries within it: below his yellow/blue sky lies a rose/green vista.

Pissarro in particular was concerned with vitalizing compound colors. At the moment of his radiant watercolor, whose effect depends upon layer after layer of the purest hue, he was also experimenting with multiple-plate color etchings using intensely pigmented, transparent inks.[7] He criticized his contemporary Mary Cassatt, who was also printing in colors: "she does not use pure colors. . . . The drawback is that she cannot obtain pure and luminous tones . . . ,"[8] and he earlier asserted that his intention in oil painting was: "To substitute optical mixture for the mixture of pigments."[9] This had, of course, been the working premise of watercolor artists for generations.

Two mixed colors were watercolorists' particular concern. The washing tradition had begun with the practices of the topographic landscape artists, who laid in local tints over a wash drawing in "dead Colours,"[10] that is, in black diluted to varying grays, which established the tonal values of the painting, as in Rowlandson's *Mail Coach* (52). The first advance upon this method was made in the later eighteenth century through the

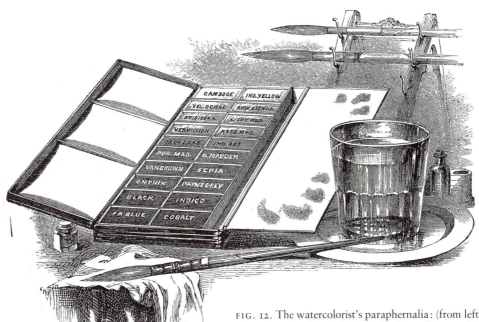

FIG. 12. The watercolorist's paraphernalia: (from left to right) Chinese white, pan moist-color box, a handkerchief for taking out lights, quill brushes, brush rack, water, gum water, washing saucers (George Barnard, *The Theory and Practice of Landscape Painting in Water-Colours* [London, 1858], p. 49).

development of "neutral tint," a "broken"[11] gray that the artist could mix himself or purchase ready-made. Although a mixture, neutral tint was perceived to have less of a deadening effect on superimposed washes than black: "black will occasion the other colors, when laid over . . . to look dingy and opaque; but if they be laid over neutral tint, they will retain their original colors."[12] The effect of neutral tint may be appreciated in an anachronistic example in *The Schelde at Antwerp* (1), where the reds and blues of foreground tints have been run together in the distance to make a warm gray.

Neutral tint was compounded from various red and blue pigments, sometimes with a small admixture of black retained to give depth. Pigments that are not susceptible to washing up[13] and are therefore suitable for under-washing were favored: Light red, Indian red, or Madder lakes; Indigo; a touch of Ivory black.[14]

The prevalent use of neutral tint (the obstinate Blake remained faithful to Indian ink [4])[15] has had unfortunate consequences. The pigments, especially Indigo and some Lakes, are notoriously fugitive. As early as 1820 Nicholson commented,

> The great beauty of this tint [a mixture of Indigo, Lake, and an unspecified yellow] . . . tempted many. . . . if works in which it has been used be kept from the light . . . they may remain a considerable time, but if they be exposed to the action of light . . . the pearly greys become by the flying of the lake of a dirty greenish hue.[16]

A great early advocate for permanent watercolors, Nicholson advised the substitution of Indian red for the fugitive Lake, but he retained Indigo. Although it is the only traditional blue not susceptible to washing-up, it is also light-sensitive, so that after some years of exposure watercolors employing this formula "become hot and 'foxed.'"[17]

In the last years of the eighteenth century, perhaps under the impulse to work in purer colors, artists separated neutral tint into its component warm and cool hues.[18] Shading was accomplished in the skies with various blues, perhaps touched with

red, and in the landscapes with browns and yellows, shaded with blues, which presented a new mixing problem. As artists worked more and more directly in color without the support of gray for tonal depth, they were forced to face the puzzle of another sort of neutral tint: green.

Some theories of the operation of colors assign to green a position of neutrality between advancing/high/hot orange-yellow and recessive/low/cool blue-purple.[19] Its ambiguous placement between the fashionable conceptual opposition of warm and cool colors would have been sufficient to engage the early nineteenth-century watercolorist, but added to this theoretical perplexity was the very practical problem of green pigments.

Through a combination of circumstances, pure green pigments in use in oil painting and even those used by earlier watercolorists were unacceptable when stable greens of full range were required. Virtually all that were available until the mid-nineteenth century were fugitive and/or excessively transparent (Iris green, Sap green), acid and thus destructive to paper (Copper green, a variant of Verdigris), or poisonous (Scheele's green).[20]

The watercolorist was, therefore, forced to mix green from blue and yellow; and the components of this mixture, their application to paper, and their predominance in the final image became the subject of endless controversy. Even after reliable pure green pigments became available with improvements in Chrome greens at mid-century, recommended palettes continued to exclude them (see fig. 12), and mixed greens were preferred. In 1887 a color chemist insisted that "No mixture of blue and yellow pigments will afford a green so beautiful and stable [as Viridian, a transparent hydrated oxide of chromium]."[21] Yet decades later a watercolorist referred to not one but three combinations of blue and yellow pigments, to establish aerial perspective through relative coolness or warmth: Cobalt blue and Yellow ochre for the distance, French blue and Gamboge in the middleground, and Indigo and "a brighter yellow" in the foreground.[22] In 1968, after Phthalocyanine green[23]—a completely satisfactory pigment in watercolor and acrylic techniques

—had been available for thirty years, an artist working in both media in the wash style reported, "I carry no prepared greens. My greens are all mixtures of yellows and blues."[24]

Various theories have been advanced for the watercolorist's persistent interest in mixing his own greens or his avoidance of the color entirely, even as a mixed tint. Some have claimed that the apparent lack of green in many artists' work, notably Turner's,[25] is the falsification of time, which has faded original mixtures of Indigo and Gamboge. There is no doubt that pigments used to mix green in the early nineteenth century, like those used for neutral tint, were fugitive. Indigo was a common component, as was Gamboge, a somewhat fugitive yellow.

The problem of fading was approached by Field in 1835 with his usual perceptiveness: as the artist's conception would suffer more in posterity's eyes if its balance altered rather than if it simply became paler, Field recommended that the components of mixed greens should have "the same degree of durability; and in these respects Prussian or Antwerp [a variety of Prussian] blue and gamboge form a judicious, though not extremely durable, compound...."[26] More recent opinion attributes a greater permanency to Prussian blue than Gamboge, and there is no doubt that many nineteenth-century landscape watercolors whose foliage is now definitely bluish have lost their yellow washes.[27]

Given Turner's obvious fondness for primary colors and the diatribes against relatively pure greens found in nineteenth-century manuals, it seems likely that many artists simply avoided the perplexities of both the pure color and its mixing by accentuating its warm and cool components. Their dislike of green may have been based in the late eighteenth-century attempts to ally watercolor landscape painting with the great tradition (and the golden patina) of oil painting of the past; Claude was their particular hero. It has been suggested that as nothing was commoner coin of the natural realm in England than green, how could the color be precious enough for fine art? An eighteenth-century watercolorist's outburst against green supports the thesis: "nothing can have a more common or vulgar air, than too much green."[28]

By the nineteenth century utter condemnation replaced disdain:

> The general tone of a picture may be yellow, red, blue, grey, or brown [in other words, any of the primary colors or their complete combination]; but a green picture, however true to Nature, becomes utterly disagreeable, and even if a green picture has been admired, it has been, not in consequence, but in spite of its being green.[29]

This author's bias against the use of green, then a predominant color in controversial Pre-Raphaelite landscapes in opaque watercolor and oil, and his ill-digested understanding of developing concepts of optical effects persuaded him to attribute to nature itself the restricted properties of the watercolor palette:

> The yellow tinge given to the atmosphere by the sun's rays does not turn, as might be expected, its blue tints into green, because the pearly grey still left in the shadows, untouched by the yellow light, interposes a neutral tint, which from its opacity prevents the mingling of the colours.[30]

And so artists frequently attempted to maintain a very broken color in their washy "broken" greens, by allowing overlapping or wet-blended blues and yellows to mix so coarsely in the eye that they appear mottled into their constituents: "To paint in yellow and then run your blues into it when wet to get green . . . often gives beautiful and varied effects."[31] There is no doubt that many of the greens in the present exhibition, particularly those in earlier transparent wash paintings, are mixed colors. In Blake's *Lucia Carrying Dante in His Sleep* (6) rich edges of blue and yellow, Blake's embodiment of nature's "spots" that "are its beauties," are visible at the near ground of the grassy plateau toward which the figures move.

On the other hand, there are in fact very few greens in the early watercolors on view. Only gradually does the use of green become prominent, in such paintings of the natural world as those by La Farge (33, 34), Pissarro (49), and Hassam (21)—and it is never common.

Techniques of "softening off," wet-sheet washing, and wet-blending led the watercolorist to reduce the intensity of washes by rewashing and manipulating the colors of his sheet. The soaked pigments would be driven into the paper grain and the depth of tone reduced on the nubs of the sheet to "improve the aerial tints, and leave a beautiful granulation upon the surface of the paper."[1] This produced the visual equivalent, but with softened rather than sparkling lights, of the effect obtained when direct wash on dry paper is "used thicker and with less in the pencil, [dragging] upon the prominences, touching these only, and leaving the intermediate parts lighter."[2]

Simple resoaking in water could reduce washes,[3] but more often the artist used at least a brush to push the color about, and often he employed more vigorous methods. A brush could be a more vigorous tool than in its usual delicate application in washing. A manual writer advised: "When any of these first tints prove too heavy, and cannot be sufficiently removed by repeated washing, it will be necessary . . . by passing large quantities of water on the drawing, and applying a rather stiff brush, against the hair, to loosen the colour, and thus remove it."[4] Though this may seem strenuous, the beginning painter was elsewhere assured that "rubbing . . . and tinting may be repeated as often as may be requisite or as the paper can bear, which will be much more often than the learner can be aware of."[5]

Studying closely the deeper tones of Turner's *Simplon Pass* (61, pl. 6), one sees that countless broken brush bristles are imbedded in the pigment. Turner must have practically worn out a brush against what seems a relatively thin sheet, yet there is no apparent damage to the paper fibers whatsoever. Turner was notorious even in his youth for complicated techniques of wash reduction; he "soaked, blistered, daubed, rubbed, and scratched with his thumb nail, until at length beauty and order broke from chaos."[6] His technical innovations became conventional within twenty years.

The brush was often relinquished for other tools, which also

44

FIG. 13. Eugène Lami, *Duke and Duchess of Brabant* (35, detail actual size).

absorbed and/or rubbed away excess color from the paper. The gentlest method was certainly simple blotting: "If it be considered desirable to increase the granulated appearance, place a sheet of absorbent white paper over the surface immediately after the tint has been washed with water, pressing equally upon it in all parts...."[7] After blotting, the color could be further reduced "by gently rubbing the part with bread-crumbs or India rubber";[8] the artist was warned not to press hard lest the paper become greasy and refuse subsequent washes.[9] The means most frequently recommended was sponging: "It is difficult to exaggerate the value of the sponge.... The reason ... may be found in its texture and nature. It is covered with a short fine pile, the hairs of which enter the hollows of the paper and gently disengage the colour, which is then drawn up with the sponge."[10]

If the handling characteristics of specific pigments were respected, methods of combined wet abrasion and absorption could produce an effect comparable to that made by the direct washing of sedimenting pigments that is seen in Hassam's *White Mountains* (21, fig. 9). In Lami's portrait (31, fig. 13) the assemblage of accessories at the right provides a transition from blank paper to the firmly painted figures. At the extremity of the design a column and drape are lightly washed in transparent, muted tones, but as the fabric falls closer to the central subject it becomes more complicated in its painted structure. A layer of gray underwashing was covered with Vermilion, an opaque red pigment susceptible to washing up. The area was then remoistened and carefully blotted to model the fabric's folds and shadows in residues of granular red over gray. Transparency and opacity are suggested simultaneously, creating a bridge from the emptiness at the right to the palpable figures in the center.

A wash could be further reduced with a greater contrast between the lightened top grain of the paper and its tinted pores, though with no color differentiation, by rubbing with pumice or fine sandpaper, "one of the most successful means by which atmosphere is given to dark and shadowed skies.... The sandpaper must be that known as number o, and ... two pieces should be well rubbed together before being used."[11] The delicate points of light illuminating the "dark and shadowed skies" in Varley's *Harlech Castle* (62) were certainly effected by the use of fine sandpaper.

Sandpaper damaged a sheet's surface sizing more than other reworking and lightening techniques. Accordingly it was recommended especially when further washes were contemplated, as they would "flow on most agreeably and be free from hard edges." Indeed, sandpapering could be substituted for preliminary moistening to break down the sizing on very large sheets that would otherwise dry out irregularly before the artist could cover their entire surface with wash.[12]

All reductive techniques applied at large could also be adapted in small. For artists interested in emulating the effects of oil painting, one approach would certainly be to imitate the traditional working sequence in oil painting of developing light accents on a darker underpainting. For the artist working in the transparent manner, the abrasive reduction of washes and the creation of highlights by color subtraction were considered the only means "by which a papery appearance is entirely done away."[13]

Previously, in the earlier eighteenth century, watercolorists had formed their highest lights by carefully reserving blank or thinly washed paper in those areas that they wanted to have remain relatively light in the finished image. This complicated the problem of laying uniform washes, as washes are most successful when painted broadly without conscious attempts to preserve interior highlights. The expedient of opaque white laid over wash was abhorrent in its compromise of the transparency of pure watercolor. And so the wash artist could either sketch broadly in the manner of Constable (12, fig. 2), leaving relatively unformed highlights;[14] or he could draw precise patches of wash set off by white, to some extent the manner of Demuth (16, pl. 3);[15] or he could simply accumulate small, colored touches in Blake's (4, pl. 1) and Isabey's (29) method until the entire sheet was modulated from light to dark. In all these techniques, "a papery appearance" is very much in evidence in the finished works.

Reductive techniques became the rule in highlight details among early nineteenth-century artists attempting to elevate the status of watercolor from drawing to painting, and Turner led the way. In 1802 it was reported that his style was "to rub, sponge, and wash off lights,"[16] methods which can be seen in his works on view (60, fig. 16; 61, pl. 6).

Two wet methods were advised. In the more traditional one,[17] while the entire area was damp the artist would draw the desired lights with a pointed absorptive tool such as a barely damp brush or a bit of sponge in a crayon-holder, picking up the color from the picture.[18] If the paint medium was made somewhat viscous, by the addition of extra gum for example, the color could simply be pushed aside by a smooth, hard point rather than absorbed from the sheet. Turner, who is believed to have added extra gum "to give his medium more of the plastic quality associated with oil color,"[19] has used this method to delineate a road winding down the left wall of the *Simplon Pass* (61). A creamy ridge of pigment remains along the track, thrown up by the artist's brush handle or, perhaps, his thumb nail. Appropriately, one modern artist removing acrylic paint, which can be mixed to a similar viscous consistency, uses a plastic credit card instead of his brush handle or finger tip.[20]

The other wet method recommended for creating highlights was to lift them out by locally redissolving the color. The artist would draw on the dry painting with a finely pointed brush the exact form of his intended highlight in pure water, to which sugar[21] or gum could be added to increase the solvent action of the water.[22] After waiting a bit—"You will know [the moment] by seeing the colour swell up a little and appear moist but no longer wet"[23]—he would wipe the area smartly with a handkerchief or piece of soft leather. "Should either of these fail, place the water on again, and then apply . . . blotting paper and rub with bread."[24] The method could also be used when the painting was still slightly moist, but the paper could not be safely rubbed very strenuously and the highlight would be softer.

Sargent's *Man Reading* (55, fig. 14), a compendium of methods of washing and highlighting, shows the use of the locally

wet take-out in the bluish reflected light along the heel of the subject's hand, taken out while the sheet was still moist and thus not a "clean" wipe. Its soft luminosity may be compared to the sparkling highlight on the forefinger, a pale, papery reserve left in the washes that model the hand. A sharper-edged wet take-out forms the bright corner of the pillow visible in the crook of the subject's elbow.

Dry removal of color for highlighting could be accomplished with bits of sandpaper, which was thought especially effective to modulate light on architectural subjects,[25] or with cuttle-bone;[26] but the abrasive tools more commonly recommended were knives and scrapers. The penknife could be stroked delicately to catch just the topmost paper fibers and produce an effect much like that given by sandpaper; this technique was probably used by Daumier to model the pail and apron in his *Butcher* (15). More often, however, the knife and scraper were recommended when bright white highlights were wanted, as their blades cut sharply through the paper itself, leaving no residue of color in the grain.

Scrapers—small, double-edged, triangular points set in handles (fig. 15)—are more suitable for the finest effects, such as the scratched-out spray breaking over the rocks in Turner's minutely worked *Bally-Burgh Ness* (60, fig. 16). As a scraper still survives among Sargent's painting equipment preserved at the Fogg, we may, perhaps, assume that it was used to flick the scratched-out lines into the pillow in his *Man Reading* (55).

Often highlights would be taken out before a picture was completed. Though tinted by subsequent washes, they would remain paler than the surrounding areas. Turner wet-lifted the light forms of the sun and its reflection from his *Bally-Burgh Ness* and then glazed the reflection with yellow to contrast it to its brighter source. Manuals traditionally recommended against the use of the knife or scraper in an unfinished painting, since they cut away the sizing and thus could cause glazes to blot.[27] But artists, particularly bravura technicians in the sketch style, were never restricted by this supposed limitation.

All three paintings by Winslow Homer in this exhibition

SCRAPERS AND ERASERS.

	Each s. d.		Each s. d.
Plain Steel Scrapers No 1 .	0 6	Cocoa handled Erasers No 5	1 3
Illuminating Erasers No 3 .	1 0	Ebony handled Erasers No 6	1 6
Cocoa handled Erasers No 4	1 0	Ivory handled Erasers No 7	2 0

FIG. 15. Scrapers and erasers (*Winsor & Newton's List of Water Colors*, p. 41, bound in Aaron Penley, *The Elements of Perspective*, [London, 1866]).

FIG. 16. Joseph Mallord William Turner, *Bally-Burgh Ness*, *"The Antiquary"* (60, detail actual size).

47

make extensive use of scraped highlights. Precise cuts form glittering lights in *Fourth of July Fireworks* (22); delicate scratches draw arcs of dead pine branches in *Hunter in the Adirondacks* (23, pl. 5); the boldest strokes make reflections in the damp washes of *Key West*'s sea (24, fig. 7). In each painting many of the scrapes were repainted, as the artist judged and altered his work in progress. In *Hunter in the Adirondacks*, for example, the paper was torn away to form the highlight on the log at the left, but a similar scrubbed-down area on the log to the right was repainted in intense red-brown.

And in *Key West*, observing that several scraped reflections encroached upon the effect of his wet-into-wet blended blue shadow, Homer carefully touched their left extremities with a blue dry enough so that it did not blot in the roughened paper but matched perfectly the washy tint of the sea. Considering the differences that wet and dry-brushed pigments show in drying, taken together with the uncertain absorption of scraped paper, these brief touches are the virtuoso coda of an astonishing technical performance.

Thus far wash-reduction and take-out methods using only the conventional materials of transparent watercolor have been discussed. But from the beginning of the nineteenth century artists sought out devices to approximate ever more closely the effects of highlights on oil painting. A method developed by John Varley about 1836 stands closest, perhaps, to conventional scratch-out techniques. He laminated thin brown paper to a white sheet, in a sandwich similar to printers' laid-china proof paper. Working his dark tones on the brown surface, he scraped through to the supporting sheet for white highlights,[28] creating a full range of values comparable to oil painting in intensity and tint.

The late eighteenth-century invention of masking agents was saluted by Ackermann in 1813 specifically because of its approximation of oil: "the effect produced by its means, is similar to that of glazing in oil, and so powerful is its extent, that copies of oil paintings have been made in watercolours, which vie with the originals in force of colour and brilliancy of effect."[29]

Masking agents can be as simple as pieces of paper clipped to shape and pasted into place, to be removed after the washes have been laid in, leaving white reserves in their place. Turner and Cotman are reputed to have used this expedient.[30] Ackermann referred specifically, however, to a process invented by Francis Nicholson and first published in the 1799 transactions of the Society for the Encouragement of Arts, Manufactures, and Commerce: the artist mixes "whitened bees' wax in oil of turpentine, to which may be added as much flake-white as will give sufficient body to appear opaque when the touches made with it on the paper are held between the eye and the light."[31] The artist then commences his washes, stopping out lights at each layer much as an etcher stops out lines he wishes to have remain lightly bitten in his plate prior to reimmersing it in acid. Nicholson continues: "when the whole of the water colours are dry, with a hog's hair brush and oil of turpentine wash away the composition; as it dissolves wipe it off with a rag. . . . this will not affect the colours, because those used with gum water are not soluble in oil of turpentine."[32]

Although Nicholson successfully sued to retain his rights to this invention, others claimed it or proposed their own mixtures. In France Merimée concocted a paint of Lead white, Cobalt blue, and oil of turpentine, thickened by evaporation into a sticky paste. Laid on the watercolor paper, dried, and washed over delicately, it could then be removed with day-old bread to produce highlights.[33] Other masking agents, usually having a gum-resin or lac base and soluble in turpentine or alcohol, were patented through the nineteenth century.[34] None seems to have been widely used, however; "the complexity of the process was doubtless the cause of its failure. . . ."[35]

In the twentieth century new rubber-based masking agents were developed that combine the resistance to washing of Nicholson's film and the easy removal of Merimée's paste. Among the mixtures intended especially for use by watercolorists, Maskoid,™ introduced in 1939,[36] a fluid that dries to a rubbery film, is perhaps the best known in the United States. Common rubber cement and masking tape are equally expedient,

however, and widely used. Wax and oil crayons that repel washes may also be used as masking agents.[37] They have proved a favorite means of Henry Moore, the English sculptor whose drawings are frequently executed in watercolor washes.

Another masking device which was fully reported in manuals by the end of the nineteenth century is the stencil, which can be used to make both positive and negative images. In a landscape watercolor, for example, the horizon line with projecting silhouettes for buildings and trees can be cut out of stiff card and laid over the bottom of a watercolor sheet to permit a broadly washed sky;[38] or a stencil from which desired light forms have been cut can be laid over a completed wash, and the lights sponged out through the holes. One author cautioned against water seeping under the stencil's edge,[39] but the method has been used with success by at least one noted artist:

One of Mr. [George] Grosz's interesting tricks is to cut little stencils of various forms, particularly grass forms, out of old photo film. He then lays this stencil over the water color, rubbing over it with a sponge. This picks up the color and the result is a beautiful clean and light blade of grass in a dark area.[40]

Stencils were suggested in particular to permit local corrections in watercolors, "so as not to disturb surrounding washes."[41] Errors and their corrections were a constant problem in the medium, although methods of scraping and reglazing were employed for corrections as well as for the creation of deliberate effects. In gouache, the opaque watercolor style which allows an admixture of white with all pigments, mistakes have traditionally been painted out in white and the area repainted with color when dry.[42] The wash style's uncompromising transparency forbade such corrections, while its elaborate technical procedures practically guaranteed their necessity. One manual writer, before instructing the beginner in all the complexities of subtractive highlights, assumed defeat:

when any subject is placed in light it will be necessary to draw all the details . . . to give it that degree of finish which alone can cause . . . satisfaction. Without such care the subject will appear

bold and uncouth . . . and the whole will have an unfinished and defective appearance. Should a student find a difficulty in representing any particular object in light, it will be better to put such an object under shadow, where it will attract less attention.[43]

Not all artists were inclined to throw shadows over their problems, nor were they willing to subscribe to the wash-watercolorist's dogma that the only permissible white was light, that is, its reflection off paper, and not a white pigment.[44] With the development of zinc-oxide whites in the early nineteenth century, white crept back into the watercolor palette.

In eighteenth-century French painting, as represented in this exhibition by watercolors by Moreau l'aîné (45, fig. 3) and Natoire (46, fig. 1), opaque white—gouache—was used in two ways.[45] In one method, of which the Moreau is an example, white was mixed with all colors except the deepest tones, so that an opaque, rather cool pigment layer is consistent throughout. This practically negates any effect of the paper's hue except in the lightest areas of the sky. In the other, seen in both the Natoire and in Géricault's painting of the 1820s (19, pl. 4), white is not dogmatically excluded from mixture with other pigments, but it is principally used in its native hue as the lightest value. Both sheets are only partially covered with pigments, some opaque, some transparent. The papers are themselves dyed, so that their hues form the general middle tone in the images and provide an over-all dominant color, to be modulated rather than obscured by the overlying paints.[46]

Géricault's *English Horse Guard* was certainly conceived and probably executed in England at least a decade before Winsor & Newton introduced their zinc-oxide pigment, Chinese white. Yet it is painted with zinc oxide, proving that a workable permanent white was available to watercolorists in the early nineteenth century. Géricault, a French artist attracted to the English wash style, has here adapted the foreign technique to his native tradition's use of opaque white. In the translucent white reflections on the shiny horsehair, he has neatly dovetailed a characteristic of zinc-oxide white—"it has . . . a slight lack of

opacity, which gives it a bluish character when applied in thin layers"[47]—with his representational intentions—"Short-haired animals are often so glossy that the highlights upon them appear almost blue. . . ."[48]

Neither of the French gouache methods had much appeal to a watercolor school such as that which flourished in England at the beginning of the nineteenth century, which luxuriated in the brilliant luster of its new Whatman wove sheets and in the distinctive, pellucid English dry-cake colors. Yet the complexities of their developing technique led the English back to gouache. At first they employed white not in the earlier French manner but in three new usages that elaborated their wash style to a complex perfection.

The first was the gradual adoption of Chinese white as the only medium suitable for the creation of the finest highlights, where white paper reserves or scraped or lifted-out lights would not guarantee sufficient positive formal definition. This use was urged in particular by authors whose manuals incorporated Winsor & Newton catalogues:

> If possible the lights should be left when the washes are given; they will have more purity. . . . but never break or spoil a large wash for the sake of a few scattered lights. The broader the effect the better. . . . The smaller lights are often given by Chinese White. . . . there should, however, be great caution in its use, and no one part of the wash should bear the impress of its being different. . . . It is designed to produce the desired effect, without being observed as the "Chinese White" that gave it.[49]

Homer's *Fourth of July Fireworks* (22) exemplifies this use. It takes a sharp eye to see the touches of opaque white, together with scraping, in washes that Homer would not "spoil . . . for the sake of a few scattered lights."

The second use of gouache was popularized by William Henry Hunt in precious studies of nature's most cleverly crafted productions—fruit, blossoms, birds' nests, seashells. Ruskin described Hunt's watercolor technique to the amateur: "If you take [transparent] colour tolerably dark on your brush, only

always liquid (not pasty), and dash away the superfluous wash on blotting paper, you will find that, touching the paper very lightly with the dry brush, you can, by repeated touches, produce a dainty kind of bloom. . . ."[50] Such a method of hatching, the child of the miniaturist's dotting touch, required a smooth and intensely white painting surface in order to reflect light through the deep-toned pigment layers. Hunt coated his paper with Chinese white, much as a prepared white ground had also been employed by miniaturists in the seventeenth and eighteenth centuries.[51]

Hunt's innovation was in continuing use of white in the course of painting, to draw light elements of his design in white gouache over washes, so that they read as positive forms even with palpable impasto. He then glazed the lights with intensely colored transparent washes, removing any appearance of opac-

FIG. 17. William Henry Hunt, *Still Life with Fruit* (26, detail 200% actual size).

50

ity from the pigment combination and causing the details to gleam like particles of stained glass or gems. The grape stems in his still life (26, fig. 17) are painted in heavy white impasto (relative to the scale of the image) and dotted over with pure yellow, red, and green.[52]

The glassy firmness of Chinese white allowed this use; the pigment was known for its fluidity in the brush even when concentrated and for its resistance to washing up.[53] Although Hunt also used opaque white for concentrated points of reflection such as that on the glistening skin of the red berry in his still life, he equally would employ scraped highlights for diffuse effects such as the bright points within the stippled skin tones of his pear. It was his glazed impasto technique in particular that brought his pictures to the closest approximation yet seen to oil technique, despite their miniaturist touch.

Hunt's use of Chinese white prompted a contemporary observation that "It is quite certain . . . that as no luminous sky can be produced with body colour [opaque white], so no still-life of the highest excellence can be produced without it."[54] The sky, of course, is a light source, whose radiance is represented in watercolor landscapes by the white of the paper shining through the washes, whereas objects are perceived only by the reflection of light from their opaque surfaces. And the use of white was continuously advanced in still-life paintings such as Joseph Lindon Smith's image of a marble tomb (58) or in still-life details in larger works, such as the picture frame in Boldini's *In the Studio* (7, fig. 19).

Yet the third English usage of gouache was introduced in landscape, and it was the implications of its effect here, in its opposition of transparent and reflective surfaces, that would have the most far-reaching consequences in nineteenth-century watercolor painting. White was used as a dilute medium in the wash style, the white added to a considerable amount of water. This seems to have been Turner's innovation, and it may be seen in his *Simplon Pass* (61, pl. 6). White has been added to several passages in this painting, not merely to represent an Alpine glacier but to suggest the glimmering sublimity of the *idea* of mountains, of their hoary age, and of the ancient forces that formed them.

The effect of Turner's use of gouache was formulated by the manual writers. It became an expedient to make tints wash more evenly[55] and to achieve effects of distance and atmosphere in particular. It was not so much the pigment's whiteness that was desired; its extreme dilution guaranteed that the white of the paper would remain dominant. Rather, it was the pigment's handling qualities and opacity that were sought. Occasionally other light-hued and opaque mineral pigments were recommended for the same purpose: "opaque colors are very effective for giving an atmospheric appearance. Lemon chrome . . . is quite safe for use in distance, but it is decidedly difficult to handle for foreground, where reflected lights and colour and a transparent depth are so essential."[56]

OPACITY

The exploitation of the effect of Chinese white and other opaque pigments became as great a fetish as had been wash watercolorists' insistence upon absolute transparency. Having mastered the transparent technique, artists now emphasized contrasts in pigment characteristics, retaining, however, the conviction that their new method, like all the others so recently invented, would bring them closer to oil painting. An author (whose manual was published by Winsor & Newton) reported in connection with inorganic pigments newly introduced in the early nineteenth century:

> there was still wanting the means of employing opaque washings and solid scumblings of a tone higher than the ground in which they might be laid—a want suggested by the attempts of the artist in his desire to imitate the free and masterly handling which distinguishes spirited execution in oil painting. It was agreed that this could be effected only by the aid of a strong-bodied *white* paint . . . Chinese white.[1]

This use of Chinese white is exemplified in Ruskin's *Fragment of the Alps* (53, frontispiece), where there are in fact very few pure white touches in the main subject itself. Ruskin believed "that however white an object may be, there is always some small point of it whiter than the rest [requiring therefore] a slight tone of grey over everything . . . except the extreme highlights. . . ."[2] And so he mixed his Chinese white with a pale tint in all but a "small point" or two and laid it over transparent darker tones, which set out the broad masses of shade. Aside from its sheer opulence of color, the great beauty of the sheet is in the contrast of opaque colors against transparent washes. Pale stippling is laid over complex gradated washes, the lights casting a net of interpenetrating tendrils around a huge translucent gemstone. If the eye focusses on a single highlight, each separate form seems to float suspended over a pool of dim reflections.

Ruskin was acutely conscious of these positive effects of opaque lights, and he advocated working with opaque pigments rather than "merely transparent tints . . . not because the process is an easier one, but because it is a more *complete* one."[3] Specifically, he believed that it met oil painting on its own ground and triumphed, "being so far as handling is concerned, the same process, only without its uncleanliness, its unwholesomeness, or its inconvenience."[4]

In his *Elements of Drawing* he described his process, perhaps even reminiscing about the *Fragment of the Alps*, which had been painted the year before:

> Use Chinese white, well ground, to mix with your colours in order to pale them, instead of a quantity of water. You will thus be able to shape your masses more quietly, and play the colours about with more ease; they will not damp your paper so much, and you will be able to go on continually.[5]

Thus all the hazards and delays of wash are overcome, although his process has its own complications:

> you may have to ground with one color; to touch it with fragments of a second; to crumble a third into the interstices; a fourth into the interstices of the third; to glaze the whole with a fifth: but whether you have one, or ten, or twenty processes to go through, you must go *straight* through them. . . . The drawing in body-colour will tend to teach you all this, more than any other method, and above all it will prevent you from falling into the pestilent habit of sponging to get texture; a trick which has nearly ruined our water-colour school of art.[6]

The pleasure in contrasting white and opaque pale colors against transparent color glowing with light reflected from the paper below was carried by Victorian artists even to the extreme of the representation of flesh. English manuals, in contrast to French, traditionally had forbidden even a touch of white for skin tones: "Remember you are never to lighten it with pure White, which will rather give it the Appearance of Fish than Flesh."[7] But in Albert Moore's *The Toilet* (41) opaque white is used throughout, most notably in the heightening of flesh tones. The artist modelled the young woman's breast with fine touches of white to highlight its rising curve. The pigment's cool, reflective opacity evokes the silky firmness of the breast to a hand's caress and contrasts its swelling fullness with the transparency of warm shadows in the underarm and chest.

Moore's painting also depends upon the effects of opaque pigments other than white. His bright yellows and oranges were not dulled by the addition of white to render them opaque; they are inherently solid. The differences in relative opacity among pigments can be seen even more clearly in Nolde's *Woman* (47), where thin, uniform washes of color over black ink show the red to be transparent and the orange opaque in their colored substances, if not in their handling. Through the nineteenth century, color chemists developed and perfected new opaque inorganic pigments, descendants of heavy mineral pigments such as Vermilion, which had been interdicted in the transparent style and had been defined in eighteenth-century France strictly as gouache pigments because of their metallic origins.[8]

Occasionally, earlier wash artists had employed Vermilion conspicuously in final touches, its tendency toward washing up

prohibiting any other use. Rowlandson developed in the 1790s a systematic method of overdrawing his near forms in Vermilion (53, fig. 18) to accent their lively expressiveness and to set their pale washes before the background forms, which were more softly outlined in gray.

Vermilion and other synthetic inorganic gouache pigments commercially available at the beginning of the nineteenth cen-

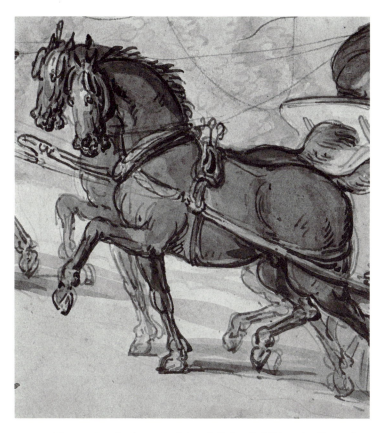

FIG. 18. Thomas Rowlandson, *Mail Coach Going Uphill* (52, detail actual size).

tury[9] were soon joined by brilliant new compounds of chromium, cadmium, strontium, and barium, with improved cobalt, zinc, and synthetic iron mixtures contributing other hues. Mid- and late nineteenth-century manual writers in particular took pains to describe watercolor pigments specifically in terms of their transparency or opacity.[10] The commonest use of these colors, especially the opaque yellows, was as an alternate to white or glazed subtractive lights in oil-manner watercolor painting. The pigment was laid on with a dry brush in points, blobs, or discontinuous streaks that allowed the darker tones beneath to penetrate their forms.

A dry-brush stroke depends for its success on a touch as sure as that required to lay a dash of hard-edged wash. Formulistic abuse of the manner in gouache, degenerating into formless scrubbings, is as endemic as washer's puddles; but the style has had its masters. In Boldini's *In the Studio* (7, fig. 19) an ornate picture frame is represented partly by discrete touches of brown and creamy yellow modelled in impasto imitation of the gilded plaster carvings of the original; but the right edge, catching the light as if reflecting the radiant beauty of the studio model, is painted in a single dry-brush stroke. So sure was the artist of his touch, of the weight and consistency of his paint, even of the spring of his loaded brush, that he drew the entire length of molding in one gesture. The edges of the stroke are resolutely parallel, to guarantee a realistic representation of the geometry of the frame; but the pasty substance of the stroke was broken by its method of application into tiny points of opaque reflection. Carving explicitly indicated in the frame's shadowed cove is here only suggested by coruscating light.

Perhaps only watercolorists can fully exploit the play of reflection and refraction of light developed in combinations of opaque and transparent colors. Turner's use of reds and blues in combination in *Bally-Burgh Ness* (60) has already been noted. French watercolorists, once they became acquainted with the English transparent style, seized on this aspect of watercolor painting, to explore it in a continuation of their traditional gouache technique.[11] Lami's mid-century portrait of the *Duke and Duchess*

of *Brabant* (35, fig. 13) contrasts the intricacy of lacy detail drawn in opaque white with its transparency where the white of the paper gleams through. It manipulates the various aspects of transparent and opaque reds in the representation of fabric stuffs of all sorts and their colors reflected off metal buttons and the Duke's gorget.

Winslow Homer[12] provides the most subtle understanding of this facet of watercolor painting. In his *Hunter in the Adirondacks* (23, pl. 5) he contrasts opaque Cadmium yellow with thin washes and subtracted lights which permit the paper to shine through. By this device he represents the brightness of sunshine glittering through occasional gaps in the green canopy and reflecting off young undergrowth. The flickering yellow contrasts with the cool luminosity of the pervasive light filtering through pine branches as if through water, in an evocation of the complex light of deep shade.

MOIST COLOR

In 1813 Ackermann announced that "the preparation of watercolours has almost attained perfection,"[1] but the penultimate was surpassed in only a few years with the development of moist colors. Ackermann was a colorman, and his enthusiasm for commercial dry-cake colors was not necessarily shared by artists, who seem to have quickly forgotten the irksome chores of color preparation. Dry-cake colors were criticized as hard and gritty, apt to crumble with heat or age,[2] and tedious to rub up into washes.[3] And so colormen continued to experiment with binders, directing their attention particularly to the addition of hygroscopic agents, which, attracting and holding atmospheric water within the color cake, would predispose it to softening and dissolving more readily.

Candy sugar[4] had long been a secondary ingredient of the gum binder of watercolors,[5] extra sugar being added to protect colors especially liable to drying out and fracturing.[6] In the early nineteenth century French color manufacturers substituted honey for sugar.[7] Their *couleurs de miel* were quickly copied by English colormen, who in the 1830s substituted glycerin,[8] a strongly hygroscopic, syrupy form of alcohol, for some or all of the honey.[9]

The new colors were christened "moist colors." They were not wet to the touch but were perceptibly sticky compared to dry cakes. Indeed, their binder might be likened to the gumdrop, which one author has recommended as a rough-and-ready substitute, should the artist be caught without his moist colors: "I have made moist water colors . . . by grinding pigments in a

FIG. 19. Giovanni Boldini, *Girl Reclining in the Studio* (7, detail 135% actual size).

thick sirupy solution of ordinary pale-colored gum drops. . . . These candies normally contain gum arabic, sugar, glucose, and glycerin in fairly good proportions."[10]

In 1841, shortly after the development of moist colors packed in porcelain pans, the metal tube container was introduced for oil paints. Five years later Winsor & Newton Co. adapted their moist watercolors for tubes.[11] Tube color must be more moist than moist color in pans, so that it can be squeezed out; and the demands of empire in late nineteenth-century Britain even required the development of especially moist moist color in tubes. Both Reeves[12] and Newman manufactured a "SLOW DRYING" form "specially prepared for use in Hot Climates," whose resistance to drying out in the tube was applauded in "Testimonials . . . from Military and Naval Officers, War Correspondents, Artists and others."[13] Winsor & Newton contented themselves with "BRASS BOUND BOXES FOR INDIA."[14]

Thus by mid-century the watercolor artist could buy his watercolors in at least three consistencies. Dry-cake colors did not become immediately obsolete, although at about the date of his *Moorland* (13), painted in 1846, David Cox was remarked upon for his use of "the old-fashioned *hard* cake colours."[15] As may be admired in *Moorland*, dry-cake colors produced the most brilliant wash effects; apparently the slight additional viscosity of glycerin or honey diminished the colloidal dispersion of the pigment particles and their even settlement upon drying sufficiently to be noticed by wash purists. Moist colors in pans were also apt to hold dust, a further hazard in washing.[16] Through the nineteenth century dry-cake colors were particularly recommended for preliminary washes,[17] as added glycerin or sugar renders all pigments not only more soluble on the palette but also more disposed to wash up on the sheet.

In the early twentieth century, when the sketch style with its emphasis on direct washing was at its height, dry-cake colors enjoyed a revival: "many artists have gone back to the use of hard cakes . . . with which the earlier men [that is, Cox *et al.*] obtained their delicate and luminous results."[18] Otherwise, only "engineering and architectural draughtsmen" used dry-cake col-

or, presumably to guarantee the greatest possible transparency in finely detailed working drawings.[19] Finally, in 1974, Winsor & Newton discontinued their production of this first form of prepared watercolors altogether, from lack of demand.[20]

The immediate popularity of moist colors arose from their ease of use. The speed with which they could be diluted into workable consistency was raised by colormen's catalogues from a convenience to a positive creative force.

> In sketching from Nature, and, when representing transient and evanescent effects, the superiority of the Moist Colours is at once felt and appreciated. Ever ready for instant application, they enable the desired tint to be produced *at once*—a result unattainable by the old tedious method of rubbing dry cakes, which not infrequently permits the effect, and with it the *thought* of the artist to vanish. . . .[21]

This paean saluted moist colors in pans; one might think that moist colors in tubes would be all the more popular with the outdoor sketcher, being all the softer. In fact, this was not the case for outdoor work. Tube moist colors, requiring the addition of so little water, often caused the outdoor artist, working in haste to capture evanescent effects, to become careless. "Buy [moist colors] in pans," he was advised, ". . . by doing so you are more likely to mix well and properly."[22] Also, the heavy lead tubes were comparatively inconvenient out of doors: "When one gets settled in the countryside, the tubes upset, fall and roll away with the least motion."[23] And so, with the possible exception of certain colors that are better handled in closed tubes,[24] moist colors in pans have been preferred by the outdoor sketcher, or else he has squeezed his tube colors onto a palette before setting out to paint.

Tube colors were eagerly adopted by the studio painter, however, for whom their practical disadvantages were negligible. Their greatest attraction was proclaimed in Winsor & Newton Co.'s first advertisement for tube color,[25] which announced: "Moist Water Colours in Patent Collapsible Tubes. A new preparation . . . particularly adapted for large works . . . these

colours present a range of pigments, which, in brilliancy and similarity of manipulation, much resemble Oil Colours."[26]

The new colors were not perfected immediately. In an 1878 catalogue Winsor & Newton Co. confessed that they were "somewhat wasteful and troublesome in use" and had to be used "within reasonable time, as they do not keep so long or so well as the ordinary solid or 'Pan' form of Moist Colour."[27] In 1871 J. Barnard & Son advertised that their tube colors neither dried out in the tube nor fermented,[28] presumably alluding to the ills to which the new paint form was prone.

The viscous consistency of tube colors and their immediate accessibility at full strength and with substantial body attracted artists who otherwise would probably have continued to paint in oils. "Dreading the darkening of oil and disliking its greasiness,"[29] Burne-Jones created watercolor paintings so close in appearance to oils that several of his works were destroyed in well-meaning attempts to varnish them.[30] Burne-Jones preferred a "stiff pigment of the texture of soft cheese"[31] (tube colors resemble nothing so much as a well-ripened *Brie*), and he made free "use of the not long invented moist paints, ordering tubes and cakes by the dozen."[32]

Burne-Jones's exaggerated preference, which is seen in the heavily textured surface of *The Second Day of Creation* (9, pl. 2), led to difficulties when he attempted to paint out of doors. Flies, attracted to the gooey, sweetish mass of color, "came and settled on his drawings, and then rain . . . glued them on. . . ."[33] Such technical problems encouraged his natural disposition—"there seemed little reason for him to torment himself by a struggle with the outer world"[34]—and Burne-Jones, as well as most other watercolorists who have preferred tube colors, painted "from notes . . . and then dealt by memory and imagination."[35] Today artists' tube watercolors outsell pans eighty to one at Winsor & Newton Co.[36]

The added body of moist colors and of tube colors in particular led artists predisposed either to the imitation of oil or to the contrast of opaque color with transparent wash to use moist color full strength on the brush in a barely spreadable consis-

FIG. 20. Edouard Manet, *Race Course at Longchamps* (37, detail 150% actual size).

56

tency.[37] Even such paintings as Homer's *Key West* (24, fig. 8), conceived essentially in sequences of wash, feature accents of viscous, dragged moist color; the opaque Vermilion of the boot toppings of Homer's boats was applied straight from the pan and in such heavy layers that it has cracked over the years much as oil paint and varnish crack on aging canvas.

Watercolor artists of the late nineteenth century were perhaps less aware of the potential fragility of heavily applied colors or of color coated with a layer of extra gum than earlier painters, who had prepared their own pigments. The liability of fracture of such paint structures had been a standard test for over-gumming in earlier years, although even in the eighteenth century extra gum and other additives were utilized by miniature painters to enrich their jewel-like portraits. Gum varnish can be seen throughout the hair and costume of *Henry Hamilton* (2). Although in the age of washed topographical landscapes, the "shining of the Colours"[38] had indicated an excess of gum, such excess became a virtue in the imitation of oil painting.[39] Extra binder was incorporated especially in the gouache technique as practiced in nineteenth-century France, where without added gum the heavily whitened colors would have appeared chalky, dull, and old-fashioned.

Manet's *Race Course at Longchamps* (37, fig. 20) was painted in the full gouache style with white added to practically every color that was not used at full intensity, but its colors were exceptionally heavily gummed. The painting is therefore much lower in tonality than the earlier Moreau *l'âiné* (45, fig. 3), to which its pigments with their admixture of white are otherwise comparable. The Manet's paint "bears out." A close inspection reveals, however, that so much gum was added to achieve this richness that it actually foamed from the brush; note the cluster of dried burst bubbles at the upper center. Wherever the pigment hardened in thick layers, as on the near fence posts, a prominent crackle pattern is visible.

Other materials were advanced to approximate the color-intensifying effect of moist color used pure from the tube and of added gum arabic. The earliest manuals specified distilled rose-mary water,[40] which seemed to act also as a wetting agent to facilitate pigment grinding and inhibit the foaming of heavily gummed colors.[41] Others recommended ox-gall for the same dual purpose,[42] while eel-gall was even more highly regarded in the earliest manuals. Added to the wet color, it would give "all green, black, gray, and yellow colors . . . luster and *éclat*."[43] Ox-gall is a yellow substance that was also used as a pigment by watercolorists; presumably its use as a heightener would have been restricted to the same range of hues as was eel-gall.

The use of pure moist tube color and of extra gum or gall was soon supplemented by additives concocted by the colormen. Watercolor meglip became a particular favorite as, it was claimed, "This vehicle completely resembles in its effects those of oil painting."[44] Watercolor meglip was named in imitation of the mastic-varnish concoction highly popular with nineteenth-century oil painters, a translucent, viscous medium that gives body without opacity to oil paints. Fortunately for watercolorists and conservators, the water-based version of meglip is reliably permanent, whereas oil painters' meglip has caused the destruction of countless canvases.

Watercolor meglip was made from gum tragacanth, "a strong, colourless gum, soluble in hot water, and of excellent use . . . when a gelatinous texture of the vehicle is of use to prevent the flowing of the colours. . . ."[45] Meglip was advised particularly for near-ground, glowing details, to insure the solidity of heavily applied paints. Such a thickening agent may be detected in Burchfield's *August Sunlight* (8, fig. 21).

Evidently the sheet was painted, as is usual, on a slight incline. The pure dark washes applied to the centers of the sunflowers sagged slightly to form a slight bead of color at their lowest points, effectively modelling the convex forms. Such watery paint could never have coated the intensely dark, large areas of the houses without the weight of accumulated liquid breaking their lower bounds, and so Burchfield added a thickener to his paint in these areas. It not only contained the washes but also allowed Burchfield to model his surfaces, since the paint retained the track of his blunt-tipped brush.

Unlike gum arabic, gum tragacanth does not cause the paint to which it has been added to shine when dried; thus it could be worked into a washy painting such as *August Sunlight* without interrupting the general uniformity of its surface. Watercolorists working in the oil manner did not consider this a virtue, however: "As the Meglip causes the colour to dry rather dull, glazings of transparent colours are necessary. . . ."[46] Fortunately, gum tragacanth not only dries hard but "fixes the underneath colour so that other tints may be washed over with freedom,—an advantage to be gained by the use of no other vehicle."[47]

Painters have experimented with many other vehicles and colormen have patented many other concoctions to vary the handling and drying properties of watercolor. Winsor & New-

ton Co. now provides a sort of "super meglip" in its Aquapasto, a mixture of gum arabic and silica in the form of a translucent jelly that allows the modelling of watercolors in high relief.[48] Other natural resins such as gum ammoniac and sarcocolla were advocated as hardeners for the dried paint film in the nineteenth century,[49] and the synthetic resin polyvinyl alcohol has been suggested in more modern times.[50]

In the last few decades synthetic acrylic resins have been perfected in water-emulsion paints that combine the attributes of gum or gall to heighten pigments' hue and luster, of pure tube color or meglip to give translucent body to the paint mass, and of meglip or fixatives to give solidity to the dried film. Acrylic paints are commonly handled in a thick consistency on canvas,

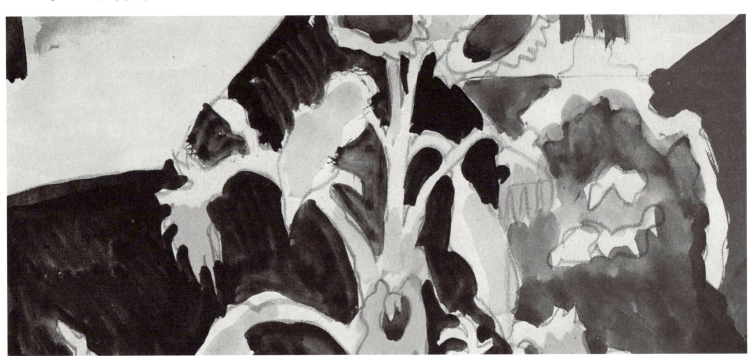

FIG. 21. Charles Burchfield, *August Sunlight* (8, detail actual size).

the oil painter's traditional support, with his traditional tools, stiff brushes and a palette knife. There is, however, no technical barrier to diluting the acrylic medium with water to the point where the paint handles much like traditional watercolors. The tough dry acrylic film does not, however, permit subtractive highlights.

Many different synthetic resins have been formulated into proprietary mediums by artists' suppliers. Reeves & Sons has lately followed its eighteenth-century invention of dry-cake colors with the introduction of an acrylic polymer emulsion in water bearing its name.[51] The modern manual writer assures us that acrylic emulsions used in the watercolor style "can do just about everything that traditional watercolor paints can do, plus a great deal more,"[52] and synthetic resin additives such as acrylic matte medium and gel can carry the effects of meglip and other gum additives to the exact imitation of oil. Just as the prejudice against opaque white was rapidly overcome when stylistic ambition coincided with technical advances, so too the watercolor painter of today may find that the physical properties of acrylic paints will complement his vision and sire their share of masterpieces.

PRESENTATION

With the exception of larger miniatures and cabinet portraits,[1] watercolor paintings in the first years of their period of highest fashion were not hung up for viewing. They were pasted into albums, to be savored in sequence and at length. In 1813 "Amongst the most polite circles, the library [had] become the place of refined amusement in the long evenings, not only within town houses, but during their residence at their country seats. . . ."[2] In the eighteenth century these country seats were often themselves the subjects of the paintings. After the end of the Napoleonic Wars, watercolor views extended the armchair sightseer's prospect beyond his home and county through the world at large. The *peintre voyageur* went on the Grand Tour,

and the returned traveller was encouraged to "separate the album and enframe each sheet to make a gallery or collection of varied and precious paintings, through which he can relive his voyage."[3]

Through the same years professional watercolor painters were ambitiously pursuing their chimera of the attainments of oil painting, which led them to insist that their medium be recognized as worthy of public exhibition.[4] In 1780, on the event of the inauguration of the Royal Academy's first official residence, the anteroom of the galleries at Somerset House was given over to watercolors and drawings.[5] Presumably these watercolors, among the first to go on public show, were displayed much like Blake's paintings that were exhibited in 1785 in "close rosewood frames (a far from advantageous setting)."[6]

The separation of watercolor and oil paintings in exhibitions has been commonly maintained to this day, as it is generally believed that "they greatly injure each other's effect."[7] When watercolor has been considered a minor art form, wash paintings have usually been relegated to a decidedly inferior position: "water-colour drawings would form a fitting decoration for a *boudoir*. . . ."[8] The anteroom of the Royal Academy was lit by side windows and was a less prestigious gallery than the Grand Exhibition Room, which was reserved for oil painting. Watercolors that hung in the anteroom and other secondary galleries were framed under glass for their protection and were practically invisible in the glaring reflections.[9] Artists and manual writers objected to the glazing of watercolors for this reason and recommended varnishing in its stead.[10]

Watercolor paintings mounted on board and varnished, moreover, would more closely approximate the appearance of oil paintings on display;[11] and artists who have aspired to exhibit their work in direct competition with oils, from Paul Sandby in the eighteenth century (54) to contemporary painters in watercolor and acrylic,[12] have employed varnish. Early varnishing techniques, which used natural resins such as copal or mastic, were adapted for watercolor by being laid over a priming of several coats of thick, warm isinglass, "to prevent any part of [the

varnish] from penetrating or coming in contact with the paper."[13] Egg white was also recommended as a varnish in early manuals,[14] although it was apparently an application of egg white that ruined a watercolor painting by Burne-Jones in 1893.[15]

By this date watercolor paintings such as those by Burne-Jones, which attempted to imitate oil paintings, incorporated so much added gum and glycerin that they were susceptible to serious damage from varnishing techniques that had earlier protected more simply washed sheets. Accordingly, nineteenth- and early twentieth-century colormen developed proprietary varnishes and fixatives especially for watercolors. Most of these coating agents seem to have had a shellac, sandarac, or damar resin base, with the purest "extra pale" resins being selected.[16] Later in this century synthetic resins were adapted for the same purpose, with nitrocellulose ("Duco") varnish recommended in the 1930s[17] and vinyl and acrylic resins superseding it more recently.[18]

Despite this continuing interest in watercolor varnishes, most artists in the medium have preferred to frame their works under glass.[19] At first watercolor paintings were either close-framed in wood or matted in a reminiscence of their presentation on gray or white album pages, which had often been decorated with ruled lines and washes.[20] Predictably, however, watercolorists soon adopted the traditional carved and gilded frames of oil paintings.

> It is only of late that [watercolor landscapes] could be rendered sufficiently rich and deep in tone, to bear out against those broad and superb frames, which seemed alone fitted to the power of oil pictures. . . . water-colours, by the present improved process, have an intensity of depth and splendor of effect, which almost raises them to rivalry with cabinet pictures.[21]

How that "almost" must have rankled the watercolorists!

By mid-century gold frames were specially adapted to watercolors by the introduction of gold mats, made of gilded wood or cardboard and interposed between the painting and the glass. *Moorland* (13) by Cox retains its typical Victorian gold "flat"

within a busy, burnished frame. *Lucretia Borgia* (51) by Rossetti is framed in the typical gilded oak of the Pre-Raphaelites. The carved and inscribed mat was almost certainly designed by the artist and executed by the firm of William Morris. It embodies the Pre-Raphaelite aesthetic in its renunciation of gesso, which is usually employed to fill the grain of a wooden surface prior to gilding. The aggressive texture of oak seemed shockingly raw in its time; but the glitter of gilt from the pores of the wood is not so different after all from the effect of "Burnishing small points of the frame" as seen on *Moorland*, a gilding style that was considered by one Victorian writer, "from the greater vivacity of watercolors, less objectionable than when the frame is intended to close an oil picture."[22]

Gold mats continued to be favored by artists and patrons who appreciated the oil manner, such as Joseph Lindon Smith and Edward Forbes, the original owner of Smith's opaque and textured *Grave Monument* (58). The Fogg archives also preserve extended correspondence between Forbes and Charles Herbert Moore concerning the purchase of a broad gold mat for Turner's *Simplon Pass* (61, pl. 6).

Specific functions were attributed to the gold mat or frame. It was "an abstract boundary . . . between the vulgar surrounding world and the sort of spiritual life of Art,"[23] or else it served as a yellow-hued border to enhance the effect of distance in a landscape watercolor painted in "retiring colors."[24] By the end of the century, however, heavy gilding was scorned as a relic of overthrown pomp by advocates of the sketch style. "These masses of gold . . . supply the idea of an opulent richness, while the pictures furnish an excuse . . . for putting gold on the walls."[25] The sketch purist preferred

> a snow-white card board mat, its edge bevelled neatly down to the picture . . . doing its duty as a margin. . . . the real logical treatment has been reached where a very plain and simple wooden moulding is used. . . . the drawing is . . . not framed in a vulgar sense but simply protected. Hence the white Bristol board and the rough wood harmonize. They are sketches, and sketchy, like the drawing.[26]

In the 1920s and 1930s, simple wooden frames were themselves painted white for watercolors such as Demuth's still life (16) and Hopper's landscape (25), in a cool Art Deco analogue to Victorian gilded encrustations. Eventually the manual writers would resign themselves to suggesting that framing be chosen to suit the image,[27] and frames might even be custom-painted to match their contents, much as the more literary Pre-Raphaelites had written poetic inscriptions across their mats. The red, blue, and white-painted borders of Miró's *Femme* (40) can be profitably compared to Rossetti's *Lucretia Borgia* (51) in her carved and lettered gilded mat.

PERMANENCE

The emphasis on the proper presentation of watercolors for exhibition fairly indicates their growing status through the years as paintings worthy of constant attention. Framing and exhibition impose certain hardships on a picture, however, to which many manual writers and artists seemed indifferent. Only in the twentieth century, for example, would an author warn against the use of wood backings for framed watercolors; writing after such backings had been in use for a century, he noted that "Resinous knots stain your cardboard through and there have been countless water-colours ruined in this way."[1] Today the acidic content of wood and many woodpulp mounting boards is widely recognized as a great hazard for watercolors in particular, since remedial bathing or deacidification processes suitable for many drawings and prints can damage watercolor pigments.

The dangers of air pollution were recognized earlier, particularly in large cities such as London, whose atmosphere was saturated with the sulfuric combustion byproducts of coal and illuminating gas. Vibert's Fixatif, a veritable panacea for the ills of watercolors according to its inventor, was specifically recommended in the 1890s as a sealant against atmospheric acids.[2]

The earliest concern for the safety of watercolors, however, the concern that would prove most fruitful in the development of standards for the safe exhibition of many forms of art, arose from an awareness that light has a destructive effect on the materials of watercolor. As early as the 1820s warnings were given that the growing fashion for watercolor exhibitions would damage paintings already on view and would require new standards for the materials of the art:

> the tints used for glazing are almost entirely composed of fugitive pigments . . . without the aid of which, in spite of all that is said to the contrary,[3] those brilliant and richly harmonious combinations cannot be produced. Hence, landscape painters must be content to study for the portfolio . . . unless . . . they would forego the temptation of present applause for a more lasting though less brilliant fame, by confining themselves to . . . pigments less liable to change.[4]

Samples of pigments cited as fugitive in 1824 have been preserved unfaded in manuals such as those by Perrot (1834) and Phillips (1839) and are displayed in this exhibition. Gamboge, Indigo, Brown-pink, and above all Carmine bear witness to the fragile glories of the traditional watercolor palette.

Early warnings generally went unheeded in the rush to exhibit watercolors as freely as if they were as light-resistant as oil paintings.[5] The public was encouraged to value watercolors as highly as oils in every sense, so that by the 1880s, when the permanence of watercolor paintings became such a controversial question that a government commission was appointed to resolve the dispute, "the effect . . . of the scare was very distinctly felt, both by artists and dealers, in the increased difficulty with which they were able to dispose of water-colour drawings."[6]

The controversy did not arise overnight, however, nor had there been a sixty-year lapse in attempts to counter the dangers of fugitive pigments. Palliative suggestions were advanced throughout the nineteenth century, in particular the recommendation that light-sensitive colors be heavily gummed to retard fading.[7] In the main, however, the emphasis lay on the development of light-fast pigments, although in 1820 Francis Nicholson expressed a strong and apparently well-founded distrust of newly introduced colors from most artists' suppliers:

instead of discovering new and fine colours, of which we already have more than we want, the attention of the colour manufacturer [should be] directed to the means of making those we have as true and permanent as possible... discoveries having been less applied to the improvement of the substances ... than to the means of making them by cheaper... processes, and ... to the adulteration of such of them as are capable of affording ... an increase in profit.[8]

His suspicions were both confirmed and countered by the greatest colorman of his time, George Field. Field was a color theorist, chemist, engineer, and manufacturer so obsessed with chromatic character that he saw in pigments a metaphor of sexual identity[9] and in the three primary colors an image of the Holy Trinity. Red, blue, and yellow united in white light were "symbols of Himself ... AFTER THE PATTERN OF HIS OWN PERFECTION."[10] Field was also a very practical pioneer in the development of pigments and manufacturing apparatus;[11] and in his monumental *Chromatography* of 1835 he published the definitive results of his longtime concern for the permanency of artists' colors.[12]

Field conducted various tests, which in general condemned the natural organic pigments traditionally used in watercolor washing; his verdict on Brown-pink: "Upon the whole, it is more beautiful than eligible [as a permanent pigment]."[13] He was also perhaps the first to complain in print about the survival of archaic pigment names: "Pinks are sufficiently absurd names of yellow colours."[14]

Field was particularly concerned for the relative permanence of pigments, recognizing that the absolute alteration of hues was not so significant as their alteration in relation to each other. This was not a new idea among artists; Hogarth commented upon the problem in 1753 in his widely read *The Analysis of Beauty*,[15] and Nicholson's discussion of the relative fading of the components of neutral tint has already been quoted. Field, however, devised and reported upon practical experiments to demonstrate the problem,[16] and he systematized on a scientific basis the widely recognized imcompatibility of many pigments with each other: "colors, like characters, suffer contamination and disrepute from bad association."[17]

To conclude his *Chromatography* Field published lists of pigments, which were widely reproduced or referred to in nineteenth-century manuals.[18] His tables itemized permanent pigments, pigments that suffered from the action of various agents, and pigments that formed incompatible mixtures. In Field's eyes these tables justified his prefatory assertion that:

pigments, and fine ones too, so abound, that nearly as much experience is requisite to a judicious selection ... as was formerly required for their acquisition or production. ... respectable colourmen ... purvey, regardless of necessary expense, the choicest and most perfect materials ... so that the odium of employing bad articles attaches to the artist, if he resort to vicious sources or employ his means improperly.[19]

Thus the battlelines of responsibility for permanent painting were drawn; all-out war would erupt in fifty years.

In the interim, the proliferation of colors continued. Field had noted that "some sort of criterion of the durability and changes in colour in pigments [was] that time and fire produce similar effects...."[20] In general it became the accepted rule that substances formed by fire, that is, by oxidization, would be relatively permanent to the effects of "sunshine; whilst those which are organic in their origin are peculiarly liable to its influence."[21] All manner of exotic earths and rare metals were investigated, so that by 1869 the editor of a new edition of *Chromatography* would complain that

Strange preparations have been offered as pigments. ... Some ... do not retain their colours on drying; others [require] processes too nice, complicated, or expensive. ... There are many colours ... which exist only on paper. We have too often found the imaginations of chemical writers far more vivid than the colours they describe.[22]

Many of the new compounds reached the market, however, to the initial consternation of a public unaccustomed to the in-

tensity of pure mineral pigments in watercolors. Turner in particular was criticized for his brilliant color combinations, especially when eyes accustomed to the reproduction of his paintings in black-and-white engravings first saw the gaudy harmonies of the watercolors he prepared as models for the engraver (60).[23] Turner's paintings inspired the judgement in the 1820s that "the powerful attraction of colours . . . is the vice of our modern school."[24]

Rapid development of mineral pigments in the first half of the nineteenth century was matched by continuing investigations of the chemistry of organic coloring substances. Some of the traditional organic pigments were refined and synthesized,[25] and entirely new dyes were created from coal tars, byproducts of the distillation of bituminous coal into coke, illuminating gas, and other substances required by England's burgeoning industrial and urban centers. Unfortunately, all of these so-called aniline[26] dyes, with the exception of Alizarin, were shortly discovered to be fugitive in light. Their great beauty and low cost encouraged their continued use by unscrupulous colormen, however, so that manuals recommended that artists test their colors for the presence of analine dyes as adulterants.[27]

The notorious impermanence of organic aniline colors retarded the development of other synthetic organic pigments for decades,[28] but today new organic compounds are among the most permanent watercolor paints. For the most part, however, for the convenience and, perhaps, the peace of mind of artists, colormen have christened synthetic organics with the names of the traditional substances that they replaced.

By the 1880s the proliferation not only of actual colored substances but also of names for any given substance was such that F. W. Devoe listed 156 names for oil colors, including seventeen that included "madder" and thirty-seven that were "ancient traditional names that according to authoritative texts were either no longer in use as the actual materials or available at that time."[29] Manual authors attempted to simplify the problem of pigment selection for the bewildered watercolorist by recommending "a working 'daily-bread' colour-box" complemented by "little 'private' or 'freak' colour-boxes,"[30] such as one reserved specifically for sky-painting that contained no less than twenty-two separate named colors. Some of these were virtual chemical duplicates (e.g., Purple madder and Alizarin purple madder).[31]

The simmering controversy broke out afresh in the 1860s. In 1868 the permanency of watercolors required justification to a new market.

> The practice of water-color . . . and the public exhibition and sales of water-color painting, are comparatively new in America; and there are a good many people who . . . ask anxiously, "Are the colors permanent?" . . . a piece of paper, though protected by a glass and a wooden back [!] seems to them, somehow, to possess less durability than canvas. . . . it is our purpose to show that all such prejudices are unfounded. . . .[32]

In 1869 Winsor & Newton's color chemist rebutted critics by admitting that the palette "wants weeding; not only of the bad new colours, but of the bad old colours. This, however, must be a work of time, and depend, not on the colorman—for where there is a demand there will be a supply—but upon the artists themselves."[33] In 1878 many manuals were harshly criticized as "too evidently published in the interest of the trade; while many others recommend *villainous* pigments. . . ."[34] In 1880 in a speech before the Society of Arts, William Holman Hunt recalled his and Millais's absolute faith as students in 1848 in George Field.

> That ours was but a blind reliance was proved after George Field's death, when some of the vermilions supplied in imitation of his blackened after a short time. . . .[35]

> It transpired that the producers of colours were no longer . . . superintending all their preparations personally; [they] had been supplanted by the proprietors of large factories, where each production goes through numerous irresponsible hands.[36]

> Academies give no such attention to material matters, and accordingly the student . . . cultivates the practice of art in ig-

norance of the nature of the materials he uses. . . . To the modern painter the only difference between one paint and its fellow is that one is a bright and another is a dull colour. . . .[37]

Finally in the Spring of 1886 the storm broke in the pages of *The Times* to an astonished and outraged public. Affection for the English old masters of watercolor and investments in their paintings were threatened by the disclosure that the colors were liable to fade during prolonged exhibition. In 1878 Ruskin had admitted in print that Turner watercolors of the 1830s had deteriorated badly,[38] but in a letter of April 1886 he beguiled the nervous collectors reading their *Times*:

> Properly taken care of—as a well-educated man takes care also of his books and furniture—a water colour drawing is safe for centuries; out of direct sunlight it will show no failing on your room-wall till you need it no more. . . . is it for your heir that you buy your horses or lay out your garden?[39]

The British government, which had "continuously exhibited in full daylight for twenty or thirty years past"[40] its collection of master watercolors in the South Kensington Museum was forced to answer "yes" to the sense of Ruskin's question. The Department of Art and Science commissioned Dr. Walter J. Russell, a chemist, and Capt. William de W. Abney, a painter, to investigate the permanence of watercolors. In 1888 they published their *Report . . . on the Action of Light on Water Colours*, which was quickly acclaimed by all the leading authorities on the medium.[41] Although refined and supplemented over the years,[42] the validity of its methods and findings has been repeatedly reaffirmed.[43]

Russell and Abney established incontrovertibly that light[44] damages many pigment substances, that oxygen and water[45] in the atmosphere are also necessary for their alteration, that mineral colors are generally more permanent than the organic colors known in their time, and that all too many contemporary watercolor painters were continuing to use fugitive colors. Of the painters who responded to their survey, seventy percent used Gamboge, seventy-four percent used Vandyke brown, and fifty-two percent used Indigo. Even the notorious Carmine was still employed by eight percent.[46] Like Field, Russell and Abney concentrated their attentions on the fading effects of mixtures, for the deterioration of neutral tint in early watercolors had been a feature of the controversy in *The Times*, where it was blamed on the insidious action of Indian red on Indigo.[47]

The pigment samples tested by Russell and Abney were washes of Winsor & Newton Co.'s watercolors painted out on Whatman paper.[48] Winsor & Newton had been acclaimed for several decades as the natural successor to Field, whose patent for Lemon yellow they had purchased and whose *Chromatography* they reprinted. They were recommended to America in 1868 for the permanence of their watercolors,[49] and they continued to congratulate themselves in their catalogues for receiving "the only medal [among] the competitors English and foreign for 'Artists' Colours'" at the Crystal Palace.

Their fulsome self-appreciation seems overstated to modern ears: "Previous to the establishment of the House of Winsor and Newton (in 1832) the evil repute of want of permanence attached to the *Water Colours* in ordinary use";[50] but there is no doubt that the firm's publications, their rigorous testing methods,[51] their unprecedented willingness to disclose the ingredients of their pigments and other artists' materials, and above all their classification after 1892 of colors according to permanency set standards for art materials' suppliers that have been widely imitated in the twentieth century.

As sympathetic recognition of the importance of the permanent palette and of chemically stable papers to the art of watercolor becomes more widespread, and as the inherent fragility of earlier watercolor paintings and the practical means for their preservation become more generally known, the stuff of this art will become more secure. It is hoped that this essay, with its emphasis on the materials of watercolor, will not only foster anew an appreciation for the achievements of watercolor painters but will also inspire greater care for their paintings in the years to come.

All materials are from the Edward W. Forbes Collection of Artists' Materials, Fogg Art Museum, and all books are from the Fine Arts Library, Harvard University, unless otherwise indicated.

Watercolor paper

1. Strathmore (72 lb. Imperial, c. 1976), hot-pressed, cold-pressed, and rough.
2. Arches (240 lb. Imperial, c. 1976), hot-pressed, cold-pressed, and rough.
3. Milbourn (handmade Imperial, c. 1955). Courtesy Harold Hugo.
4. Whatman (mould-made 240 lb. Antiquarian, 1961), cold-pressed. Courtesy Whatman Reeve Angel. Whatman (handmade 300 lb. Imperial, before 1955), rough. Courtesy John N. Balston.
5. Two French papers (*à la forme* and *papier de rom*), Harding, and Cattermole, samples in Armand Théophile Cassagne, *Traité d'Aquarelle* (Paris, 1875). Loan, Library of the Boston Athenæum.
6. Canson et Montgolfier – Lavis A, in J. Bordier, *L'Aquarelle* (Paris, c. 1925), pl. 1, page paper.

Brushes

1. Winslow Homer's brushes (two brown sable, Large Swan full quills). Loan, The Homer Collection, Bowdoin College Museum of Art.
2. John Singer Sargent's brushes (ten assorted camel, sable, and badger brushes, all with metal ferrules except one wire-bound, quill "sky mop") and a scraper.
3. Pocket brush (plastic case with screw top, mid-twentieth century).
4. "Brushes for Water Colour Painting," reproduced in J. Barnard & Son, *Price Catalogue of Materials . . .* , pp. 16–17, bound in Walter Tomlinson, *The Art of Landscape Painting in Oil Colours* (London, 1871).

Artists' Paraphernalia

1. Winsor & Newton Co. "Caddy Lid" watercolor box (late nineteenth century). Loan, Winsor & Newton Co.
2. "The 'Presto' Straining Board" and "Mahogany Pinned Drawing Boards" for stretching watercolor paper, reproduced in George Rowney & Co., Ltd., *Catalogue* (London, 1926), pp. 180–181.

Pigments

Pigments are itemized in this Appendix only when they represent as a group a selected palette. All are hand-washed samples, identified by the author of the publication in which they appear. French names of pigments have not been translated, because of the historical confusion in the use of outdated pigment names for new substances and because there is no certain exact translation of many of the names, without analyzing the samples.

1.
Blanc léger, Jaune de Naples, Jaune mineral, Gomme gutte,

Jaune d'Or, Jaune Indien, Pierre de fiel, Jaune de Mars, Terre de Sienne, Ocre jaune, Minium, Vermillon, Carmin, Carmin de Garance, Laque, Ocre rouge, Rouge de Mars, Précipité d'Or, Cendre bleu, Bleu de cobalt, Bleu d'Anvers, Bleu de Prusse, Indigo, Cendre verte, Vert de cobalt, Vert de Vessie, Vert de Prusse, Ocre brun, Terre de Sienne brulée, Brun de Vendick, Bistre, Sepia, Encre de Chine, Noir d'ivoire, Tente neutre, Carmin et Gomme gutte, Gomme gutte et Bleu de Prusse (more yellow), Gomme gutte et Bleu de Prusse (more blue), Bleu de Prusse et Carmin, Indigo et Gomme gutte, in A.-M. Perrot, *Manuel du Coloriste* (Paris, 1834), pl. II.

2.
Lemon yellow (Platina), Orange vermilion, Madder lake, Ultramarine, Chrome green, Citrine lake (from quercitron bark), Madder brown, Olive lake (from green ebony), in George Field, *Chromatography* (London, 1835), pl. I, fig. 3 (frontispiece), their pigments identified in the text, *passim*.

3.
Naples yellow, Roman ochre, Yellow ochre, Light red, Madder brown, Burnt umber, Burnt Sienna, Sepia, Cobalt blue, Indigo, Cool green (watercolor washes on etched plates on Whatman paper), in Giles Firman Phillips, *A Practical Treatise on Drawing, and on Painting in Watercolours* (London, 1839), frontispiece (pl. XX) and title page (pl. XIX), their pigments identified on pp. 47–48.

4.
Lemon yellow, Gamboge, Indian yellow, Cadmium, Yellow ochre, Raw Sienna, Orange chrome, Mars orange, Burnt Sienna, Light red, Vermilion, Rose madder, Crimson lake, Venetian red, Indian red, Purple madder, Brown madder, Vandyke brown, Brown pink, Sepia, Payne's gray, Ivory black, Indigo, French blue, Cobalt (each washed in pale and dark intensities, the dark varnished with gum), in George Barnard, *The Theory and Practice of Landscape Painting in Watercolours* (London, 1858), pl. IV.

5.
Nineteen dry pigments, their suppliers' names indicated in parentheses, arranged according to the moist-color palette recommended in George Barnard, *The Theory and Practice of Landscape Painting in Watercolours* (London, 1858), p. 49.

Gamboge (Newman)
Yellow ochre (Newman)
Burnt Sienna (Winsor & Newton)
Vermilion (Weber)
Crimson lake (Ansbacher Seigle)
Purple madder (Madderton)
Vandyke brown (Winsor & Newton)
Brown pink (Weber)
Ivory black (Rowney)
French blue (Winsor & Newton)
Indian yellow (Rowney)
Raw Sienna (Roberson)
Light red (Weber)
Rose madder (Weber)
Indian red (Winsor & Newton)
Brown madder (Newman)
Sepia (Weber)
[Payne's gray, a mixed tint, is omitted]
Indigo (Newman)
Cobalt blue (Winsor & Newton)

6.
John Singer Sargent's moist colors in tubes, their suppliers' names indicated in parentheses, arranged in an approximation of Barnard's moist-color palette (see above).

Gamboge (Weber)
Chrome yellow (Newman)
Burnt Sienna (Newman)
Scarlet vermilion (Winsor & Newton)
Deep vermilion (Hatfield)
Vandyke brown (Newman)
Ultramarine (Schmincke)
Cadmium yellow pale (Newman)
Cadmium yellow no. 2 (Newman)
Rose madder (Winsor & Newton)
Alizarine crimson (Newman)
Viridian (Winsor & Newton)
Brown pink (Newman)
Cobalt blue (Newman)
Lamp black (Winsor & Newton)

7.

Winslow Homer's twenty-pan moist-color box (Winsor & Newton), the same in form and size as that recommended by George Barnard (see above), although the arrangement is Homer's. One pan is missing; one pan is empty. See Appendix B for a further discussion of the orientation of the colors in the box and for pigment identifications, where known. Loan, The Winslow Homer Collection, Bowdoin College Museum of Art.

8.

Seventy-two identified Winsor & Newton Co. wash samples on Whatman paper, c. 1887, in J. Scott Taylor, *A Descriptive*

Handbook of Modern Water Colours (London, 1887), and two other copies, c. 1887–1893, of Winsor & Newton Co. watercolor handbooks.

9.

Bleu de Prusse, Outremer, Cobalt, Jaune Indien, Ochre jaune, Cadmium clair, Garance, Vermillon, Sienne brun, Sepia, Brun Van Dyke, Noir d'ivoire, and forty-five mixtures, in J. Bordier, *L'Aquarelle* (Paris, c. 1925), pl. 1.

10.

Eighty-four identified Winsor & Newton Co. wash samples, c. 1975, with indications of permanency, in *Winsor & Newton Artists' Water Colours, Sample Sheet No. 51* (London, c. 1975).

Pigment Analysis Appendix B

by R. Craigen Weston

The nature of the watercolor technique is such that less pigment is usually deposited on the support than in the oil-color technique. Therefore, taking a sample from a watercolor painting is a delicate problem—one does not want to remove much pigment from an area where there is only a small amount in all. Thus, in undertaking analysis of the chemical elements of watercolor pigments it is extremely important to choose a method of analysis (Walter C. McCrone and John Gustav Delly, *The Particle Atlas*, 2nd ed. [Ann Arbor, Michigan: Ann Arbor Science Publishers, Inc., 1973] I, 119–199) which is effective with a minimum of sample—the size, in layman's terms, of a speck of dust (approximately 10 micrometers). It is also desirable that the analytical technique be nondestructive, as there would be no extra sample for retesting, if the need should arise.

The obvious approach is the use of the microscope. The problem that immediately arises is the size of the individual pigment particles. Many, especially those that were machine-ground, are too small to be identified under even the best polarizing microscope operated by the most experienced microscopist, so other systems for examination are necessary. To the restrictions imposed by the size and value of the samples was added in this particular project the factor of accessibility, in choosing another analytical technique. The scanning electron microscope (SEM) with an energy dispersive X-ray analyzer attachment answered our requirements. Two machines were used: an Advanced Metals Research, Inc., Model 900 SEM with a microprobe attachment, which is owned by the Department of Engineering and Applied Physics and housed in the Gordon McKay Laboratories at Harvard University; and a Cambridge Instrument Co., Ltd., SEM with an Ortec energy dispersive X-ray detector, which is operated by the electron optics group in the Department of Materials Science and Engineering at the Massachusetts Institute of Technology.

All the samples were taken with a tungsten needle or a very

sharp scalpel under low magnification (10×–30×). In most cases they were stored in cupped glass slides before mounting for analysis. For examination under the polarizing microscope, the most minute sample that was still manageable—a factor that depended upon the amount of binder present in the pigment area and its brittleness—was mounted in Aroclor 5442 between a glass slide and a cover glass. Preparation for the SEM with a microprobe attachment involved mounting the sample on an aluminum stud using silver paint as the conductive adhesive and then coating the unit with graphite. The magnification of the pigment samples in the SEM always fell in the range of 2000×–8000×, and usually was about 4000×.

Table I summarizes the results of the analyses of fifteen samples. All were also examined under the polarizing microscope, and the data from those observations were taken into consideration, though they do not appear in the table with the SEM data. The first column lists the artist, title, and catalogue number of the work that was sampled. Columns two and three give the colors of the pigments that were sampled as they appear on the paintings and the areas from which the samples were taken. In the column entitled "elements detected," those elements which are listed first are the ones whose intensities were greatest, and therefore form the pigment compound; minor elements appear in parentheses. In many of the samples aluminum (Al) and silver (Ag) are evident—they are due almost entirely to the aluminim stud and silver paint. Other elements such as calcium (Ca), iron (Fe), magnesium (Mg), and silicon (Si) are common impurities in pigment samples, and, unless they appeared as strong peaks, they have been disregarded. It was impossible to determine whether stray paper fibers or sizing on the fibers caused significant interference, but it is probable that neither was a factor. Two pigment samples were run in the emission spectrograph for experimental purposes—the data are included in Table 1 and are marked with an asterisk.

The second phase of the analysis was the study of Winsor & Newton moist watercolors in pans which once belonged to Winslow Homer and are now in the Homer Collection of the Bowdoin College Museum of Art, which has kindly made them available for analysis. Because relatively large amounts of pigment were available, emission spectrography, which is a destructive technique but which yields explicit data with samples somewhat larger than those required by the SEM—the size of a pinhead (about .10 milligrams)—was used instead of the latter instrument. Again, all samples were examined under the polarizing microscope. The samples were inserted into graphite electrodes and vaporized in the emission spectrograph. The particular instrument used was the Applied Research Laboratories Spectrographic Analyzer located in the Center for Conservation and Technical Studies in the Fogg Art Museum at Harvard University.

Although every effort was made to obtain pure samples, the pans of color were so contaminated by dust and other pigments that the analysis showed many trace elements. Again, only the major elements were considered actually to be part of the specific pigment compound. Table 2 lists the data obtained. In the "sample" column, "R" refers to the right side of the watercolor box, and "L" to the left; and the samples read 1 to 10 from the top to the bottom of the box. Homer's color notes on the adjacent palette establish the orientation. "Color" refers to the naked-eye color of relatively pure sample. A column giving the color as seen through the microscope is included because occasionally it differs drastically from the naked-eye color. The last two columns are arranged as in Table 1, giving the elements and possible compound(s). Note that there are many questionable identifications as well as colors which have not been identified at all—analysis will eventually include the use of the X-ray diffraction technique: at present it is not complete.

KEY TO TABLE 1:
* Data from analysis by emission spectograph; see Appendix B introduction.
† The question mark indicates that the presence of the element is suggested but not confirmed by the data.

TABLE 1

ARTIST AND WORK	COLOR	LOCATION OF SAMPLE	ELEMENTS DETECTED	PROBABLE COMPOUND, PIGMENT NAME
Demuth, *Fruit and Sunflowers* (16)	bright blue	upper right	Co, Hg, K, S, Si (Ag, Al, Ca, Fe)	Silicate (glass) and HgS, Smalt and Vermilion
Demuth, *Fruit and Sunflowers* (16)	red	fruit, lower center	Hg, S (Ag, Al, Ca, Co, K)	HgS, Vermilion
Demuth, *Fruit and Sunflowers* (16)	yellow-orange	upper left	Cd, Hg, S (Al)	CdS and HgS, Cadmium yellow and Vermilion
Géricault, *English Horse Guard* (19)	white	left of horse's left leg	*Zn	ZnO, Chinese white
Hassam, *White Mountains, Poland Springs* (21)	green	lower right corner	As, Cu, Mg (Ca, Fe, S and/or Hg?†)	$Cu(C_2H_3O_2)_2 \cdot 3Cu(AsO_2)_2$, Emerald green
Homer, *Key West* (24)	red	boot topping, center boat	Hg, S (Ag)	HgS, Vermilion
Homer, *Hunter in the Adirondacks* (23)	yellow	middle, left edge	Cd, Hg, S (Al, Co, Si) *Cd (Fe)	CdS, Cadmium yellow
La Farge, *Chinese Pi-Tong* (33)	yellow, brown cast	streak, lower left	Co, K (Fe, Pb, Zn)	$CoK_3(NO_2)_6 \cdot H_2O$, Cobalt yellow (Aureolin)
Lami, *Duke and Duchess of Brabant* (35)	red	chair back	Hg, S (Ag, Ca, Co, Zn)	HgS, Vermilion
Gustave Moreau, *The Sirens* (44)	green	lower right	As, Cu, Mg (Ca, Cr, Fe, K, S and/or Hg?†)	$Cu(C_2H_3O_2)_2 \cdot 3Cu(AsO_2)_2$, Emerald green (possibly mixed with Prussian blue)
Louis-Gabriel Moreau, *Parc de Saint-Cloud* (45)	red	woman's dress	Pb (Ag, Fe, Si)	Pb_3O_4, Red lead
Louis-Gabriel Moreau, *Parc de Saint-Cloud* (45)	white	fountain spout	Pb	$2PbCO_3 \cdot Pb(OH)_2$, White lead
Louis-Gabriel Moreau, *Parc de Saint-Cloud* (45)	yellow	brushes at right	Pb, Sb (Ag, Al, Ca? Sr?†)	$Pb_3(SbO_4)_2$, Naples yellow
Natoire, *Mythological Scene: Bacchanale* (46)	white	drapery between legs of reclining woman in foreground	Pb (Ag, Al, Ca, Cu, Si)	$2PbCO_3 \cdot Pb(OH)_2$, White lead
Rowlandson, *Mail Coach Going Uphill* (52)	red	head of seated woman in lower left corner	Hg, S (Ag, Fe)	HgS, Vermilion

TABLE 2

SAMPLE	COLOR	COLOR (MICROSCOPE)	ELEMENTS DETECTED	PROBABLE COMPOUND, PIGMENT NAME
R1	brown	red-brown	Fe (Al, Ca, Be, Mg, Si)	earth pigment, possibly Sienna
R2	gray-blue-green	blue, yellow, purple	Al, Fe, Si (Ca, Mg, Na, Ti)	composite of several pigments
R3	blue with green cast	blue with green cast	(Al, Ca, Fe, Pb)	—
R4	yellow	yellow	(Ca, Fe, Mg, Si)	organic, possibly Indian yellow or Gamboge
R5	green	blue with green cast	Ca, Fe (Al, Mg, Si)	—
R6	black	brown-black	Ca, Mg, P (Hg?)	$Ca_3(PO_4)_2$ + carbon, Bone black
R7	orange	orange	Hg (Ca, Fe, Mg, Sn)	HgS, Vermilion
R8	orange	orange	Hg (Ca, Fe, Mg, Si, Sn)	HgS, Vermilion
R9	orange-rust	red-brown	Ca, Fe, Si (Al, Be, Mg, Mn)	earth pigment, possibly Burnt Sienna
R10	yellow-orange	yellow	Cd (Al, Ca, Fe, Mg, Si)	CdS, Cadmium yellow or Cadmium orange
L1	brown	red-brown	Fe, Mg (Al, Be, Ca, Si)	earth pigment, possibly Raw umber
L2	brown	brown	(Mg)	—
L3	dark blue with violet cast	dark blue	(Al, Ca, Fe, Mg)	—
L4	light green	blue with green cast, brown	(Mg, Si)	—
L5	red	cool red on glassy particles	Ca (Al, Fe, Mg, Si)	organic red on Ca compound base
L6	rust	brown-black	Ca, Si (Al, Mg, Mn)	earth pigment
L7	orange-yellow	orange	Cr, Pb (Ca, Fe, Mg)	$PbCrO_4$, Chrome yellow
L8	orange-red	red-rust	Hg, Mg (Ca, Si)	HgS, Vermilion
L9	brown	brown	Ca, Mg, Si (Al, Cu, Fe)	earth pigment, possibly Van Dyke brown

WATERCOLOR

1. William Stevenson Smith, *Interconnections in the Ancient Near East* (New Haven: Yale University Press, 1965), p. 77.

2. Barbara Haskell, *Arthur Dove* (Boston: New York Graphic Society, 1974), p. 77.

3. Frank Jewett Mather, Jr., *Charles Herbert Moore, Landscape Painter* (Princeton: Princeton University Press, 1957), p. 48.

4. Charles Herbert Moore, "The Fogg Art Museum of Harvard University," *New England Magazine*, August 1905, p. 703.

5. Lloyd Goodrich, *Winslow Homer* (New York: MacMillan, 1944), p. 127.

6. Norton as described by Santayana: "He loved refined English life. He spoke rarified English. He loved Turner and Ruskin. His personal friends were Burne-Jones and Matthew Arnold" (George Santayana, *The Middle Years* [New York: Scribner's, 1945], p. 163).

TECHNICAL PERSPECTIVE

1. Grace Barton Allen, *Watercolor Painting*, p. 2. Here and throughout these notes only the best example among several manuals will be cited for a particular point. Amateurs' manuals changed over the years with the development of the medium itself, as did the nature and status of amateurs. The subject is complex and lengthy enough to deserve a study in itself, which is, unfortunately, outside the scope of this publication. The interested reader should consult Martin Hardie, *Water-Colour Painting in Britain*, III, Appendices I and II, for a discussion of the changing definition of "amateur" and "professional" in watercolor art.

2. William Sanderson, *Graphice: The Use of the Pen and Pensil*, p. 66.

3. "Gouache" is used in this quotation and throughout this essay to refer to opaque color and/or color mixed with white pigment.

4. J.-G. Vibert, *La Science de la Peinture*, p. 248. L'aquarelle . . . est, en différentes proportions, un mélange des anciènnes peintures des missels avec la gouache et la lavis. Tous ces procédés de peinture, qui ont pour liquide l'eau et pour agglutinatif la gomme arabique, sont de la plus grande antiquité; mais l'aquarelle proprement dite, qui n'est qu'un lavis en couleurs et où le papier est reservé pour faire les lumières, ne remonte guère qu'au commencement de ce siècle. . . ."

5. Philippe Huisman, *French Watercolours of the 18th Century*, p. 84.

6. A. J. Finberg, *The Life of J. M. W. Turner, R.A.* (Oxford: Clarendon, 1939), p. 195.

7. d'Apligny, *Traité des Materielles*, p. 61. "Voilà tout ce qu'on peut dire sur un genre, qui n'est en usage que pour lever des plans, mais qui exige la science du dessin."

8. [Rudolph Ackermann], "Observations on the Rise and Progress of Painting in Watercolours," VIII, 258-259.

9. John Lewis Roget, *A History of the "Old Water-colour" Society*, I, 190-191.

10. [Carrington Bowles], *The Art of Painting in Water-Colours*, pp. 47-48. "*Ranunculusses.* There are a great variety of these Flowers; the Student will have a delightful Pastime in studying from Nature; and as his Eye will be agreeably entertained with a Diversity of Colours, so will he find himself improved by Painting from them. We should recommend him therefore to observe and peruse with Attention the Rules of Nature and the following: A fine Wash of Red Lead, striped with Carmine, finished with Carmine and Sap-Green mixed. . . ."

11. Roget, I, 175, n. 1. See p. 426 for the opinion of 1824, entirely in favor of watercolor *painting*.

12. The *Oxford English Dictionary* (1961 ed.) cites the use of "watercolour" as a pigment in the late sixteenth century and as an adjective in the late seventeenth century, but the word did not appear as a noun describing either a single picture or an art form until the nineteenth century.

13. The royal appointment is cited in manuals published by Winsor & Newton Co. in 1853 but not in those of 1851.

14. Barbara S. Shapiro, *Camille Pissarro: The Impressionist Printmaker* (Boston: Museum of Fine Arts, 1973) n.p. [p. 1 of Introduction]; John Rewald, ed., *Camille Pissarro; Letters to His Son Lucien* (New York: Pantheon, 1943), p. 39.

15. Friedrich Jaennicke, *Handbúch der Aquarellmalerei*, p. 186.

16. Horace J. Rollin, *Studio, Field, and Gallery*, p. 69.

17. See Armand Théophile Cassagne, *Traité d'Aquarelle*, pp. 1-11, for a particularly expressive example of the foreign attitude toward English products.

18. Rosamund D. Harley, *Artists' Pigments c. 1600-1835*, p. 167. *Saint Catherine* (18) and *Fidelia and Speranza* (63) are touched with white that has darkened. Both the Moreau *l'âiné* (45) and the Natoire (46) have yielded positive tests for Lead white, but the pigment has not discolored in either case.

19. George Field, *Rudiments of the Painter's Art*, pp. 20-21.

20. Hardie, III, 38.

21. S. F. Constant-Viguier, *Manuel de Miniature et de Gouache*, p. 105.

22. Roget, II, 89-90.

23. J. B. Adams, President of Winsor & Newton Co., to Marjorie B. Cohn, November 16, 1976. The author would like to thank Mr. Adams for his willing cooperation in providing information concerning the firm of Winsor & Newton's history and processes.

24. Hardie, II, 26-43. In a continuation of the influence of watercolor technique noted in Turner's oil style, Pre-Raphaelite oil technique—specifically the brushes, touch, pigment density, and technical restrictions described by William Holman Hunt—duplicates in condensed form those given by mid-century English watercolor manual authors. See William Holman Hunt, *Pre-Raphaelites and the Pre-Raphaelite Brotherhood*, 2 vols. (New York: MacMillan, 1904), I, 276-277.

25. Georgiana Burne-Jones, *Memorials of Edward Burne-Jones*, 2 vols. (New York: MacMillan, 1904), II, 61-62.

26. Roget, I, 90. "Les artists qui se donnent tant de peine pour faire avec de l'eau ce qu'ils feraient aisément avec de l'huile, ressemblent à ces amants romanesques qui entrent par la cheminée quand la porte est ouverte à deux battants."

27. Hereward L. Cook, "Winslow Homer's Watercolor Technique," p. 180.

28. Rollin, p. 85.

· 29. Leslie Parris *et al.*, *Constable: Paintings, Watercolours, and Drawings* (London: Tate Gallery, 1976), p. 10.

30. Burne-Jones, II, 13. The more immediate cause of his resignation was a painting of a female nude that offended exhibition officials.

31. J. Hullah Brown, *Water-Colour Guidance for the Student, the Amateur, and the Occasional Colourist*, pp. 37-38.

32. Goodrich, p. 51.

33. Philip C. Beam, *Winslow Homer at Prout's Neck* (Boston: Little Brown, 1966), pp. 78, 100-101.

34. Homer's procedures were not novel. They were close to Turner's as reported in 1819, but they remain a significant harbinger of the new style. The description of Turner is worth repeating: "At Rome a sucking blade of the brush made the request of going out with pig Turner to colour—he grunted for answer that it would take up too much time to colour in the open air—he could make 15 or 16 pencil sketches to one coloured . . ." (Finberg, *Life of Turner*, p. 262). Note that "sucking" indicates the watercolorist's habit of pointing his brush with his lips.

35. Raymond Lister, *Infernal Methods: A Study of William Blake's Art Techniques* (London: Bell, 1975), p. 2.

36. Brown, p. 38.

37. See Note 10 of this section.

38. Brown, p. 39.

39. Hardie, III, 65.

40. Picasso's *Weeping Woman* has been catalogued as a watercolor ever since its accession in 1940, but in fact the pigment was so strongly absorbed into the paper that it must have been applied in a medium such as turpentine that was a much more satisfactory wetting agent than water on a hard-sized sheet. Also the reverse of the painting is heavily stained in the manner typical of oil paint on paper.

41. Brown, p. 2.

42. Colin Hayes, *The Technique of Water-Colour Painting* (London: Batsford, 1967), pp. 12-15.

43. Carl Chiarenza, "Terror and Pleasures: The Life and Work of Aaron Siskind" (Ph.D. diss., Harvard University, 1973), p. 202.

PAPER

1. Karol J. Mysels, *Introduction to Colloid Chemistry* (New York: Interscience Publishers, 1959), p. 103.

2. [Ackermann], IX, 92. Whatman sold his mill in 1794 jointly to William Balston, his employee of two decades, and to a Mr. Hollingsworth. Hollingsworth and Balston parted company in 1805 and worked independently, Balston marking his paper J WHATMAN and Hollingsworth marking his J WHATMAN TURKEY MILL, by mutual agreement. In 1859 Hollingsworth's mill abandoned handmade paper production, and the Balston firm obtained the rights to all Whatman watermarks. As their paper continued to be known in the trade and by artists as Whatman paper, this name will continue to be referred to throughout. The Balston mills, owned since 1974 by Whatman Reeve Angel and still active in the production of chemical filter papers, ceased production of handmade papers c. 1955 and production of mould-made watercolor papers in 1962.

I am indebted for much of the above information to John N. Balston, who has generously shared fruits of his ongoing research into the history of English watercolor papers; he is not, however, responsible for emphases or errors of omission or commission in this section on paper. More detailed information on the Whatman, Hollingsworth, and Balston firms is given in Thomas Balston, *James Whatman, Father and Son* (London: Methuen, 1954), and Thomas Balston, *William Balston, Papermaker 1759-1849* (London: Methuen, 1957).

3. Dard Hunter, *Papermaking*, pp. 125, 128. In fact, Whatman's invention was apparently made before 1757, when the first book was printed on wove paper. Watercolor paper was developed over the next several decades; in England it has traditionally been called drawing paper, and it has been used, of course, for pen and pencil drawings as well as watercolors. Most of J. A. D. Ingres's early pencil portraits and landscape drawings are on Whatman paper, which was available to him even in Italy during the Napoleonic blockade.

4. Roget, I, 25.

5. Aaron Penley, *A System of Water-Colour Painting*, 3rd ed., p. 6.

6. Cassagne, p. 55.

7. One can determine the number of washes in a given area by a careful examination of its edges—or at least decide whether the area was washed more than once.

8. John Ruskin, *The Elements of Drawing*, p. 206, n. 1.

9. Ernst A. Hauser and J. Edward Lynn, *Experiments in Colloid Chemistry* (New York: McGraw-Hill, 1940), pp. 45-46: "Each liquid atom, ion, and molecule exerts attraction and repulsion on every other. . . . In the bulk of the liquid these forces are

everywhere balanced in all directions. . . . the surface atoms, ions, and molecules are attracted strongly toward the interior. . . . This causes the liquid to tend to assume a spherical shape. . . ."

10. Clarence William Day, *The Art of Miniature Painting*, p. 52.

11. Thomas John Gullick and John Timbs, *Painting Popularly Explained*, p. 106.

12. Constant-Viguier, p. 46.

13. Jules Adeline, *La Peinture à l'Eau: Aquarelle, Lavis, Gouache, Miniature*, p. 5.

14. [Ackermann], IX, 92.

15. L. A. Doust, *A Manual on Watercolour Drawing*, p. 12; Wendon Blake, *Acrylic Watercolor Painting*, p. 39.

16. [Ackermann], IX, 92.

17. Gerald Wilkinson, *Turner's Early Sketchbooks* (London: Barry & Jenkins, 1972), p. 70. *Simplon Pass* (62) bears no watermark, but it appears to have been painted on Whatman "Not." See the following note.

18. Watermarks are impressions made in the paper by various means. They are intended to identify the sheet's size, maker, etc. Watercolorists were cautioned to place their sheets right side up, as the watermark's impression, which might disturb the even flow of the wash, is more perceptible on the reverse (screen) side of the paper than on the front, if it can be felt at all. Watercolorists were advised to paint so that the watermark would fall at the edge of the paper or to cut the mark off entirely, which was often incidentally achieved in removing a stretched sheet from its mounting. It is not surprising that most of the sheets in this exhibition do not bear watermarks; the Demuth and Pissarro watermarks are at the very edges of their sheets. Interestingly, watermarks, which in the eighteenth century and before were usually located near the midline of sheets, were moved toward the edges in the nineteenth century, perhaps in response to suggestions from artists (George Barnard, *The Theory and Practice of Landscape Painting in Watercolours*, p. 40). The only grossly visible watermark in this exhibition is found on Cross's sketchbook (14), where the folding of the signature to form the pages prohibited

an observance of the right-side/wrong-side convention.

19. Cassagne, p. 29.

20. de la Roca y Delgado, Mariano, *Compilación de Todas las Prácticas de la Pintura*, p. 199.

21. Cassagne, p. 29.

22. Whatman paper was very expensive, and many artists appreciated the opportunity to purchase seconds, called "retrieve" or "retree," a corruption of the French *retrait* meaning shrinkage or withdrawal (E. G. Lutz, *Practical Water-Color Sketching*, p. 92). Flaws included breaks in the sizing, which could be corrected by resizing or burnishing. Seconds comprised ten to twenty percent of a mill's handmade paper production, too valuable to discard (Hunter, p. 45). See also Note 31 of this section.

23. Alfred W. Rich, *Water Colour Painting*, p. 17.

24. Thomas Rowbotham, *The Art of Landscape Painting in Water-Colours*, pp. 18–19.

25. A. DD. Chirac, *Traité Complet de Peinture à l'Aquarelle*, p. 27.

26. *Ibid.*; Constant-Viguier, p. 164; F. P. Langlois de Longueville, *Manuel du Lavis*, p. 243; A.-M. Perrot, *Manuel du Coloriste*, p. 191.

27. Vibert, pp. 250–251. The author goes on to recommend that until artists can own papermills, they had best take their watercolors to the store and try the sheets on the spot, without specifying who would pay for the wasted paper.

28. Roget, II, 155. The paper on Cox's *Moorland* (13) fits the traditional description very well. Note that the wash did not penetrate the grain of the hard-sized, rough paper.

29. Roget, II, 64.

30. Adeline, pp. 10–11.

31. *Ibid.*, p. 11. Antiquarian was produced with the griffin trademark after 1859. A Whatman Antiquarian had been made since 1773, but the Griffin sheet was a special production of 340 lb. weight, compared to the usual 240 lb. John N. Balston estimates from a study of company records that for every seven reams of first-class Griffin Antiquarian paper, Balston would have had to manufacture almost twenty reams. In 1866 Winsor & Newton Co.

described the standards of Griffin Antiquarian manufacture: "The *purest linen rags* have alone been used: *no chemical bleach* whatever has been employed: *no surface scraping* has been permitted [therefore the sizing was intact on both sides of the paper]. . . . Every attention has been paid to the suggestions kindly made from time to time by eminent Artists. Each succeeding batch of Paper may consequently be considered an improvement on the preceding one, and a step nearer the realization of that most desirable consummation, A PERFECT SHEET OF WATER COLOUR DRAWING PAPER" (Winsor & Newton Co. catalogue, p. 24, bound in Aaron Penley, *The Elements of Perspective* [London, 1866]). The price—7s per sheet in 1866—may be compared to the prices of ordinary Whatman Antiquarian, 4s per sheet, and of Whatman Imperial, 5d per sheet (*ibid.*, p. 23).

32. John Chase, *A Practical Treatise on Landscape Painting*, p. 15.

33. *Ibid.*

34. Romilly Fedden, *Modern Water-Colour*, p. 92.

35. *Ibid.*, pp. 92–93.

36. Hardie, III, 138.

37. *Ibid.*

38. William J. Barrow, *Permanence/Durability of the Book – V. Strength and Other Characteristics of Book Papers 1800–1899* (Richmond, Va.: W. J. Barrow Research Laboratory, 1967), p. 15. Later paper made from wood pulp was beyond the traditional watercolorist's pale. It has all the defects attributed to cotton and has never been considered a permanent substance.

39. Francis Russell Flint, *Water-colour for Beginners* (London: The Studio Publications, 1951), pp. 12–13. The intrinsic qualities of cotton and linen may not be so crucial as the source of the fibers from which watercolor paper is made. The handling characteristics of paper made from cotton rags may be quite different from those of paper made from cotton linters, the fuzz left on cotton seed after the gin has removed fibers usable for thread. In any case, there certainly existed the belief through the nineteenth century and into the twentieth that linen

fiber was superior to cotton in watercolor paper, which probably reflected the greater care taken in the production of linen-fibered paper, always a more expensive sheet.

40. Hayle Mill's production of handmade watercolor papers, interrupted in 1970, was resumed in 1975 with the production of "Cotman-handmade," a cotton-fiber sheet watermarked with its date of manufacture and the Barcham Green monogram. Recently approved by the Royal Society of Painters in Water-Colour, its marks were changed on January 1, 1977, to include a crown and the mark "RWS handmade."

The author would like to thank Simon B. Green for the above information and would like to offer a personal testimonial to the handmade papers such as those still made by Barcham Green & Co., the last survivors of a tradition of great craftsmanship. Barcham Green & Co. watercolor paper is available in the United States through Andrew/Nelson/Whitehead, 30-10 48th Ave., Long Island City, N.Y. 11101.

41. Roget, I, 91, n. 3.

42. Winsor & Newton Co. catalogue, p. 37, bound in Aaron Penley, *A System of Watercolour Painting*, 39th ed.

43. Francis Nicholson, *The Practice of Drawing and Painting from Nature in Watercolours*, p. 53.

44. Barrow, p. 14.

45. George Field, *Chromatography*, p. 215.

46. Barrow, p. 16.

47. [Bowles], pp. 19, 54, 55.

48. Adeline, p. 2.

49. *Ibid.*, pp. 17–18.

50. *Ibid.*, p. 18.

51. Arthur H. Church, *The Chemistry of Paints and Painting*, p. 14.

52. "Relatively" is stressed, as the author realizes the danger of even small amounts of acidity to paper. However, the generally excellent condition of pre-twentieth-century watercolors that were painted on handmade sheets and have since enjoyed a favorable environment, combined with the nearly universal recommendation of the use of alum, would lead to the reasonable conclusion that in such works

alum in its pure form (and in small amounts) is not necessarily destructive.

53. Barrow, p. 17. Presumably alum's traditional status as a valued papermaker's chemical masked its destructiveness in its new use for some years. Any degradation of newly made papers would naturally be ascribed to chlorine, the new and therefore more mysterious and suspect chemical.

54. Marie Elisabeth Cavé, *Color: The Cavé Method of Drawing*, p. 15.

55. Adeline, p. 11.

56. *Ibid.*

57. A condensed listing of recommended papers includes: Arches, Canson, Johannot, Lavis Fidelis (France); Arnold, Crisbrook, Hayle Mill, Milbourn (England); Fabriano (Italy); Strathmore (United States). In 1918 the following papers were recommended in order of increasing difficulty, with the first two suitable for beginners: thin Whatman, Arnold, Allenjè, Michallet, David Cox, Creswick, Varley, Cartridge, Van Gelder, white Canson, Burlington (Rich, pp. 17–18).

58. "The Failure of Our Watercolour Tradition," *The Burlington Magazine*, VII (1905), 112.

59. Hume Nisbet, *On Painting in Water Colours*, p. 89.

60. Machine-made paper commonly has a "better" and a "worse" side, with the better side presenting a texture deliberately imposed by rollers and the worse side retaining the more-or-less mechanical impress of the woven belt of screening that sieved the fibers from the paperpulp slurry.

PAPER PREPARATION

1. James Steuart, *Sketching in Water-Colours*, pp. 14–15 (recommending 200–300 lb. paper); Adolf Dehn, *Water Color Painting*, p. 8 (recommending 300–400 lb. paper). The thickness of paper is measured by the weight of a ream (500 sheets; in England often 480 sheets) in its standard size, which in watercolor paper is usually 22 by 30 inches, the so-called Imperial paper.

2. E. H. & A. C. Friedrichs Co., *Fredrix's Catalogue*, p. 183.

3. Oswald Garside, *Landscape Painting in Water-Colour*, p. 13.

4. Cavé, p. 17.

5. Dehn, p. 46.

6. Nicholson, p. 54.

7. Adeline, p. 19.

8. The sheet was not to be shiny with moisture, but it should be limp enough so that a corner folded over would not spring back. The artist could incorporate sizing (either gelatin, alum, or starch) into the water used for dampening his sheet. Often, however, it was stipulated that the artist should moisten it with pure water only, by sponging the reverse side, to avoid disturbing the original sizing of the sheet.

9. Nisbet, p. 30. The drawing board could be faced with ordinary paper as a protective lining for the watercolor paper.

10. Perrot, p. 18.

11. Adeline, p. 19.

12. Dehn, pp. 7–8.

13. Blake, p. 32.

14. Hardie, II, 105.

15. Mary Philadelphia Merrifield, *The Art of Portrait Painting in Water-colours*, pp. 11–12.

16. J. Barnard & Son catalogue, p. 15, bound in Chase.

17. Winsor & Newton Co. catalogue, p. 54, bound in Rowbotham.

18. Cassagne, p. 42.

19. Turner's *Simplon Pass* (61), very large and freely washed, was painted on a thin sheet of paper which must have been stretched on a board and painted, one presumes, in the manner described by an admiring eyewitness in Turner's studio: "There were four drawing-boards, each of which had a handle screwed on the back. Turner, after sketching his subject in a fluent manner, grasped the handle and plunged the whole drawing into a pail of water by his side. Then, quickly, he washed in the principal hues . . . flowing tint into tint, until this stage of the work was complete. . . . By the time the fourth drawing was laid in, the first would be ready for the

finishing touches . . ." (R. P. Leitch, quoted by Walter Shaw Sparrow in "The Later Water Colours," *The Studio*, Winter 1903, pp. w vii – w viii).

20. Brown, p. 53.

21. Cassagne, p. 44.

22. Ralph Mayer, *The Artist's Handbook*, p. 249. Many of the conservation problems of watercolors derive from adhesive residues that may be difficult to remove without jeopardizing the painting.

23. Chirac, p. 30.

24. Steuart, p. 14.

25. Rich, p. 19.

26. Nicholson, pp. 73–74.

UNDERDRAWING

1. Graphite, a natural form of pure carbon, is the black pigment used in the so-called lead pencil. Because of the traditional use of "pencil" to describe watercolor brushes (see the following discussion of brushes), "graphite" is here used to describe the pencil or the pencil's mark wherever possible.

2. Constant-Viguier, pp. 66–67.

3. Arnold Blanch, *Methods and Techniques for Gouache Painting*, p. 48.

4. Hardie, I, 206.

5. *Ibid.*, III, 234.

6. Harley, p. 146.

7. John Gadsby Chapman, *The American Drawing Book*, p. 32.

8. Until recently, the graphite pencil, as well as the quill pen, was sharpened with a penknife. Early nineteenth-century watercolorists soon pressed their penknives into service to scratch out white highlights.

9. Chapman, p. 32.

10. Constant-Viguier, p. 165.

11. J. Bordier, *L'Aquarelle*, pp. 12, 52.

12. Charcoal may be made by slowly charring animal matter such as ivory or bone, but the term usually refers to woody vegetable matter such as willow twigs, roasted slowly in the absence of air to carbonize them.

13. J[ohn] B[ate], *The Mysteryes of Nature and Art*, p. 104.

14. Nisbet, pp. 36–37.

15. In fact, the color is adsorbed onto the surface of the charcoal particles.

16. Church, p. 244.

17. Fedden, p. 97; Flint, p. 30.

18. Langlois, p. 229.

19. Barnard, p. 76.

20. Bread has been a commonly used eraser. Winslow Homer was nicknamed "The Obtuse Bard," in an obscure pun that referred to erasing with bread, when he joined an artists' club whose members were known by pseudonyms (Goodrich, p. 51).

21. Barnard, p. 76.

22. Adeline, p. 25.

23. F. J. Delamotte, *The Artist's Assistant*, p. 52.

24. B[ate], p. 104.

25. Lutz, pp. 179–180.

26. Barnard, p. 77: ". . . without this the paper appears opaque and cold."

27. Cassagne, p. 29.

28. Field, *Chromatography*, p. 182.

29. Maria Turner, *The Young Ladies' Assistant in Drawing and Painting*, p. 12. This homey adaptation of the adhesive properties of casein is not suitable for stretched or mounted watercolor paper.

30. Russell O. Woody, *Painting with Synthetic Media*, p. 52.

31. David Cox, *A Treatise on Landscape Painting in Watercolours*, p. 13.

BRUSHES

1. The usage of "pencil" to denote a pointed brush seems to have become obsolete around 1900, perhaps after watercolor artists working in the oil manner had accustomed themselves and succeeding generations to painting with blunt-tipped brushes.

2. Rewald, pp. 169–170.

3. Sanderson, p. 58. The old custom of testing a brush before purchasing it by pointing it with the lips is one example among many of traditional practices that were modified by nineteenth-century English manual writers, perhaps to protect the delicate sensibilities of the Victorian women who comprised a large proportion of their readership. Readers were assured that the colorman would provide a glass of water for testing brushes. Earlier or Continental manuals' instructions also included recommendations for licking smooth the priming for a portrait miniature, using "mouth glue," testing sizing with the tongue, and painting watercolor on the hand and flexing it to test the binder's strength.

Watercolorists also pointed their brushes with their lips while painting, and so the question of poisonous pigments was important to them. Early manual writers typically discounted the hazard with the obvious exception of pigments made from arsenic (Realgar, Orpiment, etc.). It was even noted that watercolors "do not taste badly" (C[laude] B[outet], *Traité de Mignature*, p. 23), not surprising in that at the time they were often made with honey or candy sugar. Even in the nineteenth century some manual writers were not about to abandon a useful procedure for safety's sake: "one must not fear to slip [brushes] between the lips. They never contain so much color, even if it is the most harmful (such as orpiment or gamboge [?]), to make one apprehensive of dangerous properties, and as for mineral colors, the gum modifies their action greatly to prevent their attacking the tooth enamel" (Constant-Viguier, p. 42). But as new pigments were introduced, safety was considered a prime virtue (Harley, p. 66), and eventually manuals and color catalogues came to identify noxious pigments more carefully and warn against their careless use.

4. *The Painter, Gilder, and Varnisher's Companion . . .* (Philadelphia, 1875), p. 15.

5. Rutherford J. Gettens and George L. Stout, *Painting Materials*, p. 279.

6. Perrot, p. 11. This manual describes the traditional processes used in France to make quill brushes (pp. 8–11).

7. J. Barnard & Son catalogue, pp. 16, 4, bound in Walter Tomlinson, *The Art of Landscape Painting in Oil Colours* (London, c. 1871).

8. Winsor & Newton Co., *Winsor & Newton Artists Materials: 1975 Catalogue Price List*, pp. 19, 6.

9. Roget, II, 166.

10. Constant-Viguier, pp. 41–42.

11. *Ibid.*, p. 43.

12. Hilaire Hiler, *Notes on the Technique of Painting*, p. 258.

13. Rich, p. 27.

14. Constant-Viguier, pp. 42–43.

15. Hiler, p. 255.

16. Cassagne, p. 17.

17. *Ibid.*

18. Delamotte, p. 41.

19. Hiler, p. 255.

20. Adeline, pp. 54–55. Watercolorists were also recommended to use two separate water containers, one for wash and one for brush-washing, for analogous reasons. See figs. 4, 5, and 6 on the cover of this catalogue.

21. Cassagne, pp. 20–21.

22. Quoted in Joseph S. Trovato, *Charles Burchfield: Catalogue of Paintings in Public and Private Collections* (Utica: Munson-Proctor Institute, 1970), p. 37.

23. T. M. Rooke, "Note on Burne-Jones's Medium," in *Centenary Exhibition of Paintings and Drawings by Sir Edward Burne-Jones*, p. 8.

24. J. Barnard & Son catalogue, p. 17, bound in Tomlinson.

25. Constant-Viguier, p. 40.

26. Alexander Gilchrist, *Life of William Blake*, 2 vols. (London, 1863), II, 49. The second volume of this work, which contains Blake's own writings on art and technique, was compiled by Dante Gabriel Rossetti after Gilchrist's death.

27. Lister, p. 39.

28. Cassagne, pp. 21, 23.

29. Adeline, p. 56. The sponge in a crayon holder is here described as the equivalent of the palette knife in oil painting.

30. Dehn, pp. 46–47.

31. Separate touches reflecting the brush's actual shape (probably a sable "bright") describe the pine trees in Marin's *Mount Chocorua* (38).

32. Langlois, p. 247. There were extremes in everything at the height of the watercolor fashion. "Some artists . . . wishing to give to their watercolors a largeness and simplicity of touch, use brushes equiped with brushes more than a meter in length. . . . By this means one can judge immediately the effect of tones. . . . one must add that these long brushes can only be used for some works, landscapes, and notably those which, on a grand scale permit a certain liberty of handling" (Adeline, pp. 51–52).

33. Constant-Viguier, p. 43. The color of a transparent watercolor wash is practically invisible in the brush, and accidental contamination is a real possibility.

34. David McKibben, *Sargent's Boston* (Boston: Museum of Fine Arts, 1956), figs. 31, 41.

PIGMENTS

1. Walter Thornbury, *The Life of J. M. W. Turner, R.A.*, 2nd ed. (London, 1877), p. 85.

2. Hauser, p. xi.

3. Mayer, p. 350. "The tremendous extent of increase in surface produced by such minute subdivision is not always realized, but this magnification of surface area and the consequent predominance of surface phenomena is considered the chief element governing colloidal behavior."

4. Henry W. Levison to Marjorie B. Cohn, December 3, 1976.

5. "Regular" and "soft" differentiate the fineness of grind for oil-paint pigments and watercolor pigments respectively.

6. B[ate], p. 120.

7. Mayer, p. 80. Here and throughout pigments will be referred to by name only when the particular substance is under consideration. Colors (hues) will be described in general terms to avoid the confusion of using pigment names as descriptive adjectives (e.g., "the blue skies" rather than "the ultramarine skies"). This essay will not catalogue all the watercolorist's pigments and their constituents and history, as they have been discussed in several excellent publications, notably Field, *Chromatography*; Church; Winsor & Newton, *A Brief Account* (1938), and their current catalogue; Gettens; Harley; Levison.

8. R. P. Leitch, *A Course of Water-Colour Painting*, p. 7. Note that Hassam used Emerald green in the foreground of his *White Mountains* (21) specifically because the heavy pigment would settle into the pores of his paper.

9. Gilchrist, I, 69–70. "He ground and mixed his watercolours himself . . . with common carpenter's glue diluted. . . . Joseph, the sacred carpenter, had appeared in a vision and revealed *that* to him. . . ." In 1820 Nicholson urged the artist to prepare his own colors, to forestall adulteration, but he went unheard by watercolorists.

10. The granular texture of Natoire's eighteenth-century washes (46) may be compared to the smooth and limpid washes in Turner's (60, 61) and Ingres's (27, 28) paintings.

11. J. Barnard & Son catalogue, p. 3, bound in Tomlinson.

12. *Ibid.*, p. 2.

13. Adeline, pp. 31–32.

14. George Rowney & Co., Ltd., *Catalogue*, p. 7.

15. F. Weber Co., *Illustrated Catalogue Volume 500*, p. 5.

16. Mayer, p. 245.

17. Lutz, p. 114.

18. Nicholson, p. 53. The author was an advocate of hand-ground, homemade pigments.

19. Mayer, p. 106. Mayer also notes that in gouache, mixed grays containing carbon black may dry darker because the carbon, a very light pigment, will float above the heavier metallic white pigments.

20. Lutz, p. 43.

21. Homer would later adopt Prussian blue, a pigment with similar handling characteristics. See Cook for a discussion of Homer's palette.

22. Harley, pp. 127, 64.

23. They act as electrolytes which attract and precipitate colloidal particles of the opposite ionic charge.

24. Nicholson, pp. 46–47.

25. Church, p. 195: ". . . the presence of such saline matter is easily detected by mixing [Viridian] with water and noting if coagulation or curdling takes place."

26. H. Gautier, *L'Art de Laver*, pp. 66–67; Con-

stant-Viguier, pp. 38–39. Gautier comments that shells are apt to overturn when set out on a table; Constant-Viguier deplores the customary use of scallop shells in particular, as too much pigment would be wasted in the shell's grooves.

27. Marjorie J. Vold and Robert D. Vold, *Colloid Chemistry: The Science of Large Molecules, Small Particles, and Surfaces* (New York: Reinholt Publishing Corp., 1964), p. 17.

28. Rich, p. 22.

29. Perrot, p. 2.

30. [Bowles], p. 24. According to Ruskin, "The two best colourists of modern times, Turner and Rossetti [were] as slovenly in all their procedures as men can well be . . ." (Ruskin, *Elements of Drawing*, p. 200).

BINDER

1. Gilbert Richard Redgrave, *A History of Watercolour Painting in England*, p. 3.

2. Vibert, pp. 252–253.

3. Mayer, p. 319. "Gum senegal is harder and less easily dissolved than the more common grade called gum arabic, and it produces a water-color medium which has more balanced working qualities." On heating with sodium carbonate, gum senegal makes a greenish-yellow solution, gum arabic an amber solution. Powdered gum senegal may be adulterated with less costly gums, dextrin, or starch powders. Pure gum senegal is completely soluble in cold water (Maurice de Keghel, *Les Encres, les Cirages, les Colles et Leur Preparation*, 2nd ed. [Paris: J. B. Baillière et fils, 1927], p. 328).

4. Wilder D. Bancroft, *Applied Colloid Chemistry: General Theory* (New York: McGraw-Hill, 1926), p. 203.

5. Field, *Chromatography*, p. 197.

6. Hauser, pp. 166–167.

7. Mysels, p. 74, fig. 4-1. An apt sensory analogy to the heightened visual effect arising from the colloidal dispersion of pigments is provided by the homogenizing of cream: when the particle size of the fat globules is reduced by homogenization, the concentration is increased per unit volume. "Thus, the cream tastes richer" (Hauser, p. 12).

8. Field, *Chromatography*, p. 197.

9. Rich, pp. 36–37.

10. Modern pigments known by these names in fact contain combinations of more stable substances. The practice of retaining traditional names for new pigments of similar hue is common but confusing.

11. Constant-Viguier, p. 34.

12. B[outet], p. 19.

13. Adeline, pp. 179–181.

14. Vibert, p. 255.

15. de la Roca, p. 204.

16. Constant-Viguier, p. 34.

17. Reeves & Sons advertisement, n.p., bound in Nisbet, [p. 113], quoting the minutes of the Society, February 1, 1781.

18. [Ackermann], IX, 91.

19. Hauser, p. 95.

20. Mayer, p. 6. Mayer presents a thorough discussion of the balance of solubility required in paints.

WASHING

1. Sanderson, p. 77.

2. Huisman, p. 120.

3. Roget, II, 166.

4. de la Roca, p. 210.

5. *Ibid.*

6. Constant-Viguier, pp. 39–40.

7. Ruskin, *Elements of Drawing*, p. 33.

8. Leitch, p. 6.

9. *Ibid.*, p. 7.

10. Hiler, p. 226.

11. Blake, p. 91.

12. In the drawing of Turner at work reproduced in Finberg, *Life of Turner*, pl. 2, the artist is shown putting fine detail into his work rather than washing. He is steadying his brush with his little-fingertip, and the board is placed on a 45° angle.

13. Or vice versa. Two separate wash edges can be discerned, but they are so transparent that it is impossible to judge which was laid first.

14. Thomas Hatton, *Hints for Sketching in Water-Colours from Nature*, 2nd ed., p. 38.

15. Adeline, p. 69. The author cautions the artist: "It is absolutely imperative . . . that the paper not be scorched, for apart from the fact that this beginning of burning destroys the solidity of the working surface, it further betrays itself by reddish stains which might change the washes' tonality in a most unfortunate manner" (Adeline, p. 70).

16. Blake, p. 32.

17. N. E. Green, *Hints on Sketching from Nature, Part III.—Colour*, p. 35.

18. Ruskin, *Elements of Drawing*, p. 71.

19. Nicholson, p. 47.

20. Hatton, p. 37.

21. Ruskin, *Elements of Drawing*, p. 37.

22. Merrifield, p. 36.

23. Sanderson, p. 65.

24. Cox, pl. LXX.

25. Penley, p. 25.

26. Allen, pp. 3–4.

27. Blake, p. 32. Artists who maintained a sheet's wetness by dampening it from the back during work were warned to remoisten it uniformly. Because washes with binder would be absorbed into the wet paper rather than remaining to dry on the surface, the paper's sizing having been softened by preliminary wetting, the colors would dry lighter in moistened areas. The pigments would have lost the binder's aid in causing them to bear out. See Nicholson, p. 55.

28. Garside, p. 33.

29. Lutz, p. 190.

30. Ruskin, *Elements of Drawing*, p. 38.

COLOR MIXING

1. Unlike snow and ice, an opaque passage of a watercolor pigment is not necessarily lighter in tone than a transparent one, as its opacity blocks out light reflected from the white paper.

2. Mayer, pp. 27–28, 30.

3. Brown, p. 146.

4. Garside, p. 11.

5. Gullick, p. 294.

6. Edward Dayes, in the eighteenth century: ". . . colour colder than the drawing is intended to be when finished: the necessity of this practice arises from the warm colours easily affecting the cold ones. . . . once a part is made too yellow, or too red, it can never be overcome (Hardie, I, 191). Fedden, in 1917: ". . . it is safer to start out to paint rather with a warm than a cold tendency. It is a simple matter to make a water-colour colder, but when we begin to place hot paint on the top of cold we land ourselves in endless technical difficulties" (Fedden, p. 99). Many of the differences of opinion are attributable to the differing handling characteristics of the pigments used.

7. Shapiro, cat. no. 37. One of Pissarro's finest color etchings is a view of Eragny.

8. Rewald, p. 150.

9. *Ibid.*, p. 64.

10. [Bowles], p. 24.

11. "Broken" in the context of color denotes a compound rather than a simple hue. It does not necessarily mean that the hue's components are visible to the naked eye.

12. Turner, p. 26.

13. Rowbotham, pp. 41–42.

14. The mixture did not produce violet because Indigo has a stronger green component than purer blues such as Ultramarine. An early variety of neutral tint, composed of Indigo, Crimson lake, and Ivory black and named Payne's gray after its inventor, is still available, although compounded from different pigments of greater stability.

15. Hardie, I, 198.

16. Nicholson, p. 52.

17. Hardie, III, 236–237. This usage of "foxed" does not indicate that the sheet has been stained by contamination by mold, commonly called "foxing." Instead it denotes a rusty red hue, similar to the coat of the red fox.

Discussion of neutral tint raises another problem of word usage. Although "grey" is commonly thought of as the English spelling of "gray," we find one English author describing the fading of neutral tint: "It is not very permanent, as the gray is apt to become grey by exposure" (J. Scott Taylor, *A Descriptive Handbook of Modern Water Colours*, p. 64). The *Oxford English Dictionary*, 1961 ed., s.v. grey, reports that the 1885 edition of Field's *Chromatography* makes the following distinction: "Grey is composed only of black and white; the term gray is applied to any broken colour of a cool hue, and therefore belongs to the class of chromatic colours." After conducting a sort of survey, the *O.E.D.* concluded that in "the distinction most generally recognized . . . *grey* denotes a more delicate or a lighter tint than *gray*. Others considered the difference to be that *gray* is a 'warmer' colour, or that it has a mixture of red or brown. . . ."

18. Hardie, II, 16–17. To show the amazing conceptual complications to which artists and authors seemed liable, Phillips is quoted at length on the subject of warm and cool values as found in nature: "As there is no object in nature depending so essentially on the combinations of its colour for its grateful influence over our feelings as the iris [the flower; Phillips was not writing a manual on flower painting, and he gives no reason why he selected this subject for analysis beyond its "grateful influence"], it may not be unimportant to consider the proportion of the various tints of which it is composed. . . . dividing the whole into 100 parts, the purple will be 11; red, 11; orange, 8; yellow, 14; green, 17; blue, 17; violet, 22. Thus, taking the palpably warm tints, —red, 11; orange, 8; yellow, 14,—making 33; and considering the green, being compounded of yellow and blue, giving 8½ parts of yellow; and the purple, being compounded of red and blue, giving 5½ parts red, making together 14 parts—and from the influence of the blue, whenever its cheerful character from the strength of light can render it a portion of those colours which imply warmth, we obtain 17,— the show of warm colour, or of colour opposed to neutrality, will be as 64 to 36, or in the proportion of something more than 6 to 4. And if we take the three primitive colours, and consider their relative proportions—red, 11; yellow, 14; blue, 17—we shall discover nearly the same result as to proportion; the warm colours, red and yellow, giving 25 parts, the blue 17; that is, the warm in the proportion of about 6 to 4. The mind may be further led . . ." (Giles Firman Phillips, *A Practical Treatise on Drawing, and on Painting in Watercolours*, pp. 40– 41).

19. Hiler, p. 81. See also the color wheel in Field, *Chromatography*, pl. 1.

20. Harley, pp. 70–81.

21. Taylor, p. 53.

22. Steuart, p. 83.

23. Introduced in 1938 (Levison, p. 26). The color on the cover of this publication reproduces Winsor green, Winsor & Newton Co.'s brand of Phthalocyanine green.

24. John C. Pellew, *Acrylic Landscape Painting*, p. 23.

25. Wilkinson, *Turner's Early Sketchbooks*, p. 66.

26. Field, *Chromatography*, p. 128. These were the components of Hooker's green no. 1 and no. 2.

27. Original hues of generally faded watercolors may often be seen at their edges, which were protected from the action of light by mats.

28. Hardie, I, 191.

29. Hatton, p. 49.

30. *Ibid.*, p. 22.

31. Garside, p. 21.

LIGHTS

1. Nicholson, p. 61.

2. *Ibid.*, p. 62.

3. C. J. Holmes, *Notes on the Science of Picture-Making* (New York: D. Appleton, 1909), p. 198.

4. Barnard, p. 78.

5. Nicholson, p. 66.

6. Hardie, II, 34, quoting William Fawkes, a great patron of Turner.

7. Barnard, p. 77.

8. Penley, p. 18.

9. de la Roca, p. 200.

10. Green, p. 42. Algerian sponges were especially recommended (Cassagne, p. 47), and the little dome-shaped, hollow "eye sponge," available from the druggist, was considered a convenient size and shape (Allen, p. 94).

11. Penley, p. 18.

12. *Ibid.*

13. *Ibid.*, p. 27.

14. Constable used no subtractive methods in his sketch, but he did establish the forms of reflections of trees in the Stour by dropping water to dissolve and break horizontal strokes of color in appropriate places.

15. Demuth separated the washed areas of the major elements of his still life, but he used elaborate rewashing, wet-into-wet blending, and wet-lifting methods within each element.

16. Hardie, II, 29.

17. Apligny, p. 61.

18. Ruskin, *Elements of Drawing*, p. 74.

19. Gerald Wilkinson, *Turner Sketches 1802–20: Romantic Genius* (New York: Watson-Guptil, 1974), pp. 79–80.

20. Blake, p. 26. It is more difficult to scrape highlights in dried acrylic films than in gum, and it is virtually impossible to redissolve acrylic to use wet take-out methods. See Blake, p. 23, for a discussion of the problems.

21. Rowbotham, p. 38. The author cautions that the sugar-water must not be confused with wash-water: "the early tints and washes must not be put in with this water, as it would cause them to wash up and blend with any colour laid over them."

22. Cassagne, p. 50.

23. Nisbet, p. 78.

24. Penley, p. 27.

25. Cassagne, p. 52.

26. Langlois, p. 262.

27. Bordier, p. 17. Other authors suggest that the cut surface could be mechanically resized by burnishing so that a glazing wash would "lie on that part nearly or quite as well as on the unbroken surface . . ." (Rowbotham, p. 21).

28. Roget, II, 29–30.

29. [Ackermann], IX, 148.

30. Derek Clifford, *Collecting English Watercolours* (London: St. Martin, 1970), p. 29.

31. Nicholson, p. 63.

32. Nicholson, p. 64. He continues: "If it be desirable to remove the oil of turpentine remaining in the paper, it may be done by washing it with highly rectified spirit of wine, both on the front and back."

33. Langlois, pp. 252, 276.

34. Roget, I, 93, "Girtin's Stopping Out Mixture"; Vibert, pp. 262, 304, "Vibert's Fixatif" and "Liquide dissolvant."

35. Holmes, p. 116.

36. Trade Mark Reg. No. 900,053; October 6, 1970. The date of first use—"on or about August 15, 1939"—is given in *U.S. Patent Office, Official Gazette*, July 21, 1970, TM 136.

37. Dehn, p. 21; Woody, p. 52. Woody recommends masking techniques for acrylic watercolor painting, since subtractive lights are particularly difficult to form through the tough acrylic film.

38. Adeline, pp. 82–84.

39. Green, p. 52.

40. Dehn, pp. 46–47.

41. Cassagne, p. 48.

42. Gautier, p. 42.

43. Barnard, pp. 72–73.

44. In the frontispiece of his *Chromatography*, George Field used pigments to indicate all colors while reserving the blank paper within engraved boundaries for white—although he listed numerous white pigments in his text. Ironically, the frontispiece was printed on chemically unstable paper, now brittle and darkened, and Field's "white" has discolored to tan.

45. The French considered gouache an Italian specialty (Constant-Viguier, pp. 9–10), and the French word *gouache*, which has been adopted into the English vocabulary, derives from the Italian *guazzo*, meaning "puddle."

46. Note in particular the horse's hoof whose color is formed by the reserved brown of the paper.

47. Taylor, p. 34.

48. Allen, p. 199.

49. Penley, p. 33.

50. Ruskin, *Elements of Drawing*, pp. 72–73.

51. B[ate], p. 125. "First you must lay on a white colour tempered with gumme-water, and when it is drie you must go over again with Vermillion or lake. . . ."

52. Hunt was trained as a wood-engraver. In this printmaking technique, the block is commonly coated with white and the drawing is laid in in black ink. Hunt may also have been acquainted with William Blake's "fresco" paintings—easel paintings executed in water-based colors laid over a white ground. Blake called these paintings "frescos" in one of his usual provocative perversions of the English language. In annotations to Sir Joshua Reynold's discourses, "when Reynolds speaks of *fresco* as a mode 'of painting which excludes attention to minute elegancies,' Blake observes 'This is false. *Fresco*-painting is the most minute. It is like miniature painting. A wall is a large ivory'" (Gilchrist, I, 264).

53. Chinese white was also notorious for its habit of drying rock-hard in its tube or bottle. The artist was advised to keep the pigment in a widemouthed bottle to which water or ammonia could be added as needed to keep it moist (Green, p. 39).

54. Hardie, III, 108, quoting James Orrock.

55. Lutz, p. 72.

56. Doust, p. 31.

OPACITY

1. Rowbotham, p. iv.

2. Ruskin, *Elements of Drawing*, p. 76. Ruskin is quoted extensively, in part because he is one manual author with a watercolor included in this exhibition, in part because he was the chief English exponent in print of opaque watercolor, and in part because his writings are irresistibly persuasive.

3. *Ibid.*, p. 206.

4. *Ibid.*, p. 202.

5. *Ibid.*, p. 201.

6. *Ibid.*, p. 206.

7. [Bowles], p. 26.

8. Huisman, p. 118, quoting Watelet's *Dictionary of the Arts* (1792).

9. A French writer listed White lead and silver salts, Red lead, Chrome yellow, and Copper oxide green (Adeline, pp. 475–476). To these should be added Naples yellow and Cobalt blue; see Harley, *passim*. The Moreau *l'âiné* (45) gouache of this

period contains White lead, Red lead, and Naples yellow.

10. See Barnard's discussion of individual pigment qualities, defined in terms of relative transparency and opacity, pp. 33 et seq.

11. Once converted to the wash technique, the French purified every aspect of their processes. One French manual specified that pigments should be ground only on glass slabs, as the traditional marble grinding surface could wear down and mix an amount, however small, of white particles with the pigment.

12. Although the technical development of Homer's mature watercolor style is usually dated from the early 1880s when he visited England and presumably saw English techniques firsthand, he may well have learned the complexities of granulation, rewashing, the taking-out of lights, and contrasting pigment handling from John La Farge. Homer and La Farge worked in the same New York studio building in the 1870s and remained close acquaintances through the rest of their lives.

La Farge was a master of the most complex watercolor techniques even in the 1860s and 1870s, as may be seen by his *Chinese Pi-Tong* (33). He considered flower paintings such as this "in great part a means of teaching myself many of the difficulties of painting, some of which are contradictory, as, for example, the necessity of extreme rapidity of workmanship and very high finish" (quoted in Royal Cortissoz, *John La Farge: A Memoir and a Study* [Boston: Houghton Mifflin, 1911], p. 135).

MOIST COLOR

1. [Ackermann], IX, 91.

2. Gullick, p. 294n.

3. Redgrave, p. 251.

4. Candy sugar was also called double-refined sugar. Apparently the term referred to the equivalent of today's white sugar, in an era when ordinary sugar was brown.

5. [Bowles], p. 54; B[outet], p. 18.

6. Sanderson, p. 56.

7. Redgrave, p. 251.

8. Glycerin was also recommended as an additive to wash water to retard drying, although it was feared that the substance remaining in the finished painting would transform watercolors into "veritable barometers" (Vibert, p. 257) and "render them more susceptible to mould" (Garside, p. 33). The addition of alcohol, on the other hand, has been recommended to hasten drying and to prevent wash water from freezing in cold weather. Outdoor sketchers have been known to carry along a little gin or brandy for this purpose (Hardie, I, 10, 106–107; Steuart, p. 23).

9. William Winsor first added glycerin to his moist colors in 1835 (J. B. Adams to Marjorie B. Cohn, November 16, 1976). Glycerin's chemical formula is $C_3H_5(OH)_2$. No more than five percent is added to the gum binder, according to Gettens, p. 28. De Keghel, pp. 188–189, reported in 1927 that glycerin was often adulterated with starch syrups or dextrin, especially by Dutch manufacturers. Moist-color paints using entirely synthetic water-soluble binders have been formulated more recently. The formula of a single example, patented in 1953: 30 parts by weight of soluble, wax-like, solid polyethylene glycol; 1–1.25 parts by weight of stearyl alcohol; 1–2 parts by weight of polyhydric alcohol having from 2 to 6 carbon atoms; 1–2 parts by weight of water; coloring agent (Binny & Smith Co., "Artists Water Color Paints, U.S. Patent 2,662,-031," *U.S. Patent Office Official Gazette*, 677 [1953], p. 491).

10. Mayer, p. 247.

11. J. B. Adams to Marjorie B. Cohn, November 16, 1976.

12. Reeves & Sons, Ltd., advertisement bound in Nisbet, n.p. [p. 113].

13. James Newman, *Catalogue, 1910*, pp. 7, 10.

14. J. Scott Taylor, *A Descriptive Handbook of Modern Water-colour Pigments*, p. 9.

15. Roget, II, p. 166.

16. Rich, p. 22.

17. Barnard, p. 32.

18. Alexander J. Finberg, "The Development of British Landscape Painting in Water-colours," *The Studio*, Winter 1917, p. 8.

19. Reeves & Sons, Ltd., advertisement bound in Nisbet, n.p. [p. 113].

20. J. B. Adams to Marjorie B. Cohn, November 29, 1976.

21. Winsor & Newton Co. catalogue, p. 2, bound in Penley, 3rd ed.

22. Doust, p. 10.

23. Cassagne, p. 3.

24. "There are only two which I advise you to have in tubes—Aureolin, a sticky, soft colour—and Viridian, which goes very hard in open pans" (Doust, p. 10). Aureolin has been identified as the yellow pigment used by La Farge to represent the texture of wood grain at the lower left in *Chinese Pi-Tong* (33). Under the microscope the paint looks peculiarly viscous, and it was undoubtedly applied straight from the tube.

25. The earliest Winsor & Newton Co. listing of tube watercolors that this author has found is in various 1851 catalogues. N. D. Cotton's catalogue of approximately the same date does not list tube watercolors among the various Winsor & Newton products carried by the Boston firm.

26. Winsor & Newton Co. catalogue, p. 5, bound in Penley, 3rd ed.

27. Winsor & Newton Co. catalogue, p. 23, bound in Hatton, 16th ed.

28. J. Barnard & Son catalogue, p. 5, bound in Tomlinson.

29. Rooke in *Centenary Catalogue*, p. 9.

30. *Centenary Catalogue*, p. 14, no. 21; p. 16, no. 35.

31. Rooke in *Centenary Catalogue*, p. 9.

32. *Ibid.*, p. 8.

33. Burne-Jones, I, 280. Wash colors mixed with honey or sugar were also attractive to flies. Although the insects did not stick in the liquid wash, they were still a hazard "as any one knows who has ever . . . been exasperated by a fly, wet with . . . color, walking over a large area of pure white paper" (Lutz, p. 33). The standard fly repellent in old watercolor recipes was a "light infusion" of colocynthin (Constant-Viguier, p. 34), a resinous extract from the bitter-apple, a fruit of the gourd family.

34. Burne-Jones, I, 280.

35. *Ibid.*, p. 281.

36. J. B. Adams to Marjorie B. Cohn, November 16, 1976.

37. Dehn, p. 25.

38. [Bowles], p. 54.

39. Penley, p. 55. These gum heightenings were applied as the last stages in the completion of a painting (Chase, p. 25). Rowbotham, p. 38, notes that "any details put in with gum water cannot be washed over without the risk of being carried off, or at least having their sharpness destroyed."

40. [Bowles], p. 56.

41. Sanderson, p. 85.

42. See Church, p. 15, for the use of ox-gall as a wetting agent on watercolor paper. Apligny, p. 67, gives instructions for preparing eel-gall: "take eel galls, which you hang on a nail to dry, and when you wish to use it, dissolve a bit in brandy, to mix with the color, which you have already tempered with gum and a little candy sugar."

43. B[outet], p. 16. Gamboge, a yellow vegetable-gum pigment, was also recommended for this purpose (Lutz, p. 52), with analogous restrictions on the colors to which it could be applied.

44. Penley, p. 45.

45. Field, *Rudiments*, p. 129. The gum is derived from the "genus *Astragalus*, a leguminous shrub." A three to four percent solution of gum in water will produce a "moderately thick mucilage" (Church, pp. 80–81). Gum tragacanth's traditional use in art materials is as a binder for pastels. Starch paste has also been frequently recommended since the early nineteenth century to give body to watercolor paint (Field, *Rudiments*, p. 129). It had been in use with pigments for several centuries to make "paste paper," decorative papers used in bookbinding. See also Walter Beck, *Painting with Starch: A Tempera Method* (Princeton: D. Van Nostrand, 1956).

46. Penley, p. 45.

47. Chase, p. 35.

48. Winsor & Newton Co., *Notes on the Composition and Permanence of Artists' Colours*, p. 19.

49. Field, *Rudiments*, p. 128; Vibert, pp. 268–270; Hiler, p. 229.

50. Gettens, p. 76.

51. A useful summary of brands of acrylic paints available in 1966 is given in José Gutiérrez and Nicolas Roubes, *Painting with Acrylics* (New York: Watson-Guptil, 1966), pp. 81–98.

52. Blake, p. 11.

PRESENTATION

1. Hardie, III, 96.

2. [Ackermann], IX, 24. As a publisher, Ackermann was, of course, delighted to encourage the fashion for libraries.

3. Constant-Viguier, pp. 11–12.

4. With the triumph of the oil manner in watercolor exhibitions, works by topographical landscape masters such as Lear, who continued to wash in the earlier style, continued to be relegated to albums. Also, as matting and framing has always been expensive, the poor painter has had to be content with album mountings. Pissarro wrote in 1891, the year he painted *Landscape, Eragny* (49), "I have had all my watercolors mounted, and I am arranging them in portfolios. If I could exhibit them! But it would cost too much to have them mounted. After all, I have 161" (Rewald, p. 146).

5. Gilchrist, I, 34–35.

6. *Ibid.*, p. 57.

7. Gullick, p. 313, n. G.

8. *Ibid.*

9. Roget, I, 127–130.

10. Nicholson, pp. 75–76.

11. Roget, I, 444–445.

12. Blanch, pp. 43–44, quoting Adolf Dehn: "The varnish brings out the color much more and intensifies the darks.... The resulting effects are so similar to oil painting that it is difficult to tell the difference. The picture can then be framed as an oil without glass, and shown in exhibitions of oils rather than in watercolor shows." Woody, p. 46: "All plastic [acrylic] paintings, even those created in a watercolor method, are impervious to water. When given a coat of matte varnish they can be washed with mild soap and water and can be framed without a glass protection."

13. Nicholson, p. 80. See also Hardie, I, 39, for a description of the method of varnishing used by Thomas Gainsborough.

14. Apligny, p. 63.

15. *Centenary Catalogue*, p. 14, no. 21.

16. Hiler, pp. 244–245; F. Weber Co., *Illustrated Catalogue*, p. 33; Winsor & Newton Co., *A Brief Account of the Composition and Permanency of ... Water Colours*, p. 26. J.-G. Vibert's patented "Fixatif" for watercolors, which may have been white shellac in alcohol, was recommended for use both as a final varnish and as a substitute for isinglass sizing under other varnishes (Vibert, p. 305). Vibert also patented watercolor paints that incorporated a heat-setting resin. A picture done in these paints would be gently warmed; its colors would briefly melt. On hardening, their effect would be intensified and they would become insoluble in water (Adeline, pp. 40–41).

17. Hiler, pp. 240–241.

18. Winsor & Newton Co., *Notes on the Composition and Permanence of Artists' Colours*, p. 21.

19. Manuals concerned themselves with the glass itself. Nicholson, p. 75, is troubled by the flat and brilliant reflections from plate glass, which was required by large works, and recommends old-fashioned ripply glass. Garside, p. 45, recommends more expensive extra-clear glass, as "Ordinary glass has a greenish tinge and is apt to spoil the colour of drawings...."

20. Redgrave, p. 11; Hardie, I, 40; Langlois, pp. 310–311.

21. Roget, II, 109, quoting William H. Pyne, writing in 1824. See also Roget, I, 464.

22. Gullick, p. 315.

23. Percy Fitzgerald, "Picture Frames," *The Art Journal*, 1886, p. 325.

24. Lutz, p. 21. This concept had been anticipated by Field, in his suggestion for gallery wall color: "a mean, or middle colour ... such as a crimson hue ... which contrasts with the general *green* of nature and pictures" (Field, *Chromatography*, p. 262, n. 1 to p. 60).

25. Fitzgerald, p. 325.

26. *Ibid.*, p. 327.

27. Lutz, pp. 203–204.

PERMANENCE

1. Garside, p. 46.

2. Vibert, pp. 260–261.

3. In the same year, 1824, the Old Water-colour Society proclaimed, "when this art first began to de-velope new and extensive powers, the prejudices which probably originated in a contempt of its an-cient feebleness, degenerated into a species of hostil-ity.... an opinion was industriously spread abroad, that these qualities were evanescent, and the ma-terial on which these works were executed, so frail and perishable, that the talents of the artists were rendered useless by the ephemeral nature of his pro-ductions... but no philosophical reasons ever were, or ever could be, adduced against the possibility of producing by means of water-colours, pictures equal in ... permanency ... to those executed in oil" (Roget, I, p. 427).

4. Roget, I, 442, quoting an anonymous critic of 1824.

5. Oil paintings have often been executed in the same light-sensitive pigments as watercolors, but their colors are somewhat protected by yellowing films of binders and varnishes. Also, the use of the most fugitive organic pigments was discontinued in oil painting long before watercolorists, who sought the greatest possible transparency, would relinquish such pigments as Carmine and Indigo.

6. Taylor, p. 2.

7. Field, *Rudiments*, p. 129.

8. Nicholson, p. 48.

9. George Field, *Chromatics; or, An Essay on the Analogy and Harmony of Colours* (London, 1817), pp. 56–57: "... the many requisites of a perfect pigment [are] never wholly united in the same sub-stance: hence it is generally necessary to employ two pigments of the same colours if you would produce the fullest effect.... delicacy and depth in the beauty of colours are at variance in all pigments.... they are the male and female in beauty."

10. *Ibid.*, p. 57.

11. In 1816 Field was awarded a gold medal for his "apparatus for preparing coloured lakes" (R. B. Beckett, ed., *John Constable's Correspondence*, 6 vols. [London: H.M.S.O. and Suffolk Records So-ciety, 1966], IV, 171).

12. Colormen such as Ackermann and Winsor and artists such as Constable were subscribers to *Chromatography*. Field also sent a copy to Turner, "who did not think that colours were reducible to scientific rules and pronounced the book to be falla-cious" (*ibid.*, p. 172).

13. Field, *Chromatography*, p. 142.

14. *Ibid.*, p. 84.

15. William Hogarth, *The Analysis of Beauty* (London, 1753), p. 119, n. 1.

16. Field reported an experiment that determined the relative discoloration on exposure of natural and artificial Ultramarine, Cobalt blue, and Prussian blue. Interestingly, he did not include Indigo, per-haps because he already felt certain of its imperma-nence (Field, *Chromatography*, pp. 110, 112–113).

17. Field, *Rudiments*, p. 41.

18. See, for example, Barnard, p. 10, and Cas-sagne, p. 67. One nineteenth-century manual even recommended that the artist compensate for antici-pated fading: "The upper lip being almost always in shadow is both darker, and less intense, and less bright in colour, than the lower lip; but as these reds will lose somewhat by time, they may be painted a little brighter in colour than they are in nature, to allow for this loss" (Day, p. 33).

19. Field, *Chromatography*, p. xi.

20. *Ibid.*, p. 44.

21. Taylor, p. 10.

22. Thomas W. Salter, ed., *Field's Chromatog-raphy*, p. 115.

23. Finberg, *Life of Turner*, p. 290.

24. *Ibid.*, p. 279.

25. The coloring matter of Indigo was isolated in 1826; the coloring matter of Madder was synthe-sized in 1868.

26. Aniline was named after the Romance lan-guages' (ultimately the Sanskrit) word for Indigo, the first organic pigment to yield its coloring matter to chemical analysis.

27. Hiler, p. 95. Tests for many different kinds of adulterants were as common in nineteenth-century pigment handbooks as instructions for pigment preparation were in eighteenth-century manuals.

28. Henry W. Levison, *Artists' Pigments: Light-fastness Tests and Ratings*, p. 25. Levison presents a summary of the history and current status of perma-nent pigments; he has been a pioneer in the develop-ment of modern standards.

29. *Ibid.*, p. 16.

30. Brown, p. 90.

31. *Ibid.*, p. 73.

32. Albert Fitch Bellows, *Water-Color Painting*, pp. 8–9.

33. Salter, p. 44.

34. Rollin, p. 3.

35. Hunt, II, 455.

36. *Ibid.*, p. 454.

37. *Ibid.*, pp. 452–453.

38. Ruskin found the faded Turners (all from his own collection) "even in their partial ruin mar-velous" and thought that their "colours... changed so harmoniously that I find in their faintness more to discover through mystery than to surrender as lost" (John Ruskin, annotator, *Notes by Mr. Ruskin on his Drawings by the Late J. M. W. Turner, R.A....* (London: Fine Arts Society, March 1878), pp. 9; 29, no. 26.

39. Taylor, n.p. [prefatory page].

40. Sir William Armstrong, "The Permanency of Water Colours," *The Art Journal*, 1886, p. 253.

41. See, for example, Roget, II, 128, and Red-grave, p. 254.

42. See, for example, *Burlington Fine Arts Club, Reports I. & II. of a Sub-Committee Appointed to Test Certain Methods Devised for the Preservation of Drawings in Water Colour* (London, 1895); J. A. MacIntyre and H. Buckley, "The Fading of Water-Colour Pictures," *The Burlington Magazine* LVII (1930), 31–37; and Garry Thomson, "A New Look at Colour Rendering, Level of Illumination, and Protection from Ultraviolet Radiation in Museum Lighting," *Studies in Conservation* VI (1961), 49–70.

43. A summary of Russell and Abney's report, more accessible than the original publication, is

available in Norman S. Bromelle, "The Russell and Abney Report on the Action of Light on Water Colours."

44. It has since been established that ultraviolet radiation, an invisible component of sunlight, is the most damaging fraction of solar radiation to pigments and many other art materials. Ultraviolet radiation is also present to a lesser degree in fluorescent lighting and is almost entirely absent in conventional incandescent lighting. Glass and plastic sheeting may be specially prepared to obstruct the passage of ultraviolet radiation, thereby protecting watercolors on exhibition to some extent. Low levels of light and limited periods of exhibition are always advisable, however, as the effect of light and ultraviolet radiation is cumulative.

45. The deleterious effect of humidity had been reported by Field. Bellows, who argued that only thinly painted watercolors were susceptible to damage from light, claimed in 1868 that "our dry American climate [would be] particularly favorable to the durability of tints and colors" (Bellows, p. 15n).

46. Church, p. 341.

47. Taylor, pp. 13–16. The action of Indian red on Indigo (if in fact the effect was real, a moot point) was blamed on the impurities present in the natural pigment, which was superseded in the late nineteenth century by man-made iron oxides.

48. Bromelle, p. 144; Burlington Fine Arts Club, p. 3.

49. Bellows, p. 7.

50. Winsor & Newton Co. catalogue, p. 3, bound in Penley, 39th ed.

51. According to Levison, p. 19, Winsor & Newton Co. exposes washes of their pigments to a north light for twenty-five years.

This bibliography lists publications that may be of general interest. Other more specific references are fully cited in the Notes and the Catalogue of the Exhibition. Where known, earlier editions of certain publications are noted in brackets, so that the reader can learn when certain materials became current. The author has estimated the dates of undated publications and has listed them in brackets, also. Those publications that are bound with artists' suppliers' catalogues (usually paginated separately) are identified, as are those that contain hand-washed identified pigment samples and identified paper samples. Almost all of the publications cited in the Notes, Bibliography, and Catalogue of the Exhibition can be found in the library of the Center for Conservation and Technical Studies and the Fine Arts Library in the Fogg Art Museum, Harvard University, in the Department of Art of the Library of the Boston Athenæum, and in the Boston Public Library.

[Ackermann, Rudolph.] "Observations on the Rise and Progress of Painting in Water Colours." *The Repository of Arts, Literature, Commerce, Manufactures, Fashions, and Politics* VIII (1812), 257–260, 324–327; IX (1813), 23–27, 91–94, 146–149, 219–221.

Adeline, Jules. *La Peinture à l'Eau: Aquarelle, Lavis, Gouache, Miniature.* Paris, n.d. [c. 1890].

Allen, Grace Barton. *Watercolor Painting.* Boston, 1898. Winsor & Newton Co. wash samples.

d'Apligny, M. le Pileur. *Traité des Couleurs Materielles, et de la Manière de Colorer. . . .* Paris, 1779.

Barnard, George. *The Theory and Practice of Landscape Painting in Watercolours.* London, 1858.

B[ate], J[ohn]. *The Mysteryes of Nature and Art . . . , The Third Booke of Drawing, Limning, Colouring, Painting, and Graving.* London, 1634.

Bellows, Albert Fitch. *Water-Color Painting: Some Facts and Authorities in Relation to its Durability.* New York, 1868. Listed in the New York Public Library union catalogue under New York City. American Watercolor Society.

Blake, Wendon. *Acrylic Watercolor Painting.* New York: Watson-Guptil, 1970.

Blanch, Arnold. *Methods and Techniques for Gouache Painting (Opaque Water Color).* New York: American Artists Group, 1946.

Bordier, J. *L'Aquarelle.* Paris: Edition et Librarie Etiènne Chiron, n.d. [c. 1925]. Wash and paper samples.

B[outet], C[laude]. *Traité de Mignature pour Apprendre Aisément à Peintre sans Maître. . . .* Paris, 1711. [2nd ed. Paris, 1674.]

[Bowles, Carrington.] *The Art of Painting in Water-Colours: Exemplified in Landscapes, Flowers, &c.* 8th ed. London, 1786. [1st ed. London, 1731.]

Bromelle, Norman S. "The Russell and Abney Report on the Action of Light on Water Colours." *Studies in Conservation* IX (1964), 140–152.

Brown, J. Hullah, *Water-colour Guidance for the Student, the Amateur, and the Occasional Colourist.* London: A. & C. Black, 1931.

Burlington Fine Arts Club. *Reports I. & II. of a Sub-Committee Appointed to Test Certain Methods Devised for the Preservation of Drawings in Water Colour.* London, 1895.

Cassagne, Armand Théophile. *Traité d'Aquarelle.* Paris, 1875. English and French watercolor paper samples.

Cavé, Marie Elisabeth. *Color; the Cavé Method of Drawing . . . 2nd Part.* New York, 1869.

Chapman, John Gadsby. *The American Drawing Book: A Manual for the Amateur. . . .* New York, 1847.

Chase, John. *A Practical Treatise on Landscape Painting and Sketching from Nature in Water Colours.* London, n.d. [c. 1873]. J. Barnard & Son catalogue.

Centenary Exhibition of Paintings and Drawings by Sir Edward Burne-Jones, including "Note on Burne-Jones's Medium" by T. M. Rooke, pp. 8–9. London: The Tate Gallery, 1933.

Chirac, A. DD. *Traité complet de Peinture à l'Aquarell. . . .* Paris, n.d. [c. 1839].

Church, Arthur H. *The Chemistry of Paints and Painting.* 3rd ed., London: Seeley, 1901. [1st ed. London, 1890.]

Condit, Charles L. *Painting and Painters' Materials.* New York, 1883.

Constant-Viguier, S. F. *Manuel de Miniature et de*

Gouache. 2nd ed., Paris, 1830. Bound with Langlois.

Cook, Hereward L. "Winslow Homer's Watercolor Technique." *Art Quarterly* XXIV (1961), 169-194.

Cotton, N. D. *Cotton's Catalogue of Drawing Materials . . . to Which is Prefixed Instruction in Water Color Painting by T. & T. L. Rowbotham, Jr.* Boston, 1851.

Cox, David. *A Treatise on Landscape Painting in Watercolours.* London, 1813. Reprinted in *The Studio*, Autumn 1922, pp. 9-20, pls. I-LXXII.

Day, Clarence William. *The Art of Miniature Painting.* London, 1853. Winsor & Newton Co. catalogue.

Dehn, Adolf. *Water Color Painting.* New York: Studio Publications, 1945.

Delamotte, Francis G. *The Amateur Artist; or, Oil and Water Color Painting without the Aid of a Teacher.* Chicago: F. J. Drake, 1906.

Doust, L. A. *A Manual of Watercolour Drawing.* London: Frederick Warne, 1933.

Fedden, Romilly. *Modern Water-Colour.* Boston: Houghton Mifflin, 1917.

Field, George. *Chromatography; or, a Treatise on Colours and Pigments, and of their Powers in Painting, etc.* London, 1835. Wash samples.

Field, George. *Rudiments of the Painter's Art; or, a Grammar of Colouring. . . .* London, 1850.

Friedrichs Co., E. H. & A. C. *Fredrix's Catalogue: Artists' Materials, No. 60.* New York, n.d. [c. 1925].

Frost & Adams Co. *Catalogue: Artists' Materials. . . .* Boston, n.d. [c. 1903].

Garside, Oswald. *Landscape Painting in Water-Colour.* London: Winsor & Newton, 1929.

Gautier, H. *L'Art de Laver; ou, Nouvelle Manière de Peindre sur le Papier, Suivant le Coloris des Desseins qu'on Envoye à la Cour.* Lyon, 1687.

Gettens, Rutherford J., and Stout, George L. *Painting Materials: A Short Encyclopaedia.* New York: D. Van Nostrand, 1942.

Goupil, H. A. *L'Aquarelle et le Lavis en Six Leçons.* Paris, 1858.

Green, N. E. *Hints on Sketching from Nature, Part III.—Colour.* London: George Rowney, n.d. [c. 1915].

Gullick, Thomas John, and Timbs, John. *Painting Popularly Explained.* London, 1859.

Hardie, Martin. *Water-Colour Painting in Britain.* 3 vols. London: Batsford, 1966-1968.

Harley, Rosamond D. *Artists' Pigments c. 1600-1835: A Study in English Documentary Sources.* London: Butterworth, 1970.

Harley, Rosamond D. "Artists' Brushes—Historical Evidence from the Sixteenth to the Nineteenth Century." *Conservation of Paintings and the Graphic Arts.* London: International Institute for Conservation, 1972, pp. 123-129.

Hatton, Thomas. *Hints for Sketching in Water-Colour from Nature.* 2nd ed. London, 1853. 16th ed. London, 1878. Winsor & Newton Co. catalogue.

Hiler, Hilaire. *Notes on the Technique of Painting.* London: Faber & Faber, 1934.

Holmes, C. J. *Notes on the Science of Picture-Making.* New York: D. Appleton, 1909.

Huisman, Philippe. *French Watercolours of the 18th Century.* London: Thames & Hudson, 1969.

Hunter, Dard. *Papermaking: The History and Technique of an Ancient Craft.* 2nd ed. New York: A. A. Knopf, 1957.

Jaennicke, Friedrich. *Handbüch der Aquarellmalerei.* Stuttgart, 1885.

Kautzky, Theodore. *Ways with Watercolor.* New York: Reinhold Publishing Corp., 1947.

Langlois de Longueville, F. P. *Manuel du Lavis à la Sepia et de l'Aquarelle.* Paris, 1830. Bound with Constant-Viguier.

Leitch, R. P. *A Course of Water-Colour Painting.* London, 1887.

Levison, Henry W. *Artists' Pigments: Lightfastness Tests and Ratings.* Hallandale, Fla.: Colorlab, 1976.

Lutz, E. G. *Practical Water-Color Sketching.* New York: Charles Scribner's Sons, 1931.

MacIntyre, J. A., and Buckley, H. "The Fading of Water-colour Pictures." *The Burlington Magazine* LVII (1930), 31-37.

Mayer, Ralph. *The Artist's Handbook of Materials and Techniques.* New York: Viking Press, 1940.

Merrifield, Mary Philadelphia. *The Art of Portrait Painting in Water-colours.* 2nd ed. London, 1851. Winsor & Newton Co. catalogue.

Newman, James. *Catalogue, 1910.* London, 1910.

Nicholson, Francis. *The Practice of Drawing and Painting from Nature in Water Colours.* London, 1820.

Nisbet, Hume. *On Painting in Water Colours*. 6th ed. London: Reeves & Sons, 1920 [first published c. 1903]. Reeves & Sons catalogue.

Pellew, John C. *Acrylic Landscape Painting*. New York: Watson-Guptil, 1968.

Penley, Aaron. *A System of Water-colour Painting*. 3rd ed. London, 1851. 39th ed. London, 1878. Winsor & Newton Co. catalogue.

Perrot, A.-M. *Manuel du Coloriste*. Paris, 1834. Wash samples.

Phillips, Giles Firman. *A Practical Treatise on Drawing, and on Painting in Watercolours*. London, 1839. Wash samples, watercolors done with identified pigments on Whatman paper.

Pretty, Edward. *A Practical Essay on Flower Painting in Water Colours*. London, 1810. Washed plates on Whatman paper watermarked 1811.

Redgrave, Gilbert Richard. *A History of Watercolour Painting in England*. London, 1892.

Rich, Alfred W. *Water Colour Painting*. Philadelphia: J. B. Lippincott, 1918.

Richmond, Leonard, and Littlejohns, J. *The Technique of Water-colour Painting*. London: Pitman, 1929.

de la Roca y Delgado, Mariano. *Compilación de Todas las Prácticas de la Pintura. . . .* Madrid, 1880.

Roget, John Lewis. *A History of the "Old Water-colour" Society*. 2 vols. London, 1891.

Rollin, Horace J. *Studio, Field, and Gallery*. New York, 1878.

Rowbotham, Thomas, and Rowbotham, Thomas L., Jr. *The Art of Landscape Painting in Water-Colours*. 4th ed. London, 1851. Winsor & Newton Co. catalogue.

Rowney & Co., Ltd., George. *Catalogue*. London, 1926.

Ruskin, John. *The Elements of Drawing*. London, 1857.

Russell, Walter J., and Abney, William de W. *Report to the Science and Art Department . . . on the Action of Light on Water Colours*. London, 1888. Listed in the Harvard College Library union catalogue under Great Britain. Science and Art Department.

Salter, Thomas W., ed. *Field's Chromatography; or, Treatise on Colours and Pigments as Used by Artists*. London, n.d. [c. 1869].

Sanderson, William. *Graphice. The Use of the Pen and Pensil; or, the Most Excellent Art of Painting*. London, 1658.

Stebbins, Theodore E., Jr. *American Master Drawings and Watercolors*. New York: Harper & Row, 1976.

Steuart, James. *Sketching in Water-Colours*. London: T. C. & E. C. Jack, n.d. [c. 1925].

Taylor, J. Scott. *A Descriptive Handbook of Modern Water Colours*. 2nd ed. London, 1887. Winsor & Newton Co. wash samples.

Thomson, Garry. "A New Look at Colour Rendering, Level of Illumination, and Protection from Ultraviolet Radiation in Museum Lighting." *Studies in Conservation* VI (1961), 49–70.

Turner, Maria. *The Young Ladies' Assistant in Drawing and Painting*. Cincinnati, 1833.

Vibert, J.-G. *La Science de la Peinture*. Paris, 1891.

Weber Co., F. *Illustrated Catalogue Volume 500*. Philadelphia, 1923.

Winsor, W., and Newton, H. C. *The Hand-book of Water-colours, a Brief Treatise on Their Qualities and Effects when Employed in Painting. . . .* 6th ed. London, n.d. [c. 1893]. Winsor & Newton Co. wash samples.

Winsor & Newton Co. *A Brief Account of the Composition and Permanence of Winsor & Newton's Artists' Oil and Water Colours. . . .* London, 1938.

Winsor & Newton, Inc. *1972 Catalogue of Quality Merchandise for the Artist. . . .* Secaucus, N.J., 1972.

Winsor & Newton, Ltd. *Notes on the Composition and Permanence of Artists' Colours. . . .* London, n.d. [c. 1972].

Woody, Russell O. *Painting with Synthetic Media*. New York: Reinholt Publishing Corp., 1965.

Catalogue of the Exhibition

The primary purpose of these catalogue entries is to provide technical information (dimensions, medium, type of paper, watermark, inscriptions) and brief explanatory notes on the exhibited watercolors. Abbreviated footnotes appear in the text of the entries. Sources for further information on the works can be found in the selected references which follow each listing.

All dimensions are given in millimeters. Height precedes width; measurements are taken at left and bottom edges of watercolor sheets. Exhibited works are listed alphabetically by artist.

Much helpful information has been obtained from the following catalogues: Agnes Mongan and Paul J. Sachs, *Drawings in the Fogg Museum of Art*, 2nd ed., 2 vols. (Cambridge: Harvard University Press, 1946); *Paintings and Drawings of the Pre-Raphaelites and Their Circle* (Cambridge, Mass.: Fogg Art Museum, 1946); *Grenville L. Winthrop: Retrospective for a Collector* (Cambridge, Mass.: Fogg Art Museum, 1969); and *American Art at Harvard* (Cambridge, Mass.: Fogg Art Museum, 1972). Agnes Mongan has generously shared her research notes compiled for her forthcoming catalogue of early nineteenth-century French drawings in the Fogg collection.

1 *Anonymous,* Flemish

The Schelde River at Antwerp, late sixteenth – early seventeenth century
Watercolor over brown ink and traces of graphite; cream antique laid paper; 250 × 400 mm.
Inscribed in brown ink, upper left, in sixteenth-century "batarde" script: *January?*
Gift of Dr. Fritz B. Talbot, 1956.216

Although in the past this watercolor has been attributed to Jan Brueghel the Elder, scholars who have recently seen the drawing doubt the attribution.

2 *Anonymous*

Henry Hamilton, late eighteenth century
Watercolor and white gouache; extensive gum varnishing; ivory; 80 × 66 mm. (oval)
Lent by the Houghton Library, Harvard University Portrait Collection, Gift of Mrs. C. I. Rice, HUP C52

Miniature portraits on ivory first became popular in the eighteenth century. Hamilton, who died in 1796, was a British soldier who served as Lieutenant Governor of Detroit and Canada and as Governor of Bermuda. He fought on the British side during the American Revolution. The present attribution of this portrait to the English miniaturist Robert Field (Huntsinger, cat. no. C52) seems unlikely. When Field sailed for the United States in 1794, Hamilton was in the West Indies, where he died two years later. Hamilton had returned to England for a few years in the early 1780s, but Field (born c. 1770) was certainly too young at the time to have been active as a portraitist.

Reference: Laura M. Huntsinger, *Harvard Portraits* (Cambridge: Harvard University Press, 1936), p. 67.

3 *John James Audubon (1780–1851),* American

Bird, 1826
Watercolor and colored chalk over graphite; accented with graphite; cream wove paper; 280 × 223 mm.
Inscribed in brown ink, at bottom: *John J. Audubon / Drawn at Green Bank / 1826–*
Gift of Grenville L. Winthrop, 1941.84

The bird, an *Erithacus rubecula melophilus* or English robin, rests on a species of honeysuckle vine. Audubon painted this bird while a guest at Green Bank, the home of his friends the Rathbones, three miles outside Liverpool. He presented the watercolor to Mrs. Rathbone III on her birthday, August 30, 1826 (Ford, p. 126). As was his usual practice, Audubon killed the bird and fixed it in place with wires while he rapidly completed his drawing (Audubon, I, 100, n. 1; Herrick, I, 356).

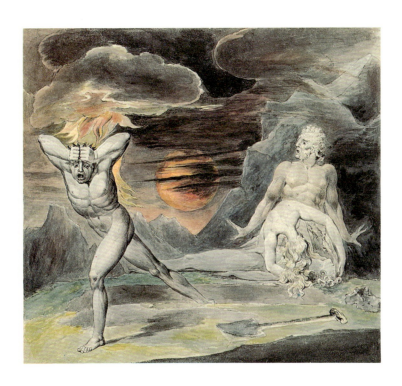

PLATE I. William Blake, *Cain Fleeing from the Wrath of God* (4).

References: John James Audubon, *The 1826 Journal of John James Audubon*, transcribed by Alice Ford (Norman, Okla.: University of Oklahoma Press, 1967). Maria R. Audubon, *Audubon and his Journals*, 2 vols. (New York, 1897). Francis H. Herrick, *Audubon the Naturalist: A History of His Life and Time*, 2 vols. (New York: D. Appleton and Company, 1919).

4 *William Blake (1757–1827)*, English

Cain Fleeing from the Wrath of God, c. 1800–1809 (plate 1)
Watercolor and black ink over graphite; cream wove paper; 303 × 326 mm.
Bequest of Grenville L. Winthrop, 1943.401

This incident in the Cain and Abel story does not appear in the Bible. Blake's invention of the scene indicates his interest in the subject of murder and death as a consequence of man's fall from grace. In 1799 Blake executed a drawing, now in the British Museum, of Cain fleeing from his brother's grave. The Fogg watercolor was most likely painted after 1799 and no later than 1809, when it was exhibited in Blake's show of his own work. The artist returned to the subject in 1826–1827, producing the tempera painting presently in the collection of the Tate Gallery (Butlin, p. 62, cat. no. 54).

References: Martin Butlin, *William Blake: A Complete Catalogue of the Works in the Tate Gallery* (London: Tate Gallery, 1971). Anthony Blunt, *The Art of William Blake* (New York: Columbia University Press, 1959), pp. 40–41.

5 *William Blake (1757–1827)*, English

Circle of the Gluttons, 1824–1827
Watercolor and black ink over graphite; off-white laid paper; 369 × 523 mm.
Watermark: W Elgar / 1796
Bequest of Grenville L. Winthrop, 1943.440

Between 1824 and 1827 Blake executed 102 watercolors illustrating Dante's *Divine Comedy*, commissioned by John Linnell.

This watercolor represents Canto VI of the *Inferno*. Although the mat is inscribed "Circle of the Carnal Sinners," the painting depicts the third circle of the Inferno, where the gluttonous, watched over by the three-headed beast Cerberus, are eternally pelted by freezing rain.

Reference: Albert S. Roe, *Blake's Illustrations to the "Divine Comedy"* (Princeton: Princeton University Press, 1953), p. 66, pl. 11.

6 *William Blake (1757–1827)*, English

Lucia Carrying Dante in His Sleep, 1824–1827
Watercolor and black ink over graphite; cream modern laid paper; 374 × 524 mm.
Watermark: V
Bequest of Grenville L. Winthrop, 1943.438

This illustration to *Purgatory* (Canto IX, lines 50–62) shows the sleeping Dante being carried upward to the gates of Purgatory by Saint Lucy, his patron saint and the symbol of illuminating grace. Virgil, Dante's spiritual guide through the Inferno and Purgatory, follows behind.

References: Laurence Binyon, *Illustrations to the "Divine Comedy"* (London: National Arts Collection Fund, 1922), no. 77. *Grenville L. Winthrop: Retrospective for a Collector* (Cambridge, Mass.: Fogg Art Museum, 1969), p. 144, cat. no. 99.

7 *Giovanni Boldini (1842–1931)*, Italian

Girl Reclining in the Studio, 1873
Watercolor and gouache over graphite; coarse textured, off-white wove paper; 254 × 350 mm.
Inscribed in brown watercolor, lower left: *Boldini 73*
Bequest of Grenville L. Winthrop, 1943.289

While John Singer Sargent was painting prominent citizens in Britain and the United States, Giovanni Boldini was painting stylish portraits in *fin-de-siècle* France. Born in Italy, Boldini spent several years in London before settling in Paris. Like

Sargent, Boldini often produced informal figure studies in the medium of watercolor. This work is typical of Boldini's style in its slashing brushstrokes, emphasis on diagonals, and striking color combinations.

8 *Charles Burchfield (1893–1967)*, American

August Sunlight, 1916
Watercolor, with added viscous medium in some colors, over graphite; cream wove paper; extensive color notes; 355 × 556 mm.
Inscribed in graphite, lower right: *C E Burchfield – 1916*; on verso in the artist's handwriting: *August Noon, August 31, 1916*
Purchase of the Louise E. Bettens Fund, 1930.463

Typical of Burchfield's watercolors of this period, *August Sunlight* includes pencil outlines, with color notes indicating washes to be filled in. Burchfield described the circumstances behind the creation of this watercolor of his backyard in Salem, Ohio: "It had been a dry summer, plants were prematurely old and rather dryed and bleached out. The brilliant sunlight on them only made them seem whiter, especially since, if you come from the darker interior of the house, as I did, and your unaccustomed eyes received the full impact of glittering light. This is the impression I tried to give, that first glorious moment. The effect of all this light made the various buildings seem much blacker by contrast" (Rowland, pp. 156–157).

References: Benjamin Rowland, Jr., "Burchfield's Seasons," *Fogg Museum of Art Bulletin* x (1946), 155–161. Joseph S. Trovato, *Charles Burchfield: Catalogue of Paintings in Public and Private Collections* (Utica, N.Y.: Munson-Williams-Proctor Institute, 1970), p. 49, cat. no. 170.

9 *Sir Edward Burne-Jones (1833–1898)*, English

The Second Day of Creation, 1876 (plate 2)
Watercolor, shell gold, and gouache on fine linen; mounted on paper stretched over a wood panel prior to the picture's execution; 1019 × 356 mm.
Inscribed, verso: *This picture is not complete by itself but is N.º 2 of a series of six watercolour pictures representing the Days of Creation which are placed in a frame designed by the Painter, from which he desires they may not be removed*
Bequest of Grenville L. Winthrop, 1943.455

This watercolor is the second in a group of six panels representing the six days of creation. Each panel shows an angel holding a crystal sphere representing God's work on that day (in this case, the separation of water from dry land); the second through sixth also include the angels of the preceding days of creation. Burne-Jones originally created the series for the six lights of a stained-glass window of a church in South Northamptonshire, England. Although the designs were conceived in 1870 and the window executed by William Morris and Company in 1873, the watercolor was not painted until 1876. The panels were exhibited in their original frame at the Grosvenor Gallery in 1877. All six were bequeathed to the Fogg by Grenville Lindall Winthrop in 1943.

References: *Paintings and Drawings of the Pre-Raphaelites and Their Circle* (Cambridge, Mass.: Fogg Art Museum, 1946), pp. 37–40, cat. no. 25. Sotheby & Co. sales catalogue, *Catalogue of the Well-Known Collection of Paintings by the Late Rt. Hon. Lord Faringdon* (London: Sotheby & Co., June 13, 1934), pp. 21–22, illustration of all six panels in original frame designed by the artist.

10 *Alexander Calder (1898–1976)*, American

Studies of a Hippopotamus, c. 1925
Watercolor and black ink; thin, off-white wove paper; 335 × 274 mm.
Watermark: INTERNATIONAL BOND MADE IN U.S. with monogram WGPU [?]
Inscribed in graphite, lower right: *A. Calder*

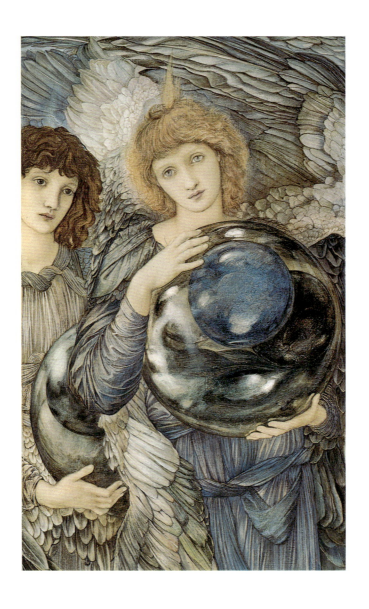

PLATE 2. Sir Edward Burne-Jones, *The Second Day of Creation* (9, detail).

PLATE 3. Charles Demuth, *Fruit and Sunflowers* (16).

93

Bequest of Meta and Paul J. Sachs, 1965.444

In 1925 Alexander Calder was assigned to depict the Ringling Bros. and Barnum & Bailey Circus for the *National Police Gazette*. At the time, he was working as an illustrator for the paper (Lipman, pp. 20, 329). These first visits inspired his lifelong interest in the circus and animals. Calder's love of animals also took him to the zoos in New York City, where he lived until 1926. The hippo studies belong to a series of watercolors that Calder executed at the Bronx and Central Park Zoos in New York (Lipman, pp. 81–82).

Reference: Jean Lipman, *Calder's Universe* (New York: Viking Press in cooperation with the Whitney Museum of American Art, 1976).

11 *Paul Cezanne (1839–1906)*, French

Le Grand Arbe, 1885–1887
Watercolor over graphite; cream modern laid paper; 319 × 495 mm.
Watermark: SVA [script monogram]
Inscribed in pencil, lower right: *No 4* [cut off at sheet edge]
Bequest of Theodore Rousseau, jointly owned by the Metropolitan Museum and the Fogg Art Museum, Harvard University, 1974.170

This watercolor is a study for the tree in the painting *Grand Pin et Terres Rouges* (c. 1890), now in the Hermitage, Leningrad.

Reference: *Drawings Recently Acquired, 1972–1975*, (New York: Metropolitan Museum of Art, 1975), cat. no. 35.

12 *John Constable (1776–1837)*, English

Flatford Mill, c. 1810–1811
Watercolor over graphite; cream wove paper; 158 × 240 mm.
Purchase of the Pritchard Fund, 1939.84

Constable's family owned Flatford Mill on the River Stour until 1846. This watercolor sketch probably dates from 1810–1811, when Constable painted many views of the mill and the locks.

Reference: *One Hundred Years of English Landscape Drawing, 1750–1850* (Cambridge, Mass.: Busch-Reisinger Museum, 1960), p. 7, cat. no. 7.

13 *David Cox (1783–1859)*, English

Moorland, 1846
Watercolor over graphite; white wove paper with a diagonal grain; 210 × 285 mm.
Inscribed in brown ink, lower left: *David Cox 1846*
Bequest of Dr. Arthur T. Cabot, 1939.304

David Cox, a member of the Society of Artists in Water-colour, published several treatises on the technique of landscape painting in watercolors. Cox's brushstrokes, which became more fluid in the 1840s, enliven his many views of meadows and moorlands.

14 *Henri-Edmond Cross (1856–1910)*, French

Sketchbook, 1897
Watercolor over graphite with black ink accents; also charcoal, conte crayon, and colored crayons; various sheets only conte crayon in combination with watercolor; cream wove paper; 162 × 123 mm. (folded size)
Watermark: NE TOCHON-LEPAGE SUCC R
Gift of May Sarton, 1964.15

Cross was a follower of the Neo-Impressionists who discovered the artistic possibilities of the South of France in 1881. His sketchbook records his momentary impressions in January and February 1897 of various towns on the Midi coast—Esterel, Juan-les-Pins, La Bocca, Agays, and Le Trayas.

15 *Honoré Daumier (1808–1879)*, French

The Butcher, c. 1857
Watercolor and black ink over graphite, accents of black crayon; cream wove paper (composite sheet); 335 × 242 mm.
Inscribed in black ink, lower left: *h. Daumier*
Bequest of Grenville L. Winthrop, 1943.347

This watercolor is composed of two sheets: the top half, showing the carcass, was added on to the lower half's figure of the butcher. It is quite possible that Daumier was influenced by Rembrandt's *Side of Beef*, acquired by the Louvre in 1857. Daumier also executed a series of butcher cartoons in 1858 for the newspaper *Le Charivari*, when the Parisian butchers lost their monopoly (Vincent, pp. 169–170, pl. 29).

References: Howard P. Vincent, *Daumier and His World* (Evanston: Northwestern University Press, 1968). *Grenville L. Winthrop: Retrospective for a Collector* (Cambridge, Mass.: Fogg Art Museum, 1969), pp. 160–161, cat. no. 107. Bernard Lemann, "Two Daumier Drawings," *Bulletin of the Fogg Art Museum* VI (1939), 13–16.

16 *Charles Demuth (1883–1935)*, American

Fruit and Sunflowers, c. 1924 (plate 3)
Watercolor over pencil; white wove paper; 457 × 297 mm.
Watermark: [WHAT]MAN 1921 ENGLAND
Purchase of the Louise E. Bettens Fund, 1925.5.3

The influence of Cubism is apparent in Demuth's watercolors of the 1920s in the faceted planes, the fading out of the image at the edges, and the play of surface and depth. The blue and white cloth serves as both a tablecloth for the fruit and a vase for the flowers.

Reference: *American Art at Harvard* (Cambridge, Mass.: Fogg Art Museum, 1972), cat. no. 136.

17 *Arthur Dove (1880–1946)*, American

Gas Tank and Building 38, 1938
Watercolor and indian ink; rough white wove paper; 128 × 178 mm.
Inscribed in black ink, lower center: *dove*.
Gift of George Burton Cumming in memory of E. Louise Lucas, 1971.3

During the late 1930s Dove produced many watercolors, some which he later worked up into oil paintings. *Gas Tank and Building 38* probably inspired the oil painting called *Tanks* of 1938, now in the collection of the William H. Lane Foundation. Although Dove began to paint abstract compositions in 1910, he continued to use representational objects in many of his works. His depiction of the industrial form of a gas tank is contemporary with mechanical and architectural subjects painted by Sheeler and Demuth.

Reference: For an illustration of the oil painting *Tanks*, see Frederick S. Wight, *Arthur G. Dove* (Berkeley and Los Angeles: University of California Press, 1958), cat. no. 66.

18 *French*, School of Lorraine

Saint Catherine of Alexandria, c. 1600
Brown ink, yellow and red watercolor, white gouache (discolored), and shell gold over traces of black chalk or charcoal; cream antique laid paper; 127 × 88 mm.
Bequest of Meta and Paul J. Sachs, 1965.277

Charles Sterling suggests that this watercolor was executed in Nancy, France, at about 1600. He identifies the woman as Saint Catherine because of the martyr's palm which she holds (Memorandum of Charles Sterling, February 1962, Fogg Art Museum, Drawing Study files).

19 *Théodore Géricault (1791–1824)*, French

English Horse Guard, 1820–1822 (plate 4)

PLATE 4. Théodore Géricault, *English Horse Guard* (19).

Watercolor and gouache over graphite; brown wove, soft-surfaced paper; 236 × 298 mm.
Bequest of Grenville L. Winthrop, 1943.365

Painted during Géricault's trip to England, this watercolor represents a member of the British Light Dragoons or the Dragoon Guards, performing an exercise in dressage.

Reference: Klaus Berger, *Géricault: Drawings and Watercolors* (New York: H. Bittner and Co., 1946), p. 30, cat. no. 35.

20 *Emile Gillieron (1851–1940)*, French

Woman Rising from Seat (Woman beside Shrine) (copy of a wall fresco from Hagia Triada, Crete), c. 1903–1912
Watercolor and gouache over graphite; cream wove paper; 1571 × 1315 mm.
Gift of Mrs. Schuyler van Rensselaer, 1926.32.53

Emile Gillieron was a draughtsman, an archaeological illustrator, and drawing teacher to the royal children of Greece. With his son he worked at excavations of ancient Minoan and Mycenaean sites, reproducing objects and frescoes for future study. This watercolor is one of a series of frescoes found in the palace at Hagia Triada in 1903. The original fresco, dating from the sixteenth century B.C., is in the Heraklion Museum, Crete.

Reference: W. Stevenson Smith, *Interconnections in the Ancient Near East* (New Haven: Yale University Press, 1965), p. 77, fig. 106.

21 *Childe Hassam (1859–1935)*, American

White Mountains, Poland Springs, 1917
Watercolor over black chalk; cream wove paper with mechanical texture and diagonal rib; 254 × 353 mm.
Inscribed in brown watercolor, lower left: *Childe Hassam Poland Springs Sept 9 1917*
Gift of Grenville L. Winthrop, 1942.73

Childe Hassam began to paint in the Impressionist manner in 1887, during his first trip to Europe. He brought back to America not only the style of the Impressionists, but also their typical subject matter—landscapes, seascapes, urban scenes—and their interest in times of day and weather conditions.

22 *Winslow Homer (1836–1910)*, American

Sailboat and Fourth of July Fireworks, Gloucester, 1880
Watercolor and white gouache; white wove paper; 245 × 347 mm.
Inscribed in blue watercolor, lower right: *W.H.*; lower left: *July 4, 1880*
Bequest of Grenville L. Winthrop, 1943.305

Homer spent the summer of 1880 in Gloucester, Massachusetts. The subject of fireworks over the water naturally appealed to an artist so concerned with the transient effects of weather and light. The bursts of light against a dark background recall Whistler's Nocturnes of the 1870s, although Homer could not have seen them at this date.

Reference: *American Art at Harvard* (Cambridge, Mass.: Fogg Art Museum, 1972), cat. no. 102.

23 *Winslow Homer (1836–1910)*, American

Hunter in the Adirondacks, 1892 (plate 5)
Watercolor over pencil; white paper; 353 × 507 mm.
Inscribed in blue watercolor, lower right: *1892 / HOMER*
Gift of Grenville L. Winthrop, 1939.230

Homer's love for the Adirondack Mountains is documented by his many watercolors of the region. Although Homer sketched at the scene, he may have finished his Adirondack watercolors back in his studio at Prout's Neck, Maine. The model for the hunter has been identified by one source (Beam, pp. 100–101) as Wiley Gatchell, a resident of Prout's Neck, and by another (*American Art*, cat. no. 105) as Mike "Farmer" Flynn.

References: Philip C. Beam, *Winslow Homer at Prout's Neck* (Boston: Little, Brown & Co., 1966). *American Art at Harvard* (Cambridge, Mass.: Fogg Art Museum, 1972).

24 *Winslow Homer (1836–1910)*, American

Key West, 1903
Watercolor over graphite; white wove paper; 553 × 354 mm.
Inscribed in gray watercolor, lower left: *W.H.*; lower right: *Key West*
Gift of Edward W. Forbes, 1956.210

Homer first visited Florida in 1890 and thereafter returned frequently; he also travelled to other tropical locales. The bright sunshine and blue waters of the South inspired a new brilliancy in Homer's palette.

Reference: Patti Hannaway, *Winslow Homer in the Tropics* (Richmond, Va.: Westover Publishing Co., 1973), pp. 262–263, pl. 61.

25 *Edward Hopper (1882–1967)*, American

Highland Light, 1930
Watercolor over graphite; rough white wove paper; 423 × 653 mm.
Inscribed in olive watercolor over graphite, lower right: *Edward Hopper / Cape Cod*
Purchase of the Louise E. Bettens Fund, 1930.462

Hopper and his wife built a house at South Truro, Cape Cod, in 1930. This watercolor of the North Truro lighthouse demonstrates Hopper's interest in depicting the forms and edges of buildings in a clear, silent light. Hopper remarked of Cape Cod: ". . . there's a beautiful light there—very luminous—perhaps because it's so far out to sea; an island almost" (Goodrich, p. 85).

References: Lloyd Goodrich, *Edward Hopper* (New York:

Harry N. Abrams, 1971). *American Art at Harvard* (Cambridge, Mass.: Fogg Art Museum, 1972), cat. no. 146.

26 *William Henry Hunt (1790–1864)*, English

Still Life with Fruit, after 1827
Watercolor and gouache over white gouache; cream wove card; 147 × 225 mm.
Inscribed in brown watercolor, lower left: *W. Hunt*
Bequest of Grenville L. Winthrop, 1943.475

Hunt was a Victorian artist who altered his technique in 1827 and began to paint sharply defined watercolors of fruits and vegetables. Ruskin, a great exponent of the detailed works of the Pre-Raphaelites, was also an admirer of Hunt.

27 *Jean-Auguste-Dominique Ingres (1780–1867)*, French

Virgil Reading the "Aeneid" to Augustus, 1850
Watercolor, white gouache, and graphite; yellow tracing paper adhered to tan wove paper; 385 × 330 mm.
Inscribed in graphite, lower left: *J Ingres. inv. Del.*; lower right: *Paris 1850 –*
Bequest of Grenville L. Winthrop, 1943.373

Ingres painted the first of several versions of this subject in 1812, in response to a commission from General Miollis to decorate a room in the Villa Aldobrandini, Rome. The Fogg drawing may be a tracing of an 1830 drawing in the Louvre.

Reference: *Ingres Centennial Exhibition (1867–1967)* (Cambridge, Mass.: Fogg Art Museum, 1967), cat. no. 93.

28 *Jean-Auguste-Dominique Ingres (1780–1867)*, French

The Turkish Bath, 1864
Watercolor and graphite over brown printing ink; white

wove "plate" paper; 167 × 126 mm. (design area: 126 × 91 mm.)
Inscribed in graphite, left center: *à Madame Beulé / 1864 Ingres*
Gift of Charles E. Dunlap, 1956.244

In 1851 Ingres collaborated closely with the publisher Albert Magimel and the engraver Achille Reveil to issue outline reproductions of his major works to date. In the representation of his early masterpiece *The Bather of Valpinçon*, Ingres added three harem figures in the background. Fifteen years later Ingres colored in this impression of the print and dedicated it to Madame Beulé, wife of the permanent secretary of the Academie des Beaux-Arts (Lapauze, p. 508, n. 1). He altered the perspective of the image to create a deeper space surrounding the main figure, and added four more background nudes, in the same spirit as his *Turkish Bath* of 1862–1863.

References: Henri Lapauze, *Ingres: Sa Vie et Son Oeuvre* (Paris: Georges Petit, 1911). Albert Magimel, ed., *Oeuvres de J. A. Ingres . . . Gravées au Trait sur Acier par* ALE *Reveil* (Paris, 1851), p. 18 [on exhibition].

29 *Jean-Baptiste Isabey (1767–1855)*, French

Count Charles-Robert Nesselrode, c. 1815
Watercolor; cream wove paper; 159 × 121 mm. (oval)
Inscribed in gray watercolor, left center: *J. Isabey*
Gift of Mrs. George Richmond Fearing, 1944.36

Isabey, a miniaturist who worked for Charles X of France, was commissioned by Talleyrand to paint portraits of the diplomats who attended the Congress of Vienna in 1815. He then combined the individual portrait heads into a group portrait (Basily-Callimaki, p. 163). Count Nesselrode (1780–1862) was a Russian foreign minister who was sent to the Congress by Alexander I.

References: Madame de Basily-Callimaki, *J.-B. Isabey* (Paris: Frazier-Soye, 1909). *French Watercolors: 1760–1860* (Ann Arbor: University of Michigan Museum of Art, 1965), cat. no. 24.

30 *Vasily Kandinsky (1866–1944)*, Russian

Landscape, 1918
Watercolor and black ink over graphite; cream wove paper; 287 × 229 mm.
Inscribed in black ink, lower left: *VK.18* [monogram]
Lent by the Busch-Reisinger Museum, Anonymous gift in memory of Curt Valentin, 1956.50

By 1918 Kandinsky had returned to Russia after years of living in Germany and travelling extensively. This watercolor is one of few dating from that year. It is transitional in that it is not as dense as the abstract, free-flowing color compositions executed by the artist prior to 1918, yet it precedes his hard-edged, geometric paintings of the 1920s. The title *Landscape* is a reference to earlier figurative works.

References: Charles L. Kuhn, *German Expressionism and Abstract Art: The Harvard Collections* (Cambridge: Harvard University Press, 1957), pp. 11, 51, fig. 40. *Twentieth Century Master Drawings* (New York: Solomon R. Guggenheim Museum, 1963), cat. no. 51, pl. 26.

31 *Paul Klee (1879–1940)*, German

Landschaftswagen Nr. 14, 1930
Watercolor on gray silk, mounted on white card; 479 × 621 mm.
Inscribed in gray watercolor, lower margin: *1930.W.2. Landschafts-wagen Nr. 14.*; on lower left of silk: *Klee*; in black watercolor, lower right of silk: *14*
Lent by the Busch-Reisinger Museum, joint purchase of the Fogg Museum and Busch-Reisinger Museum, 1951.46

This watercolor of 1930 demonstrates two characteristic aspects of Klee's work: the development of his abstractions into representational drawings, and his interest in painting on differ-

PLATE 5. Winslow Homer, *Hunter in the Adirondacks* (23).

100

ent materials. Klee's lifelong involvement with music is often manifested in his paintings. In certain of his compositions he considered the radiating lines and spatial planes plastic representations of various sounds. The addition of wheels and stick-like trees converts this abstraction into a "landscape wagon."

References: Christian Geelhaar, "Paul Klee: *Früchte auf Rot*," *Pantheon* XXX (1972), 222–228. Charles L. Kuhn, *German Expressionism and Abstract Art: The Harvard Collections* (Cambridge: Harvard University Press, 1957), p. 53, fig. 52.

32 *Hans Suess von Kulmbach (1480–1522)*, German

Saint Nicholas, c. 1511
Rose, gray, and blue watercolor over brown ink and wash; cream antique laid paper, cut into two sections with irregular outlines; 357 × 163 mm.
Bequest of Meta and Paul J. Sachs, 1965.345

Kulmbach, a pupil of Dürer, combines the linear style of his master with a certain delicate quality of his own. Perhaps Kulmbach executed this watercolor as a preliminary sketch for one of the stained-glass windows which he designed. Saint Nicholas is dressed as a bishop and holds three purses, in reference to his charity.

Reference: Agnes Mongan and Paul J. Sachs, *Drawings in the Fogg Museum of Art*, 2nd ed., 2 vols. (Cambridge: Harvard University Press, 1957), I, cat. no. 388, fig. 198.

33 *John La Farge (1835–1910)*, American

Chinese Pi-Tong, c. 1861–1879
Watercolor and gouache over graphite; off-white, textured wove paper; 433 × 432 mm. (design area: 397 × 393 mm.)
Bequest of Grenville L. Winthrop, 1943.310

La Farge exhibited this watercolor in 1879 at the American Water Color Society show (Memorandum of Kathleen Foster, 1975, Fogg Art Museum, Drawing Study files). His interest in and collecting of Oriental art began as early as 1859; this vase was most probably in his own collection. The yellow pigment Aureolin has been identified at the lower left of the watercolor; Aureolin was introduced by Winsor & Newton after 1861 (R. J. Gettens and G. L. Stout, *Painting Materials: A Short Encyclopedia* [New York: D. Van Nostrand Co., 1942], p. 110).

Reference: *Illustrated Catalogue of the Twelfth Annual Exhibition of the American Water Color Society* (New York: 1879), cat. no. 15. *American Art at Harvard* (Cambridge, Mass.: Fogg Art Museum, 1972), cat. no. 79.

34 *John La Farge (1835–1910)*, American

Mount Tohivea, Island of Moorea, 1891
Watercolor and gouache over graphite; white wove paper; 456 × 555 mm.
Inscribed in black ink, lower margin: *Unfinished, laid out for another afternoon / We were called away to get back to Tahiti / on the night of the 21st & left all sketches more or less undone. / April 20 1891 and 21st, afternoon light / Bay of Uponohu / Island of Moorea / Tohivea. 1212 metres high / Summit called pierced as above*
Bequest of Grenville L. Winthrop, 1943.311

La Farge travelled to the South Seas in August 1890, almost a year before Gauguin's trip to Tahiti. In his *Reminiscences* La Farge wrote of Tohivea: "At the edge where the blue of sky and sea came together opposite us, the island of Moorea, all mountain peaked and engrailed like some far distance of Titian's landscapes, seemed swimming in the blue. . . . This haze of green, so delicate as to be namable only by other colours, gives a look of sweetness to these high spaces, and makes them repeat, in tones of light, against the blue of the sky, chords of colour similar to those of the trees and the grass against the blue and violet of the sea" (John La Farge, *Reminiscences of the South Seas* [London: Grant Richards Ltd., 1914], pp. 301, 307).

35 *Eugène Lami (1800–1890),* French

Duke and Duchess of Brabant, 1853
Watercolor and white gouache over graphite; cream wove paper; 247 × 193 mm.
Inscribed in graphite, lower right margin: *Eug. Lami 1853*
Bequest of Grenville L. Winthrop, 1943.382

Lami, trained in the French academic tradition, helped to found La Société des Aquarellistes Français in 1878. In this watercolor he depicts the Duke of Brabant, later Leopold II of Belgium, in the year of his marriage to Marie-Henriette, Archduchess of Austria (Lemoisne, p. 237).

Reference: Paul-André Lemoisne, *L'Oeuvre d'Eugène Lami* (Paris: H. Champion, 1914), cat. no. 1042.

36 *Edward Lear (1812–1888),* English

Roorkee, 1874
Watercolor, black ink, and brown ink over graphite; off-white wove paper; 357 × 510 mm.
Inscribed in pencil, lower left: *A grove of Mango / Roorkee / March 20 1874 / 2 to 5 PM.*
Lent by the Harvard College Library, Department of Printing and Graphic Arts, Gift of William B. Osgood Field, *42M–245PF–N.II.R.6

Edward Lear was a draughtsman and painter of watercolors as well as a writer of nonsense verse. He discussed this watercolor, begun during a trip to India, in his journal: "Sitting by the (Ganges) canal road till 5:30, making 2 drawings of the grand and lovely Mango Grove—very dark pencil sketches & it is to be hoped they will cast the clear brilliancy of those stems! and the intense deep brown of the far hollow arched shades!!" In the margin of his journal, Lear added: "Penned out & colored, September 1876" (Hofer, p. 38).

References: Philip Hofer, *Edward Lear as a Landscape Draughtsman* (Cambridge: Harvard University Press, Belknap Press,

1967), no. 79. *Edward Lear, Painter, Poet and Draughtsman: An Exhibition of Drawings, Watercolors, Oils, Nonsense and Travel Books* (Worcester: Worcester Art Museum, 1968), p. 83, cat. no. 58.

37 *Edouard Manet (1832–1883),* French

Race Course at Longchamps, 1864
Watercolor and gouache over graphite; white wove paper; 221 × 564 mm. (two sheets joined vertically 225 mm. from left edge)
Inscribed in black watercolor, lower left: *Manet 1864*
Verso, left section: graphite drawing of grandstand area
Bequest of Grenville L. Winthrop, 1943.387

This watercolor may be a reworking of an oil painting of the Races which probably no longer exists in its original form (Harris, p. 81). The race track was a subject that appealed to both Manet and Degas; Manet's interest began in 1864. The choice of viewpoint is striking here—the horses are shown running straight at the viewer, perpendicular to the picture plane.

References: Jean C. Harris, "Manet's Race-Track Paintings," *Art Bulletin* XLVIII (1966), 78–82. *Grenville L. Winthrop: Retrospective for a Collector* (Cambridge, Mass.: Fogg Art Museum, 1969), pp. 180–181, cat. no. 117.

38 *John Marin (1870–1953),* American

Mount Chocorua, 1926
Watercolor over charcoal; rough, white wove paper; 437 × 558 mm.
Inscribed in gray watercolor over charcoal, lower left: *Marin 26*
Purchase of the Louise E. Bettens Fund, 1928.4

During the first week of July 1926, Marin and his family drove from New Jersey to Maine. Several watercolors of Mount Chocorua, New Hampshire, date from this trip. Marin uses planes

of color to construct his mountain into a powerful image.

References: *American Art at Harvard* (Cambridge, Mass.: Fogg Art Museum, 1972), cat. no. 139. Sheldon Reich, *John Marin: A Stylistic Analysis and Catalogue Raisonné* (Tucson: University of Arizona Press, 1970), cat. no. 26.29.

39 Circle of the Master of the Hortulus Animae (active c. 1500), Flemish

Studies of Three Men's Heads and a Chalice, early sixteenth century
Watercolor and brown ink heightened with white gouache; gray prepared, antique laid paper; 80 × 95 mm.
Verso: brown ink drawing of landscape with buildings
Bequest of Charles A. Loeser, 1932.372

The name *Hortulus Animae* derives from a manuscript of the same name produced by a workshop in Vienna at the beginning of the sixteenth century. Ruth Magurn attributes this study to the master of that workshop, suggesting that these drawings may have been preparatory studies for miniatures (Magurn, pp. 25–30).

Reference: Ruth S. Magurn, "A Sheet of Studies by a Flemish Miniaturist," *Bulletin of the Fogg Art Museum* VII (1938), 25–30.

40 Joan Miró (1893–), Spanish

Une Femme, 1935
Red, blue, black, and white gouache with an underdrawing of white chalk and graphite(?), over washes of rose and black watercolor with a stylus underdrawing; cream wove paper; 368 × 305 mm.
Inscribed in black gouache, upper right: *Miró*; on verso, upper left: *Joan Miro / "une femme" / 10/9/35*
Gift of Mr. and Mrs. Alfred Jaretzki, Jr., 1965.539

This distorted and frightening view of a woman is one of many executed by Miró in 1935 and 1936 in reaction to the ominous approach of the Spanish Civil War and World War II. Both Picasso and Miró used women as the image of suffering humanity, but while Picasso's women are the victims, Miró's are often the monsters.

41 Albert Joseph Moore (1841–1893), English

The Toilet, before 1886
Watercolor and gouache over graphite and graphite squaring; cream wove paper; 332 × 195 mm.
Bequest of Grenville L. Winthrop, 1943.909

Albert Moore was a decorative artist who in the 1860s began to paint draped figures in carefully planned arrangements, using both Greek and Japanese motifs. This watercolor may be a study for an oil painting called *The Toilet* which Moore executed in 1886. The composition has been worked out with grid lines. Moore and Whistler met in 1865 and remained friends until Moore's death, each influencing the other's art.

Reference: *Paintings and Drawings of the Pre-Raphaelites and Their Circle* (Cambridge, Mass.: Fogg Art Museum, 1946), pp. 69–70, cat. no. 62.

42 Charles Herbert Moore (1840–1930), American

Rocks by the Water, c. 1872
Watercolor and white gouache over graphite; cream wove paper; 143 × 197 mm.
Transferred from the Fine Arts Department, 1926.33.92

Charles Herbert Moore was an American artist who painted in the Pre-Raphaelite manner. He attempted to earn a livelihood by selling his works until 1871, when Charles Eliot Norton convinced him to teach scientific drawing and later a course entitled Principles of Fine Art at Harvard. This view of rocks on the Maine coast was probably inspired by Ruskin's *Fragment of the Alps* (53), which was in Norton's possession by 1858. Moore, a

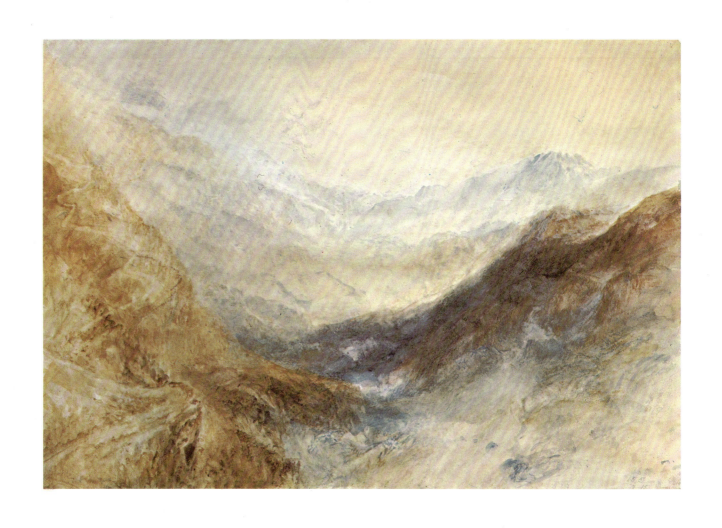

PLATE 6. Joseph Mallord William Turner, *Simplon Pass* (61).

great admirer of Ruskin, finally met him in 1876. On October 5, 1876, Ruskin reported to Norton that he (Ruskin) and Moore were in "perfect sympathy in all art matters and are not in dissonance in any others. And he is not at all so wicked nor so republican as you, and minds all I say!" (W. R. Lethaby, "The Late Charles H. Moore, A.H.," *Journal of the Royal Institute of British Architects*, March 22, 1930, p. 337.)

Reference: Frank Jewett Mather, Jr., *Charles Herbert Moore: Landscape Painter* (Princeton: Princeton University Press, 1957), p. 40, fig. 25.

43 *Giorgio Morandi (1890–1964)*, Italian

Still Life, c. 1960–1964
Watercolor on white wove paper; 136 × 258 mm.
Inscribed in black chalk, center lower edge: *Morandi*
Anonymous gift in memory of Paul Rewald (1943–1976), 1977.1

Morandi spent most of his life in Bologna painting still lifes which experiment with the variety of potentialities of a single motif, a cluster of bottles. He began to use watercolor with frequency after 1946. This still life, in which the bottles are simplified into abstract areas of color, resembles those executed in the 1960s.

44 *Gustave Moreau (1826–1898)*, French

The Sirens
Watercolor and gouache over brown ink; off-white wove paper; 331 × 210 mm.
Inscribed in brown ink, lower left: *Gustave Moreau –*; lower right: *Sirènes*
Bequest of Grenville L. Winthrop, 1943.392

The image of the *femme fatale* pervaded Moreau's mystical and personal world. The myth of the Sirens confirmed Moreau's conception of women: "Woman, in her primal nature, is the unconscious Being, mad for the unknown, the mystery, smitten with evil in the form of perverse and diabolical seduction" (Bénédite, p. 26). Moreau also produced an oil painting of the subject, which, interestingly, is less finished than the watercolor. A poem entitled "Les Sirènes" by the symbolist poet Jean Lorrain, who often dedicated his poems to Moreau, may have inspired the watercolor (*Catalogue Sommaire*, pp. 33–34, no. 103).

References: Léonce Bénédite, *Deux Idéalistes: Gustave Moreau et E. Burne-Jones* (Paris, 1899): "Femme, dans son essence première, l'Être inconscient, folle de l'inconnu, du mystère, éprise du mal sous la forme de séduction perverse et diabolique." *Catalogue Sommaire des Peintures, Dessins, Cartons et Aquarelles Exposés dans les Galeries du Musée Gustave Moreau* (Paris: Musée Gustave Moreau, 1926). Paul Leprieur, *Gustave Moreau et Son Oeuvre* (Paris, 1889), p. 32.

45 *Louis-Gabriel Moreau (Moreau l'aîné) (1739–1805)*, French

Parc de Saint-Cloud
Watercolor and gouache (over graphite?); white Chinese paper, mounted on cream wove paper; 239 × 462 mm.
Inscribed in gray gouache, lower left on rock: ·LM·
Gift of Charles E. Dunlap, 1955.188

Somewhat overshadowed in reputation by his younger brother Jean, Louis Moreau was a member of the Academy of Saint Luke and painter to the Count of Artois. He painted romantic views of Paris and its environs, always emphasizing the landscape over the figures. Although never famous in his lifetime, he exhibited a delicate touch and sense of color that presage the art of Corot.

Reference: Georges Wildenstein, *Un Peintre de Paysage au Dix-huitième Siècle: Louis Moreau* (Paris: Les Beaux-Arts, Edition d'Études et de Documents, 1923), cat. no. 135, pl. 64.

46 *Charles Joseph Natoire (1700-1777)*, French

Mythological Scene: Bacchanale, c. 1750-1777
Watercolor and gouache over graphite; squared underpainting in graphite; soft tan, antique laid paper; 381 × 527 mm.
Inscribed in gray watercolor, lower left: *C Natoire*
Anonymous gift, 1957.51

Natoire, a painter of both religious and profane subjects, was director of the French Academy in Rome between 1751 and 1774. This mythological painting and its pendant were sold with the artist's possessions after his death. Both works have been dated to Natoire's years in Italy (1750-1777) (Rosenberg, p. 186).

Reference: Pierre Rosenberg, *French Master Drawings of the Seventeenth and Eighteenth Centuries in North American Collections* (New York: New York Cultural Center, 1972).

47 *Emil Nolde (1867-1956)*, German

Head of a Woman
Watercolor over black ink; cream modern laid paper; 465 × 314 mm.
Inscribed in pencil, lower right: *Nolde*
Lent by the Busch-Reisinger Museum, Gift of Mr. and Mrs. Frederick Zimmermann in memory of Curt Valentin, 1956.44

For Nolde, the medium of watercolor provided a fluid and spontaneous means of recording his creative ideas. His subjects ranged from landscapes and seascapes to figure studies, religious compositions, and flower paintings. Primitive art appealed to Nolde because it seemed to affirm his own anti-intellectual and anti-international attitude. The heads he painted, such as this one, often exhibit Nolde's assimilation of primitive art. They are masks of complementary colors and black outlines, suspended on the otherwise blank sheet of paper.

Reference: Charles L. Kuhn, *German Expressionism and Abstract Art: The Harvard Collections* (Cambridge: Harvard University Press, 1957), p. 61, fig. 29.

48 *Pablo Picasso (1881-1973)*, Spanish

Weeping Woman ("Guernica" Postscript), 1937
Oil paints and Indian ink; off-white wove paper; 400 × 261 mm.
Inscribed in black ink, upper left: *Picasso 28 octobro 37*
Purchase of the Francis H. Burr Memorial Fund, 1940.155

In April 1937 the Basque town of Guernica was destroyed by Franco's forces. In horrified reaction and protest against this act, Picasso painted *Guernica* during May and June. Between June and October he continued to produce a series of postscripts to *Guernica*. The *Weeping Woman* is one of the series which epitomizes the suffering of the Spanish people.

Reference: Christian Zervos, *Pablo Picasso*, 30 vols. (Paris: Éditions "Cahiers d'Art," 1958), IX, *Oeuvres de 1937 à 1939*, cat. no. 76, pl. 32.

49 *Camille Pissarro (1831-1903)*, French

Landscape, Eragny, 1890
Watercolor over graphite; cream wove paper; 230 × 290 mm.
Watermark: [What]man 1886 B
Inscribed in graphite, lower edge: *après midi 13 Oct 90 Eragny C. Pissarro*; in black chalk: *N° 18*
Bequest of Grenville L. Winthrop, 1943.395

Pissarro is generally considered the Impressionist with the greatest sense of structure and solidity in his paintings. His watercolors tend to have a lighter, more atmospheric quality than his oil paintings, due in part to the character of the medium. Even in this most delicate of watercolors, however, the underlying structure of the landscape is established by the drawing. Pissarro travelled widely in northern France, constantly in

search of new subjects. In 1884 he settled with his family in Eragny, an area which appealed to him because there ". . . the fields are green, outlines are delicate" (*Camille Pissarro: Letters to His Son Lucien*, ed. John Rewald [New York: Pantheon Books, Inc., 1943], p. 58).

Reference: Martha H. Holsclaw, "A Landscape in Watercolor by Camille Pissarro," *Fogg Art Museum: Acquisitions 1968* (Cambridge: Harvard University, 1968), pp. 44–51.

50 *Clara Maria Pope, attributed to (1750?–1838)*, English

Carnations, c. 1806–1820
Watercolor; off-white wove paper; 485 × 380 mm.
Watermark: J WHATMAN
Lent by the Dumbarton Oaks Research Library and Collection, Trustees for Harvard University

Clara Maria Pope was a painter of flowers, fruit, and miniatures who did the preparatory drawings for Samuel Curtis's *The Beauties of Flora*. The first edition of this book appeared in 1806 with one flower illustration. *Carnations* is one of seven watercolors executed by Mrs. Pope for the 1820 edition, which contained ten plates in all.

Reference: Gordon Dunthorne, *Flower and Fruit Prints of the Eighteenth and Early Nineteenth Centuries: Their History, Makers and Uses, with a Catalogue Raisonné of the Works in Which They Are Found* (Washington, D.C.: Gordon Dunthorne, 1938), p. 40.

51 *Dante Gabriel Rossetti (1828–1882)*, English

Lucretia Borgia, 1871
Watercolor and gouache with heavy gum varnish in deep tones; cream wove paper; 639 × 390 mm.
Inscribed in red watercolor, lower right: *DGR* [monogram] / *1871*

Bequest of Grenville L. Winthrop, 1943.489

In 1860 Rossetti painted a watercolor of a dark-haired Lucretia washing her hands after poisoning her husband, Duke Alfonso of Bisceglia. Dissatisfied with his original conception of Lucretia, Rossetti later repainted the figure, changing the hair color, dress, and direction of her gaze. The Fogg watercolor is one of two copies of the altered composition made in 1871. Reflected in the mirror is Lucretia's father and partner in crime, Pope Alexander VI, walking the Duke back and forth to spread the poison through his system.

Reference: Virginia Surtees, *The Paintings and Drawings of Dante Gabriel Rossetti (1828–1882): A Catalogue Raisonné*, 2 vols. (Oxford: Oxford University Press, Clarendon Press, 1971), I, 77–78.

52 *Thomas Rowlandson (1757–1827)*, English

Mail Coach Going Uphill, after 1795
Watercolor and ink over graphite; cream wove paper; 277 × 470 mm.
Bequest of Grenville L. Winthrop, 1943.495

Rowlandson, a caricaturist and illustrator of English life and literature, lived the raucous and intemperate life that he often depicted. He travelled widely, and many incidents that he experienced became the subjects of his watercolors. The rococo line of the pen and diagonal composition are typical Rowlandson devices. The artist did not use the pigment Vermilion, which appears in this work, until the late 1790s (John Hayes, *Rowlandson: Watercolours and Drawings* [London: Phaidon Press, 1972], p. 39).

Reference: Martin Birnbaum, *Jacovleff and Other Artists* (New York: Paul A. Struck, 1946), p. 101, pl. 34.

53 *John Ruskin (1819–1900)*, English

Fragment of the Alps, 1854–1856

Watercolor and gouache over graphite; cream wove paper; 335 × 493 mm.
Inscribed in graphite, verso, in Charles Eliot Norton's hand: *Dont cut off this strip. put it in frame just as it is*
Gift of Samuel Sachs, 1919.506

Between 1854 and 1856 Ruskin and his parents toured the Alps where in Chamonix he painted this rock of gneiss. Ruskin's choice of subject is significant, for he believed that ". . . if you can draw that stone, you can draw anything . . . that is drawable" (Ruskin, *The Elements of Drawing . . .* [London, 1857], p. 46). Initially displeased with his watercolor, Ruskin wrote to Charles Eliot Norton on October 24, 1858: ". . . you may keep that block of gneiss altogether if you like it; I wish the trees had been either in the sky, or out of it" (Ruskin, *Works*, XXXVI, 294). Yet Ruskin characteristically changed his mind by 1886: "There is no drawing of a stone by my hand so good as your boulder" (*ibid.*, XXXVII, 563, Ruskin–Norton, May 16, 1886).

References: John Ruskin, *The Works of John Ruskin*, ed. E. T. Cook and A. Wedderburn, 39 vols. (London: G. Allen, 1912). Paul H. Walton, *The Drawings of John Ruskin* (Oxford: Clarendon Press, 1972), p. 83, fig. 60.

54 *Paul Sandby (1730–1809),* English

Large Tree with Couple Seated Beneath
Watercolor and distemper(?) over graphite, heavily varnished; cream laid paper; 660 × 474 mm.
Watermark: JW [monogram]
Gift of Grenville L. Winthrop, 1942.48

Paul Sandby, who was instrumental in the founding of the Royal Academy in 1769, was the first English draughtsman to use watercolor continuously in his works. He combined the topographical tradition with the picturesque elements of Claude and Poussin. Many of his paintings depict the parklands of Great Windsor Forest, where his brother Thomas was Deputy Ranger for many years.

Reference: *One Hundred Years of English Landscape Drawing, 1750–1850* (Cambridge, Mass.: Busch-Reisinger Museum, 1960), p. 14, cat. no. 38.

55 *John Singer Sargent (1856–1925),* American

The Man Reading, c. 1910
Watercolor over graphite; white wove paper; 349 × 535 mm.
Inscribed in brown ink, lower right: *John S. Sargent*
Bequest of Grenville L. Winthrop, 1943.315

Sargent decided to cease painting commissioned portraits in 1909. In consequence his works of 1910 are often candid views of friends and acquaintances. This watercolor of Sargent's valet, Nicola d'Inverno, is one such painting where Sargent felt free to concentrate on the formal values of light, color, and stroke rather than on the features of his subject.

Reference: *American Art at Harvard* (Cambridge, Mass.: Fogg Art Museum, 1972), cat. no. 117.

56 *Egon Schiele (1890–1918),* Austrian

Drapery Study, 1910
Watercolor and gouache over charcoal; tan wove paper; 445 × 310 mm.
Inscribed in graphite, upper center: *S.10.*; in purple pencil, lower right: *S*
Lent by the Busch-Reisinger Museum, Purchase of the Selma H. Sobin and Antonia Paepcke DuBrul Funds, 1968.13

Schiele developed an extremely personalized Expressionism characterized by sexual images and body distortions. In 1910 he executed a number of works in which his subjects are posed against totally blank backgrounds. This compositional device has the effect of flattening out the figures and emphasizing the element of design. In this watercolor the model's drapery becomes an abstract color pattern. The artist's alphabetical color notations are visible on the plaid cloth.

57 *Everett Shinn (1876–1953)*, American

Central Park, 1915
Black chalk and watercolor with white gouache; off-white
wove paper; 104 × 149 mm.
Inscribed in black crayon, lower right: *E SHINN 1915*
Gift of Mrs. John G. Pierce in memory of her husband,
1963.114

Shinn was a member of the American Eight, a group which re-
belled against the refined taste of the official art world by paint-
ing unembellished scenes of urban life. Shinn's interest in the
night life of New York probably stemmed from his involvement
with the theater as a designer, producer, and playwright. He also
loved to paint the parks and streets of New York. According to
an inscription on the back of the mounting sheet, this watercolor
represents Seventy-third Street and Central Park West in New
York City.

References: Sheldon Reich, *Graphic Styles of the American
Eight* (Salt Lake City: Utah Museum of Fine Arts, University of
Utah, 1976), cat. no. 113. *American Art at Harvard* (Cambridge,
Mass.: Fogg Art Museum, 1972), cat. no. 131.

58 *Joseph Lindon Smith (1863–1950)*, American

Grave Monument of Aristion, c. 1886–1889
Watercolor and white gouache over graphite; heavy tex-
tured, white paper; 779 × 202 mm.
Bequest of Edward W. Forbes, 1969.37

Joseph Lindon Smith developed the technique of painting in flat
tones with gouache in order to recreate the sculptural and archi-
tectural monuments of the ancient world. Denman Ross, pro-
fessor of Fine Arts at Harvard, sponsored the young artist's first
trip to Greece from 1886 to 1889, and accompanied him. This
watercolor was probably painted during that tour. In later years
Smith taught in the Department of Architecture at Harvard and
was an honorary curator of the Egyptian Department at the
Museum of Fine Arts in Boston. The original grave stele of

Aristion by Aristokles, in the National Museum, Athens, dates
from 510–500 B.C.

Reference: Fogg Art Museum Archives, Edward W. Forbes,
"History of the Fogg Art Museum," 5th rev., 2 vols. I, 66–67.

59 *Henri de Toulouse-Lautrec (1864–1901)*, French

The Trapeze Artist at the Medrano Circus, 1893
Gouache on gray cardboard; 795 × 602 mm.
Inscribed in graphite, upper right corner: *HTLautrec* [mon-
ogram initials]
Bequest of Annie S. Coburn, 1934.34

As a child Toulouse-Lautrec frequented the circus, and his love
for the clowns, acrobats, animals, and carnival atmosphere con-
tinued for the rest of his life. At the Cirque Medrano he made
sketches which he later worked up into paintings, drawings, and
watercolors. His fascination with acrobats may have resulted
from his limited ability to be active due to a physical handicap
(Gerstle Mack, *Toulouse-Lautrec* [London: Jonathan Cape,
1938], pp. 215–220).

Reference: M. G. Dortu, *Toulouse-Lautrec et Son Oeuvre*, 6
vols. (New York: Collectors Editions, 1971), II, 300, 489.

60 *Joseph Mallord William Turner (1775–1851)*, English

Bally-Burgh Ness, "The Antiquary," c. 1834
Watercolor and gouache; cream wove paper; extensive
scratchwork in highlights; 83 × 135 mm.
Bequest of Grenville L. Winthrop, 1943.509

This watercolor is an illustration of an incident in *The An-
tiquary*, one of Sir Walter Scott's "Waverly Novels." It was en-
graved in 1836 by Edward Finden (Fogg Art Museum Print
Room, bound plates of engravings after Turner, John Witt
Randall Collection, N.A.533, pl. 5-99 [on exhibition]), yet ap-

parently was never used for an edition of the book. The scene represents a dramatic moment in the novel when a knight and his daughter are in danger of being washed out to sea.

References: Sir Walter Armstrong, *Turner* (London: Thomas Agnew & Sons, 1902), pp. 240-241. W. G. Rawlinson, *The Engraved Work of J. M. W. Turner*, 2 vols. (London: MacMillan and Co., 1913), p. 288, no. 562.

61 *Joseph Mallord William Turner (1775-1851)*, English

Simplon Pass, after 1841 (plate 6)
Watercolor and gouache; cream wove paper; 380 × 552 mm.
Gift of Edward W. Forbes, 1954.133

Turner produced Alpine watercolors during several trips to Switzerland between 1836 and 1844. At that time he became interested in expressing the elemental forces of nature through broad, swirling areas of color fused with bursts of light that almost dissolve into abstraction. In the last years of Turner's artistic career the distinction between sketches and finished works virtually disappeared.

Reference: Charles H. Moore, "The Fogg Art Museum of Harvard University," *New England Magazine*, August 1905, p. 703.

62 *John Varley (1778-1842)*, English

Harlech Castle
Watercolor over graphite; cream wove paper; 216 × 312 mm.
Purchase of the Fine Arts Department Funds, 1899.6

John Varley, one of the founders in 1804 of the Society of Painters in Water-Colours, painted in the English landscape watercolor tradition which derived from Claude and Poussin. He travelled throughout England and Wales sketching architecture and landscape. Harlech Castle is in North Wales.

63 *Benjamin West (1738-1820)*, American

Fidelia and Speranza, 1784
Brown ink, watercolor, and white gouache (discolored), over graphite; cream antique laid paper; 533 × 406 mm.
Watermark: PvL
Bequest of Grenville L. Winthrop, 1943.329

This watercolor illustrates Edmund Spenser's *Faerie Queene* (Book I, Canto X, Stanzas XII–XIV) where Una and the Red Cross Knight meet the daughters of Caelia. The composition echoes West's oil painting of the same subject which he exhibited at the Royal Academy in 1777.

Reference: *American Art at Harvard* (Cambridge, Mass.: Fogg Art Museum, 1972), cat. no. 14.

64 *James Abbott McNeill Whistler (1834-1903)*, American

Maud Reading in a Hammock, c. 1880
Watercolor over graphite; cream rough wove paper; 137 × 228 mm.
Inscribed with butterfly monogram in brown watercolor, upper center; on verso: *presented to George E. Hopkins / by J. McNeill Whistler / Venice July 11th 1880*
Bequest of Grenville L. Winthrop, 1943.330

Maud Franklin was Whistler's model and mistress from 1874 until he married Beatrix Godwin in 1888. Whistler and Franklin were in Venice between September 1879 and November 1880, while the artist worked on a commission for twelve etchings of the city for the Fine Art Society, a London gallery.

Reference: International Society of Sculptors, Painters, and Gravers, *Paintings, Drawings, Etchings, Lithographs: Memorial Exhibition of the Works of J. McNeill Whistler* (London: William Heinemann, 1905), pp. 121–122, cat. no. 120

65a *Frederik de Wit (active around 1650),* Dutch

Tractus regni angliae septentrion, c. 1680
Watercolor over printing ink; cream antique laid paper;
550 × 667 mm. (plate: 589 × 490 mm.)
Watermark: H
Lent by the Harvard Map Collection, 150.1700(1)

65b *Frederik de Wit (active around 1650),* Dutch

Orientalior distrinctus regni angliae, c. 1680
Watercolor over printing ink; cream antique laid paper;
667 × 557 mm. (plate: 585 × 494 mm.)
Watermark: H
Lent by the Harvard Map Collection, 150.1700(3)

Frederik de Wit was an engraver and editor in Amsterdam who specialized in portraits and geographical maps. Number 65a is exhibited to show the map; 65b is turned over to show the selective deteriorating effect of the watercolor washes (Copper green?) on the paper.

Reference: British Museum, *Catalogue of Printed Maps Charts and Plans*, 15 vols. (London: Trustees of the British Museum, 1967), xv, 265, maps c.5.a.5(1). Impressions of these maps and others by de Wit are recorded in this publication.

Index

Reproductions appear on pages with boldface numbers.